ADVANCED PHOTOSHOP
CS3 TRICKERY & FX

ADVANCED PHOTOSHOP CS3 TRICKERY & FX

STEPHEN BURNS

CHARLES RIVER MEDIA, INC.

Boston, Massachusetts

Cover Design: The Printed Image
Cover Images: Stephen Burns

CHARLES RIVER MEDIA, INC.
10 Downer Avenue
Hingham, Massachusetts 02043
781-740-0400
781-740-8816 (FAX)
info@charlesriver.com
www.charlesriver.com

This book is printed on acid-free paper.

Stephen Burns. *Advanced Photoshop CS3 Trickery & FX.*
ISBN-10: 1-58450-531-1
ISBN-13: 978-1-58450-531-0

Library of Congress Cataloging-in-Publication Data
Burns, Stephen, 1963-
 Advanced PhotoShop CS3 trickery & fx / Stephen Burns. -- 1st ed.
 p. cm.
 Includes index.
 ISBN-13: 978-1-58450-531-0 (pbk. with cd-rom : alk. paper)
 ISBN-10: 1-58450-531-1 (pbk. with cd-rom : alk. paper) 1. Computer graphics.
 2. Adobe Photoshop. I. Title.
 T385.B864345 2007
 006.6'86--dc22
 2007012287

Printed in the United States of America
07 7 6 5 4 3 2 First Edition

CHARLES RIVER MEDIA titles are available for site license or bulk purchase by institutions, user groups, corporations, etc. For additional information, please contact the Special Sales Department at 800-347-7707.

This book is dedicated to my mom and dad
for having inspired me to always excel at what I do.
They are excellent parents.

I also dedicate this book to my students
that they may continue to find new excitement
in their digital creations.

CONTENTS

ACKNOWLEDGMENTS

Without the support of so many others, this book would not have been possible.

I would like to thank Jenifer Niles, Lance Morganelli, and Jennifer Blaney and Lee Kohse of Charles River Media for their patience and professionalism in seeing this book to fruition properly.

Thanks to Jim Plant, Michael Kornet, Donetta Colbath, Jay Roth, and Chilton Web of Newtek (*www.newtek.com*) for listening to my suggestion to create "LightWave Rendition for Photoshop" and diligently coming through with it.

Thanks to Janis Wendt, Josh Haftel, and the rest of the Nik Multimedia team for their ever-growing encouragement and support. Great job guys on producing great plug-ins for Photoshop.

In addition, I feel it is only appropriate to thank Adobe for creating such outstanding software, as well as Pete Falco of Adobe who patiently put up with all of my consistent questioning.

Thanks to Erin Wishek and Chris Hoover for being willing last-minute models, and a special thanks to Calumet Photo of Escondido, California (*www.calumetphoto.com*) for their ongoing support in keeping me informed of the new changes in digital technology.

Also, I would like to thank the members of the San Diego Photoshop Users group (*www.sdphotoshopusers.com*) for their dedication and support in helping me build a strong network of digital artists from which I draw inspiration always.

FOREWORD

What is art? What makes someone an artist? Is a computer a valid art tool? Is a computer an incredible art tool? What's your favorite color?

Tough questions? For some. For Stephen Burns, one of the hardest working artists, instructors, inspirers I have the pleasure of knowing, they are moot (all except the "What's your favorite color?" one, he's pretty uncommitted on that issue).

For me, art is about passion, and about communicating that passion through created imagery and objects, words, sounds, and movement. Stephen Burns is extremely passionate about art, and about communicating that passion through the works that he creates (and shares with the world in his numerous gallery exhibitions). But even more importantly (especially for those of you holding this book), he is passionate about communicating his thoughts and technical processes *behind* what he creates. And that is where this book comes in.

In these pages you'll follow Stephen along on many different artistic journeys—each one geared to giving you the advanced Photoshop CS3 "trickery" needed to create your own visions, often out of thin air. This intensive nuts-and-bolts instruction into our beloved Photoshop is combined with Stephen's artistic insights into light and color, composition and eye flow, and (among other things) the need for maintaining synchronistic spontaneity as part of the creative process, especially within the often left-brained art studio of the computer.

Bottom line, get ready for an E-ticket creative roller coaster ride with the unstoppable Stephen Burns—one that is sure to inspire you in your own passionate endeavors!

Jack Davis
Author, Photographer, "Artist"
www.HowToWowTraining.com

About the Author

Stephen Burns has discovered the same passion for the digital medium as he has for photography as an art form. His background began as a photographer 25 year ago where he specialized in creating special effects photography using a 4x5 camera. His studies lead him to discover painting, where he embraced the works of the great Abstractionists and& the Surrealists, to includinge Jackson Pollock, Wassily Kankinsky, Pablo Picasso, Franz Kline, Mark Rothko, Mark Tobey, Frances Bacon, Willem Dekooning, and Lenore Fini, to name a few.

In time, he progressed toward the digital medium to discover first Paintshop Pro, Aldus Photostyler, Painter, and then Photoshop. He settled on Photoshop as his program of choice.

In addition to being the president of the prestigious San Diego Photoshop Users Group (*www.sdphotoshopusers.com*), of which isthere are currently 2,600 members strong and growing, Stephen Burns has been an instructor and lecturer in the application of digital art and design for the past 10 years. His teaching style comes from his ability to share an understanding of Photoshop so that the student has the ability to intuitively apply it to his or /hers creations.

Artistically, he has been exhibiting digital fine art internationally at galleries such as the Durban Art Museum in South Africa;, Citizens Gallery in Yokahama, Japan;, and the CECUT Museum of Mexico, among others to name a few. You can see more of Stephen's works at *www.chromeallusion. com* .

1 Understanding The Layer Blend Modes

IN THIS CHAPTER You will Learn:
• A brief overview of the interface in terms as to how it is organized in relation to one another
• A brief overview of the new features in CS3
• A brief explanation Tools palette
• A brief explanation cascading Menus
• A brief explanation of the Command palettes

In this third in a series of books, we continue our journey to understanding approaches to elevating our creative voice using Photoshop CS3. The goal is to go beyond the technical application to allow our vision to shine forth with no obstruction of biases from the software. You are learning another language, and unfortunately this takes time; however, the more you use it, the more you will become fluent with its dialect. This is no different from learning any other creative medium, whether it is music, painting, drawing, or sculpture. The advantage that you have as a digital artist is the fact that your medium, the computer, combines all creative mediums. What does this mean to you as an artist? Well, it's simple. You can create and combine any or all of the art forms to express yourself with a new and exciting language.

As you work through the tutorials, be patient and enjoy the process. The digital industry tells us that within a few clicks, we can create masterpieces. However, it's a little more challenging than that because not only must you understand composition and traditional expertise such as photography or painting, but also you must learn the new digital language so that you can create intuitively. You won't create images such as the ones in this book overnight; however, you will benefit from the author's experience and insight in digital artistry.

Whenever a digital program is updated, it is with the intention to improve workflow, and Photoshop CS3 does just that. This chapter describes the new features included in the new Photoshop CS3 layout to give you a deeper insight as to how to improve your creativity with this program. To make sure we are on the same page in terms of navigating the interface, we'll give a brief explanation of the layout. Practical and creative uses of the tools will be covered in later sections.

PHOTOSHOP CS3 LAYOUT

You will access all of your commands in Photoshop CS3 in three places: toolbar, menus, and palettes (see Figure 1.1).

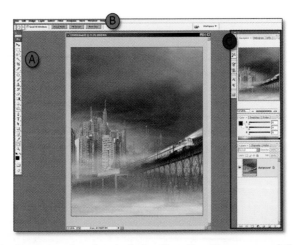

FIGURE 1.1 Photoshop interface includes A) toolbar, B) menus, and C) palettes.

When you load the program, the interface will be in the standard screen mode as shown in Figure 1.1. The beauty of this interface layout is that it's more customizable to each individual's unique workflow needs, and it maximizes real estate. Take notice that the Palette Well has gone away to be replaced with floating palettes that can be attached and detached from the edge of the interface or from one another. We will talk about palettes in more detail later in this chapter.

Take a look at the very bottom of your Tools Palette and notice a button that represents the "Change Screen Mode Option". Click and hold on the button to list the four viewing modes which are: Standard Screen Mode, Maximized Screen Mode, Full Screen Mode with Menu Bar, and Full Screen Mode (see Figure 1.2).

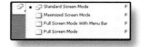

FIGURE 1.2 View of the four different screen modes.

You have already seen the Standard Screen Mode, so let's take a look at the other three.

You can toggle through each mode by using the the "F" key. Unlike the previous version of Photoshop, in CS3 the background color stays the same default medium gray in all modes except for the Full Screen Mode, which is black. To toggle your background color for each window mode, hold down the spacebar and press the "F" key. Now you can toogle through gray and black or any other color that you designate. To get a custom designated color, select the Fill tool on the toolbar, and while holding down the Shift key, click on the colored interface surrounding your image. The color that is designated as your foreground color of the Tools Palette will be the new color applied to your background.

Let's take a look at the interface for each mode. Figure 1.3 displays the default screen mode when you first load and open CS3, which is the Maximized Screen Mode.

FIGURE 1.3 View of the interface in Full Screen Mode.

Your toolbar is attached to the left side of the interface, and the palettes are on the right. One of the palettes is minimized, while others are open and ready to be accessed. Also notice that the menus are hidden to allow more space so that the tools do not crowd your image.

Figure 1.4 shows an example of the Full Screen Mode with Menu Bar. This is for those users who do not quite have most of the tools and commands in Photoshop memorized, but they know where things are in the menus.

Figures 1.5 through 1.7 show the Full Screen Mode with the gray background, the black background, and the custom background (in this case, white). Remember to toggle through these different colors by holding down the spacebar and pressing the "F" key.

FIGURE 1.4 View of the interface in Full Screen Mode with Menu Bar.

FIGURE 1.5 View of the interface in Full Screen Mode with gray background.

FIGURE 1.6 View of the interface in Full Screen Mode with black background.

FIGURE 1.7 View of the interface in Full Screen Mode with white background.

Let's go to the toolbar next.

Tool Palette

The Tool Palette is the vertical slender bar that houses a visual representation of the variety of brushes and tools that you will use in your creations. Notice that by default it is displayed in a single column (see Figure 1.8).

FIGURE 1.8 View of the single column toolbar.

You can also go back to what you're used to from the previous versions by clicking on a toggle switch in the top left-hand corner of the toolbar as shown in Figure 1.9.

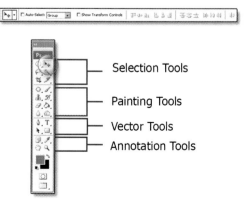

FIGURE 1.9 View of each tool set and the double column toolbar mode.

When each icon is clicked, the options bar changes accordingly. This is because, like a painter you are usually taught not to apply 100% of your pigments straight from the tube onto your canvas; instead, you will normally start in lower opacities or washes of those pigments to build form, saturation, and density over time. This provides control over your techniques. Also, notice that the bar is divided into sections by a thick line. The first section contains your selection tools. The next section contains your painting tools (see Figure 1.9). Below the painting tools are the vector graphic tools. The last section contains the annotation tool set. As you work through this book, you will be using the painting and selection tools quite regularly.

You also can tear the toolbar away from the interface corners. To do this, click and hold on the thin tab at the top of the toolbar, and drag as shown in Figure 1.10.

You can reattach the toolbar in exactly the same way by dragging it to the edge of the interface. When it comes close to the interface, a blue vertical line will appear on the left hand edge as shown in Figure 1.11. When you see this line, release your mouse to reattach the palette to the interface.

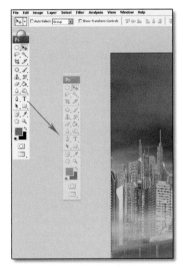

FIGURE 1.10 View of toolbar as a floating palette.

FIGURE 1.11 View of toolbar being attached to the interface.

Palettes

You can also access Photoshop's commands in the palettes. *Palettes* are basically visual shortcuts to many of the commands that can be found in the text menus. All palettes have a drop-down menu located on the top-right corner that looks like a small black triangle, as shown in Figure 1.12. This will give you other options for that palette.

The palettes, like the toolbar, also have customizable features. You can minimize them by clicking on the toggle button on the corner of the palette as shown in Figure 1.13.

FIGURE 1.13 CS3 palettes minimized.

FIGURE 1.12 CS3 palettes.

When they are minimized, you can place your mouse on the divider between the two palettes and by clicking and dragging, you can resize them to be even smaller (see Figure 1.14).

FIGURE 1.14 CS3 palettes minimized even more.

Since we no longer have the Palette Well, you can expand the individual palettes, which in this case are the Layers, by clicking on the designated icon (see Figure 1.15). When you are finished using the palette, just click anywhere on the interface, and it will automatically minimize into an iconic mode. Make sure that in your Preferences panel (Edit > Preferences) under the Interface menu that you check the "Auto Collapse Icon Pallettes" box to enable this feature.

Just like the Tools Palette, you can tear a particular palette away so that it will float on your desktop (see Figure 1.16).

FIGURE 1.15 Auto collapsing your layer palettes can be very handy since the Pallette Well is no longer available in CS3.

FIGURE 1.16 CS3 palettes floating on the desktop.

These palettes are customizable in that you can attach them not only to the interface but also to one another by clicking and dragging the title bar and placing your mouse on any palette location as shown in Figure 1.17 (A, B, and C). If the palettes are still in your way, you can access the Preferences dialog box and tell Photoshop to automatically collapse all palettes when you're done accessing them (see Figure 1.17D). This will allow you to work much like you could with the Palette Well, in which a small icon is always available if you need to access the palettes.

If the palette positions are still too annoying, press the Tab key to make all of the tools disappear. To access them again, just drag your mouse to either side of the keyboard to the locations where they once were and they will temporarily pop up to allow you access. When you're finished using them, click anywhere on your interface, and they will completely disappear again.

Another way that you might like to customize your workflow is by placing all of your palettes into one large folder so they are not split up into sections. Figure 1.18 shows a progression from a maximized palette being repositioned within a series of palette stacks. That series is then reorganized into one large palette. However you like your workflow, CS3 has the most customizable interface ever. Now let's take a look at the menus.

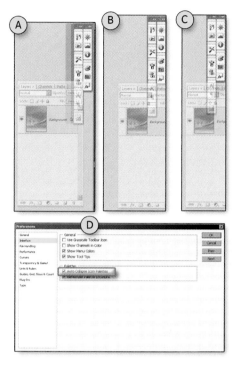

FIGURE 1.17 Reattaching the palettes to a chosen location.

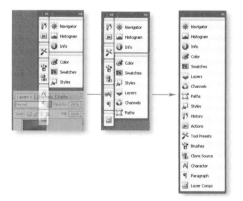

FIGURE 1.18 Organizing your palettes in a single folder can assist you with your workflow.

Menus

You can also access Photoshop's commands in the drop-down menus. The term *menu* refers to cascading text menus along the top-left side of the interface, as shown in Figure 1.19. Within each one of these menus are submenus that give you access to

deeper commands within the program. Let's take a look at the new commands added. In the File menu the following new commands are available: Open As Smart Object, Device Central, and Save for Web & Devices. The Open As Smart Object command is self-explanatory in that what once required an additional step to create a smart object from the original file is now done in one step. Device Central is aimed specifically at developers who want to preview their content on the mobile device that they are developing for such as mobile phones. The Save for Web & Devices command not only takes you into the image ready to preview your content created for the Web but also allows you to preview your content created for mobile devices.

The Edit menu has new features called Auto Align Layers and Autoblend Layers (see Figure 1.20). These features are aimed at photographers interested in producing panoramic style imagery. We will cover this in a later chapter.

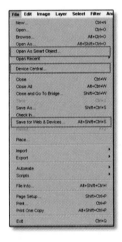

FIGURE 1.19 Photoshop menus.

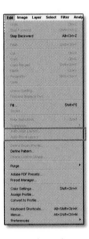

FIGURE 1.20 The Edit menu with new commands circled.

In the Image menu, the Apply Data Set command allows you to apply the meta-data to any file (see Figure 1.21).

FIGURE 1.21 The Image menu.

Also new in the Image menu is the ability to apply a colorspace that allows for a higher dynamic range (see Figure 1.22). In CS3, you can edit files with a 32-bit channel colorspace.

In the Adjustments submenu (choose Image > Adjustments), there are two new color alteration options: Black & White, and Exposure (see Figure 1.23). You'll learn how to use these options in later tutorials.

FIGURE 1.22 The Image Mode options.

FIGURE 1.23 The Black & White option and the Exposure option.

The use of 3D layers is a huge addition to Photoshop CS3. If the use of 3D content is part of your workflow, the 3D Layers menu shown in Figure 1.24 is well worth the price of Photoshop. You can now create 3D objects in another program and import them onto a layer and Photoshop. In addition, you can edit their textures and then move them around as if you're still in your 3D program. In Chapter 6, we will go over 3D content in depth.

As if 3D layers aren't enough, you can now bring in and edit video content. The Video Layers menu is used to access this feature (see Figure 1.25).

FIGURE 1.24 The 3D Layers menu.

FIGURE 1.25 The Video Layers menu.

Under the Select menu, note that the Feather command has moved (see Figure 1.26). You cannot access it under Select > Modify.

Yet another huge addition to Photoshop is its capability to apply destructiveless editing capabilities to the filters. Now, like Smart Layers, we have Smart Filters (see Figure 1.27). This too will be discussed in later chapters.

The Analysis menu has been added to make Photoshop more user-friendly to engineers and architects (see Figure 1.28). This will allow you to use digital rulers and measurement capabilities to assist with architectural layout and design and product design.

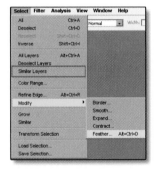

FIGURE 1.26 The Feather command is now located under the Modify submenu.

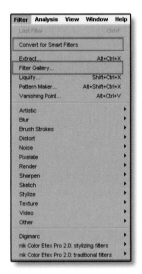

FIGURE 1.27 Smart filters are located in the Filters menu.

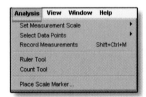

FIGURE 1.28 Analysis menu is new to CS3.

UNDERSTANDING THE PAINTBRUSH ENGINE

Since Photoshop 6.0, the Paintbrush engine has gone through extensive changes. You can now produce effects such as fire, smoke, sparks, and textures by using the Paintbrush's animated options. This engine has been optimized to use a digitized pen like that of the WACOM tablet. (For more information about this product, go to *www.wacom.com*). Let's get to know the basics of animating, altering brush properties, and saving custom brushes.

When you click on the Paintbrush icon in your toolbar, take notice of the Options bar. Click on the Brush Preset Picker as shown in Figure 1.29.

A drop-down menu of default paint strokes is listed. You can resize this menu by clicking on the bottom-right corner of the palette and pulling it to any size to see more options. Figure 1.30 shows the Maple Leaf brushed selected. You can view its variable brush properties in the Brush Palette (Windows > Brushes).

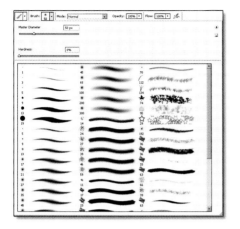

FIGURE 1.29 The Paint tool.

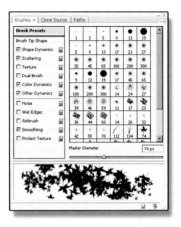

FIGURE 1.30 The default properties of the Maple Leaf brush.

CREATING YOUR OWN ANIMATED PAINTBRUSH

Now let's see how each dynamic works to create a single animated brush.

1. Select the Maple Leaf brush, and clear the check box of all its animated properties (see Figure 1.31A).

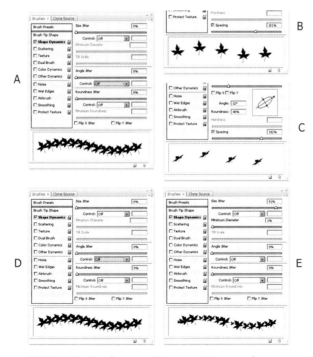

FIGURE 1.31 Brush properties are set to normal.

2. At the bottom of the Brush Palette, play with the spacing scroll bar and the preview window updates automatically (see Figure 1.31B).
3. Additionally, play with the diameter by clicking the dots on the outside of the circle and altering the shape and rotation of the brush (see Figure 1.31C).
4. Click on the Shape Dynamics layer to get the options for it, which are listed on the right. The stroke of the brush in the preview window should show one continuous size and spacing (see Figure 1.31D).
5. Adjust your jitter to 92%, and notice the stroke update in the preview window, as shown in Figure 1.31E. Jitter is simply the random application of a technique over the length of the stroke. The higher the percentage, the more drastic and varied the technique.
6. Play with the Minimum Diameter slider, and watch how the size of the stroke is varied over time (see Figure 1.32F).
7. As you adjust the Angle Jitter slider, notice that the brush applies a percentage of rotation over the length of each stroke. This is great for debris and cloud effects (see Figure 1.32G).
8. As you experiment with the Roundness Jitter slider, notice that this option allows you to apply the full diameter of your mouse shape or squish it for an elliptical effect over the length of the stroke (see Figure 1.32H).
9. Use the Minimum Roundness slider to set the minimum distortion that you want to apply to your image. In conjunction with the other properties, this adds a little more control (see Figure 1.32I).

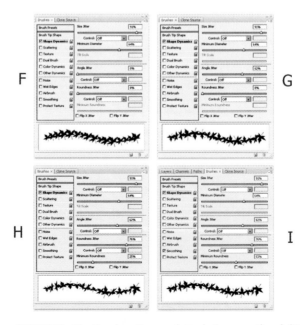

FIGURE 1.32 The Brush options palletted gives you the ability to adjust the stroke variables and size of your brush.

10. Click on the Scattering layer, and watch what happens in your preview window, as shown in Figure 1.33J. This is a favorite brush property—it's great for explosions.
11. Slide the Count slider to the right to add more of the brush effect to the scatter. Both Scattering and Count applied in combination can be visually powerful (see Figure 1.33K).
12. Click on the Texture layer to add presets to your brush pattern, as shown in Figure 1.33L.
13. Click on the Dual Brush options, as shown in Figure 1.33M, to add custom brush presets to your current animated brush.

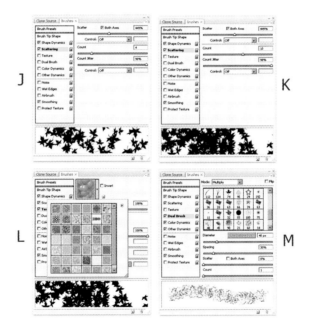

FIGURE 1.33 Add scattering to get a spraying effect.

14. Change the colors of your foreground and background swatches by clicking on the (front or foreground) color swatch near the bottom of the Tools Palette to bring up the color picker. You can choose a color for that swatch and experiment with each of the sliders to understand their effects. There is no preview for this in the stroke window, so you will have to alter each property by drawing on a layer filled with white.
15. Select the Other Dynamics layer. Here you can tell the brush engine how to apply the effects. Your options are to apply the technique with the WACOM Pen's pressure sensitivity, fade over a specified number of pixels, or use the pen tilt, stylus wheel, or pen rotation.

The WACOM tablet is a wonderful tool for artists with a painting background. One of its great attributes is its capability to apply the density of a color or an effect based on the pressure applied to the tablet's pen. The Intuos 2 and 3 have up to 1,024 levels of pressure sensitivity, which is double that of the Graphire, which has 512 levels of pressure. If you are on a budget, the Graphire is the tool for you. However, if you want precise control and subtlety in the application of your technique, the Intuos line is a wonderful tool. Everyone has a preference in terms of the size of custom brushes, so keep in mind that any of your variable brush settings can be applied with the pen's pressure sensitivity.

16. Now that you've created your new animated brush, you need to save it. Click on the small black triangle in the top-right corner of the Brush Palette. Select Save Brush Preset, and name it appropriately.

CREATING YOUR OWN CUSTOM BRUSH PALETTE

After you create a few custom brushes, you will want to create a custom brush palette. In Figure 1.34, the objective is to save the custom brushes that are highlighted in red into their own palette and discard the rest.

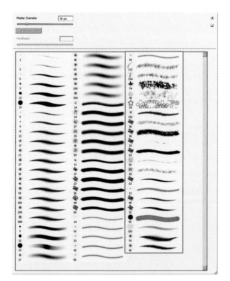

FIGURE 1.34 Stroke Palette option.

1. With your brush presets cascaded, click on the submenu icon, and click on Preset Manager, as shown in Figure 1.35.
2. Highlight all of the brushes that you are not interested in saving with a Shift+click on the first and last brush. Now click Delete to discard them (see Figure 1.36).

FIGURE 1.35 Activate the Preset Manager option.

FIGURE 1.36 Highlight the brushes to delete them.

3. Your Brush palette should now look something like Figures 1.37 and 1.38 in the stroke view on your Options Palette.

FIGURE 1.37 Final brushes in the Preset Manager option.

FIGURE 1.38 Brush stroke preview on the Options bar.

4. To save your brushes for later access, open the Brush Palette submenu, and click Save Brushes. Next, navigate and create a folder that you know you will be able to find when you need access to your brushes. In this example, the folder on the desktop is named Custom Brushes (see Figures 1.39 and 1.40).

FIGURE 1.39 Saving brushes.

Experiment with your brush settings and discover the wide range of creative uses of the brush engine. Also, be organized by saving the brushes under meaningful names that relate to your workflow, for example, hair brushes, smoke brushes, texture brushes, and so on. Now that you have an understanding of the brushes, let's take a look at the new Adobe Bridge interface.

FIGURE 1.40 Saving brushes location.

THE ADOBE BRIDGE INTERFACE

The new Bridge has gone through some significant changes to allow more effective organization and categorizing of imagery. Selecting, categorizing, applying metadata, editing metadata, and previewing digital images can be done faster within an interface that is visually appealing and fun to work with.

The interface, as shown in Figure 1.41, looks very much like its predecessor.

FIGURE 1.41 The Adobe Bridge interface.

The interface is divided up into five sections as follows:

Folders (A): Access any location on your hard drive through this folder browser.

Filter (B): Preview the thumbnails that have any or all of the designations that you choose from the Filter menu section. Some of the options used to preview your images are Ratings, Keywords, Date Created, Date Modified, Orientation, and Aspect Ratio.

Content (C): View the results of your filters or any images from a selected location on your hard drive.

Preview (D): Get an enlarged preview of the selected image or images.

Metadata/Keywords (E): Preview and edit your metadata. In addition, in the Keywords tab, you can create and designate keywords to one image or a group of images.

When previewing a large group of images, it is also helpful to be able to adjust the size of the image for easier viewability as shown in Figures 1.42 and 1.43. Use the slider to resize your thumbnails on the lower-right corner of the interface.

FIGURE 1.42 Reducing thumbnail size.

Bridge Viewing Options

You have several viewing options for the Bridge, which can be accessed from one of the three rectangular icons in the lower-right corner to the right of the slider (see Figure 1.44).

FIGURE 1.43 Increasing thumbnail size.

FIGURE 1.44 Layout options in the Bridge.

Now let's look at some of the viewing options:

Light Table view: This maximizes the interface to favor the previewing of thumbnails (see Figure 1.45).

File Navigator view: This favors the previewing of thumbnails as shown in Figure 1.46.

Metadata Focus view: This allows you to see the metadata along with the thumbnails (see Figure 1.47).

Filmstrip Horizontal view: This not only favors an enlarged preview but also allows you to line up your digital files horizontally on the bottom edge of the screen (see Figure 1.48).

FIGURE 1.45 Light Table view.

FIGURE 1.46 File Navigator view.

FIGURE 1.47 Metadata Focus view.

FIGURE 1.48 Filmstrip Horizontal view.

Filmstrip Vertical view: This is the same as the Filmstrip Horizontal view except the digital files are lined up along the vertical right edge of the screen (see Figure 1.49).

FIGURE 1.49 Filmstrip Vertical view.

The Labeling Method

If you have a client who is previewing images that you have created, the labeling method is handy for categorizing and giving rank to each of the files. Right-click the highlighted images, and select the Label submenu to assign a color to the images (see Figure 1.50).

After a color is designated to the thumbnails, you can click on the stars to designate a rank (see Figure 1.51).

FIGURE 1.50 Right-click on the selected thumbnails.

FIGURE 1.51 Designate color and rank to thumbnails.

WORKFLOW IN BRIDGE

Bridge is optimized for a more effective workflow in terms of organizing your photos from the digital camera to your storage drive. In Bridge, you can categorize your photos just by adding subfolders to a location on your hard drive. Knowing where all of your photos are located creates an effective organizational system. It is a good idea to have a separate hard drive to store all of your images. There are a number of external storage options on the market, so consider the number of photos that you capture regularly, and purchase an external hard drive system for your needs. A lesser cost alternative is to purchase an external hard drive case for under $50. Then you can purchase any size hard drive that you need and place it into the case. Most of these external cases use USB or FireWire connections and come with a built-in fan to cool the storage device.

The external drive will register as a separate drive letter on your computer and may be designated as a Removable Disk drive. Depending on the number of devices on your system, it will be given a drive letter that will range from D to Z. Now, in Bridge, navigate to your external drive.

Make sure the Folder tab is selected in the top-left window. The window where you would normally see your thumbnails will be blank, so right-click on this space and choose New Folder. Give the folder a name that best represents the photos that will be placed into it for example, "Wedding Photos" or "Night Shots" or you can organize your shots by date. Within these folders, you can add subfolders, such as "Night Shots in New York," and so on.

After you set up a variety of folders on your hard drive, navigate to any storage card that your camera used to deposit your files. You will usually see a folder called DCIM that will have subfolders with your digital photos stored in them. View your photos in Bridge on the right, and make sure that can see your newly titled subfolders listed on the left. Drag and drop your images into the proper categories.

CREATING KEYWORDS FOR EACH IMAGE

Now that you have organized all of your photos, you need to assign them keywords so that if you need a particular image or a series of images, you can plug in a search word such as "people," and all of the appropriate photos will be listed in the thumbnail view. The following steps explain the procedure:

1. Choose the Keywords tab above the preview window. By default you are given some predefined categories At this stage you will want to create your own categories, so right-click in the empty space of the keyword window and click New Keyword Set, as shown in Figure 1.52.

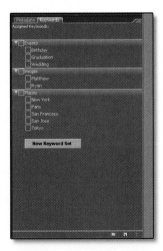

FIGURE 1.52 Create a new keyword set.

2. Make sure the title of the keyword set reflects the main category of the parent folder that each of the subfolders is located in. In this example, it is titled Death Valley (Figure 1.54A). Right-click on the Texture keyword set, and select New Keyword (Figure 1.54B). Make as many keywords as you can that will define the images associated with Texture, as shown in Figure 1.54C.

3. If you make a mistake, you always have the option to rename the keyword set. Just right-click on the keyword set and select Rename. Next, type in the new title of the keyword set. When finish, press Enter; the new set will be viewed and organized alphabetically (Figure 1.54D).

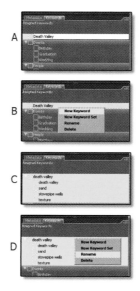

FIGURE 1.53 Create keywords to define images.

To rename the keyword set, just click twice on the title to activate the text editing mode then type in the new name. When done hit the Enter key on your keyboard.

Now, notice that after renaming the keyword set it was automatically reorganized alphabetically. This is helpful to assist you to quickly identify your categories.

4. Next, highlight a series of images by Shift+clicking between the first and the final image or Ctrl+clicking on individual thumbnails (see Figure 1.56). In the Keywords panel, click on the check box to associate the proper keywords with the image or images. Note that if you select the Sandune keyword set, all of the keywords in this category will be applied to your chosen thumbnails.

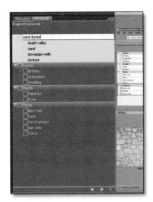

FIGURE 1.54 Creating a new name for the keyword set.

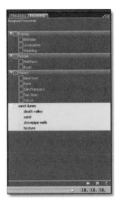

FIGURE 1.55 The keywords set is alphabetized.

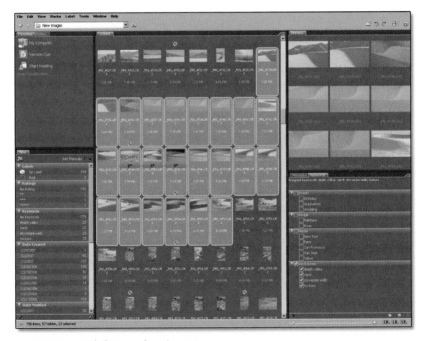

FIGURE 1.56 Apply keywords to images.

5. Now let's test our search engine. Press Ctrl+F (PC) or Cmd+F (Mac) to bring up the Find panel. In the Source section, navigate to the folder or the sub-folders that you want to search in (see Figure 1.57).
6. Under the Criteria section, select how you want Find to search for your images. Choose Keywords.

FIGURE 1.57 The Find dialog box.

7. Define the parameters that the search engine will use to identify the images. In this case, choose Contains. Finally, enter the keyword that you want to use. Sand is used here (see Figure 1.58).

FIGURE 1.58 View of the Search Parameters dialogue box.

That's all there is to it. If you take a look at the thumbnails you will now see the particular images that were associated with the "sand" search. You can also use the filters to search for images and display the thumbnails. Figure 1.59 shows check marks next to dates in December and January. Any files with these dates included in their metadata will be displayed as thumbnails.

FIGURE 1.59 Date Created filter applied.

In addition, you can preview images according to their rank or color designation. Figure 1.60 shows examples of all images that have the colored designation of red.

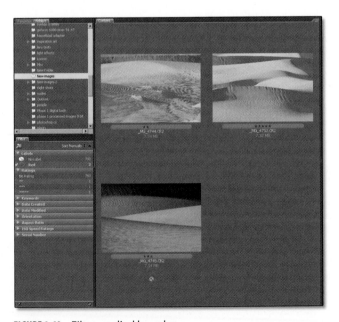

FIGURE 1.60 Filter applied by color.

Finally, you can organize images as groups or stacks to save space as well as apply properties to multiple images as a group. To do this, select two or more images, right-click, and select Stack (see Figure 1.61).

FIGURE 1.61 Multiple images selected for a stack.

This command has just organized all of the selected images into a stack as shown in Figures 1.62 and 1.63. The number of images in the stack is prominently displayed on the upper-left corner of each stack, so you can easily see the volume of images that you have organized in your folder.

FIGURE 1.62 Selected images designated as a stack.

FIGURE 1.63 Display of multiple stacks.

THE ADOBE CAMERA RAW (ACR) INTERFACE

Figure 1.64 shows an overview of the Adobe Camera RAW (ACR) interface. It shows the basic preview pane that takes up the bulk of the interface. The tonal, color, and effects controls are on the right, and the workflow and resizing options are on the lower left. Note the histogram in the top-right corner, which displays the tonal information representing the Red, Green, and Blue channels independently. Any information from the center to the left of the graph represents the middle to lower tonalities until it reaches black. Inversely, the center of the graph all the way to the right represents the middle to brighter tonalities toward white. A higher vertical mound indicates a greater amount of those particular tones and colors in your image. It is important to

note that the new ACR will not just open RAW formats. It will now open TIFF and JPEG as well as you'll see later.

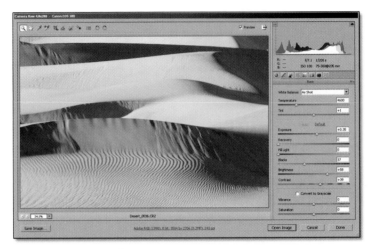

FIGURE 1.64 RAW interface.

ON THE CD

You may use your own RAW files, or you can use the one provided on the CD-ROM in Tutorials/ch 1 original images/sanddune.crw. Use Bridge to navigate to the file, right-click, and select Open In Camera Raw.

You are now going to gain some familiarity with the power of the new ACR 4 (Adobe Camera Raw) interface. There has been some improvements to the ACR interface. These changes will not only allow you to gain a better handle on correcting contrast, white balance or sharpening but it will also give you the ability to clean up any imperfections having to do with the dust on your sensor, correct redeye and give you a new improved tonal and color correction tools. Let's go explore the new

1. Click on each of the drop-down menus in the workflow area to preview your options for colorspace (A), bit depth (B), and sizing and resolution (C), as shown in Figure 1.65.
2. White balance is simply the process of making your whites in your photograph as close to a neutral white as possible. In other words, proper white balance is the process of removing any color cast in the highlight areas. ACR gives you presets that relate directly to the white balance settings in your digital camera (see Figure 1.66). So, you would choose one that would give you the best result.
3. Take a look at the color Temperature slider under White Balance Menu. Slide it to the right and then to the left. Notice that as you slide to the right, your image becomes warmer (yellow), and as you drag in the opposite direction, your image becomes cooler (blue). The histogram in the top right gives you an update as to how all of the colors are responding to any and all adjustments in the RAW interface (see Figures 1.67 and 1.68).

FIGURE 1.65 RAW interface colorspace, bit depth, and sizing and resolution options.

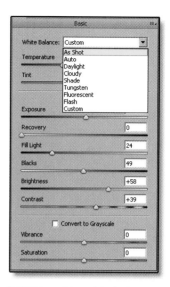

FIGURE 1.66 The white balance options.

FIGURE 1.67 RAW interface color temperature cooling options.

4. Experiment with the Tint slider, and see how you can control magenta and green. This is great for situations where textures are photographed near fluorescent lighting. Note how your histogram displays a dominant magenta or yellow, moving higher as you adjust the Tint slider to the right or left (see Figures 1.69 and 1.70).

FIGURE 1.68 RAW interface color temperature warming options.

FIGURE 1.69 RAW interface color tinting toward magenta.

5. The Exposure slider will help you make adjustments to any overexposed or underexposed images. In Photoshop CS2, you had to click the Preview button for both the Shadows and the Highlights at the top of the interface to observe what areas were losing detail due to underexposure or overexposure. This in invaluable to photographers. The way ACR communicates which areas are losing detail due to underexposure or overexposure is through color mapping. Any shadow regions losing detail are designated with a blue tint, and any highlight areas losing detail have a red tint. In CS3, the toggle for viewing this information

FIGURE 1.70 RAW interface color tinting toward green.

is different. If you look at the histogram in the top-right corner, you will see two arrows above the black point and the white point. Click on these arrows to toggle the blue and red out of gamut preview (see Figure 1.71).

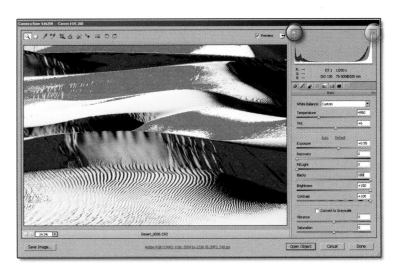

FIGURE 1.71 RAW interface Exposure option toward the shadows.

6. In a continuing effort to allow the photographer to have more control of detail in the shadow, midrange, and highlight areas of the image, Adobe has added Recovery. Experiment with the Recovery slider (see Figure 1.72), and notice that the mid-tonerange information is becoming denser. This deals

with the process of bringing back the midtone information by adding density in those areas.

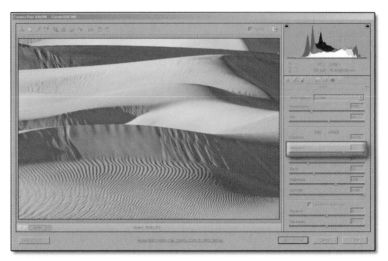

FIGURE 1.72 The Recovery slider.

7. As recovery increases the middle range total detail, the Fill Light slider allows you to brighten the middle range tonal detail (see Figure 1.73). Often in a photographic image, the shuttle and highlight information are acceptable, but the midrange of information is too dark because of the environment's extreme contrast. Adjust this slider to make changes to those areas.

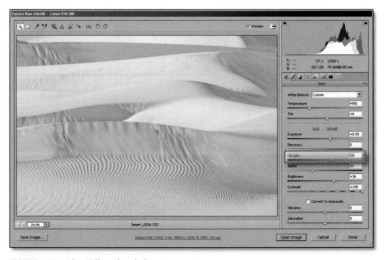

FIGURE 1.73 The Fill Light slider.

8. Click the Convert to Grayscale button below the Contrast slider (see Figure 1.74). This is a very convenient addition that will likely be very popular because it gives the photographer the ability to create black-and-white photos straight from camera RAW files. You can control every new image with the use of the Temperature slider and the Tint slider.

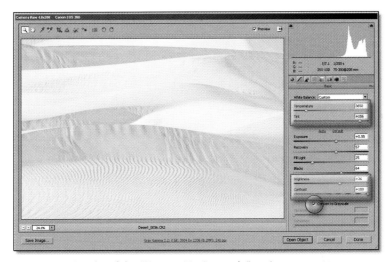

FIGURE 1.74 Results of the "Convert To Grayscale" option.

9. In this example, the sand dune is altered toward a high key tonal range. In other words, the tonal information in the image is dominated by medium gray toward bright white. To define the contour of the sand dune more effectively, the Brightness and Contrast sliders were moved toward the right.

CUTOMIZING ACR4 THROUGH THE OPTIONS PANEL

Let's take a look as to how to customize ACR 4 to better assist you in preparing your photographic images to be imported into Photoshop. Take a look at the icons in the top-left corner of the interface. If you look from right to left, you first notice two circular arrows that represent Rotate Clockwise and Rotate Counter Clockwise. To the left of those two commands, you see the Preferences Panel icon for ACR. Figure 1.75 shows some of the options that are available. For example, you can update your JPEG previews to be medium quality or high quality, you can control the cache size, you can make some default changes to your image settings, and you can determine where you want to save the XMP data from the RAW files. After you make adjustments to the settings, they will stay as default settings until you go back and alter the changes.

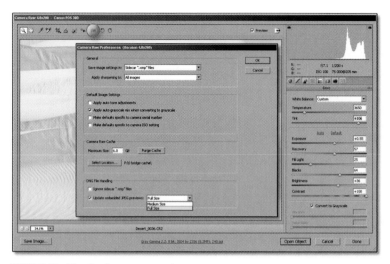

FIGURE 1.75 The Preferences panel.

The next icon to the left of the Preferences icon is the Red Eye icon (Figure 1.76A). Another very convenient addition to ACR is the ability to correct red eye. CS3 makes it very easy to apply this command. Just select the Red Eye icon (see Figure 1.76B) and click on the red eye in the portrait to automatically see the option to brighten or darken the rate tonality to remove it or make it less prominent.

FIGURE 1.76 Shows the icon that you need to select that allows you to apply the Stamp tool to your RAW images to remove blemishes or even dust problems from the camera's sensor.

Moving on to the next option, Figure 1.76C and 1.76D show both the alignment and the crop tool. The alignment tool allows you to correct a rotating or offset photograph. The crop tool does exactly as the name implies, it allows you to crop the image.

Figure 1.76E displays the Sampler Tool to assist you with white balance or tonal correction. You can lay down sampler points to assist you with adjusting the white balance. Figure 1.80 shows how the white balance can be adjusted by clicking on various areas of the print. When you click on a particular tonal range the white balance eye dropper will attempt to neutralize the highlights in your scene toward more of a day like a balanced look.

The Retouch Tool

Let's focus our attention to Figure 1.77 (A and B), which displays a facial blemish that you can eliminate with the new Retouch Tool using these steps:

1. Define the area where you need to utilize the good texture and replace it all over the blemish by making sure Heal is selected under the Type menu.
2. Click and drag your mouse to define the circumference of the brush over the area that you consider to be the clean texture to cover your blemish (Figure 1.77A).
3. Once the brush size is set, click on the laso and drag your mouse toward the area that you need to repair. Notice that a second circle has been created and it is designated with a red color and it is in connection with the green circle. The green circle determines the good texture, and the red circle determines where you're going to place that texture.
4. Drag the red circle on top of the blemish, and watch the imperfection disappear as shown in Figure 1.77B. Take a look at figure 1.79A to see the options for the Retouch tool.

FIGURE 1.77 Applying the Retouch Tool to eliminate blemishes.

Note: You are working with a RAW file so you have the ability to make several adjustments that are automically saved with with file. You can never edit the RAW file directly so you do have the option to remove and reapply any of the Retouch tool settings.

To get an idea of the differences between the Heal and Clone options, go to the Type menu and switch from Heal to Clone (see Figure 1.78). Healing blends the two textures, whereas Clone just applies 100% of the texture on top of the blemish, thus giving it the darker shading of that selected area in this example.

FIGURE 1.78 Using Clone as an option.

Finally, you can define multiple areas to retouch on the photograph. Figure 1.79A shows the use of several areas being added in one sitting.

You have another great convenience included in the new ACR interface and that is the ability to correct red eye. We are going to use the same photo used for the Retouch tool because it has red eye issues as well. Figure 1.79B shows the options that you have to eliminate the reddish color. You start by dragging the selection rectangle around the area that is affected with the reddish hue. Immediately, the red is dramatically reduced. Next, use Pupil Size to adjust the tool's sensitivity as to the amount of reduction that is required. When red eye occurs, the darker tonalities in the eye are often sacrificed, so use darken to place density back into the pupils.

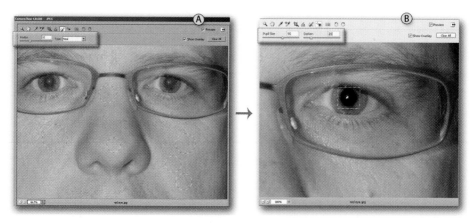

FIGURE 1.79 View of red eye and multiple placements of Retouch/Nodes.

Working with the White Balance Tool

Let's use another photo to explore how to correct any color casts. You can lay down sampler points to adjust the white balance. Figure 1.80 shows how the white balance can be adjusted by clicking on various areas of the print. When you click on a partic-

FIGURE 1.80 Using Sampler Tool to assist with White-Balance.

ular tonal range, the White Balance eye dropper attempts to neutralize the highlights in your scene toward more of a day-like balanced look.

FIGURE 1.81 The White Balance eye dropper is used to neutralize the highlights in the scene.

Other Features in ACR4

Next, we have the Curves feature. Click on the Tone Curve tab to access the standard Curves command to control the contrast in the scene. You have two options. The Point option (see Figure 1.82) basically gives you the standard Curves dialog box. Notice that it has a slightly different look and that the histogram is included in the background to help you visually assess where the tones are on the graph.

The second option, Parametric, not only gives you the standard Curves, but it also gives you the sliders for adjusting the shadow, midtone, and highlight information (see Figure 1.83). You adjust these sliders just as you do in Levels.

FIGURE 1.82 The Point option for Tone Curve.

FIGURE 1.83 The Parametric option for Tone Curve.

Now, take a look at the Hue (A), Saturation (B), and Luminance (C) options in Figure 1.84. Each has its own set of sliders to apply changes to primary and secondary colors. Dividing up all these colors for each aspect gives you incredible control over the color balance, white balance, and the overall color scheme.

FIGURE 1.84 The Hue (A), Saturation (B), and Luminance (C) options.

The Hue gives you access to both your primary and secondary colors in your image. If your intention is to isolate a particular color in your photograph and alter that color then you would choose the designated slider and make your changes to that color only. For example, if you would like to green leaves to take on a warmer appearance then you will select the slider for the Green Hues and pull that slider to the left to word a yellowish, green look.

The Saturation option allows you to increase or decrease the saturation of each individual color that is present in your image. Finally, the Luminance option gives you the ability to select a certain color that is present in the photograph and alter that colored toward white or black.

Let's take a look at a few other very nice features in the new ACR. For instance, the Detail feature applies an unsharp mask to sharpen your imagery (see Figure 1.85).

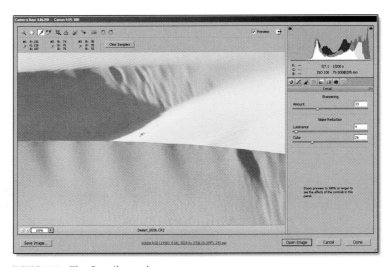

FIGURE 1.85 The Detail panel.

Next, Split Toning allows you to create images that are dominated by two colors (see Figure 1.86). Traditionally, this was a common technique by using two types of toner baths to add color to black-and-white prints.

Finally, options are available for chromatic aberrations (A) as well as color corrections for your camera profile (B) as shown in Figure 1.87). You can also apply any presets (C) that were created in ACR as shown in Figure 1.87).

When you have applied the settings and are satisfied with the results, you can save them as XMP data presets. In this example, a new preset is titled "high key dunes" (see Figure 1.88).

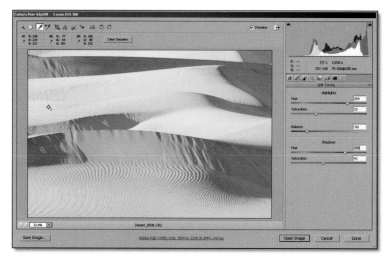

FIGURE 1.86 The Slit Toning panel.

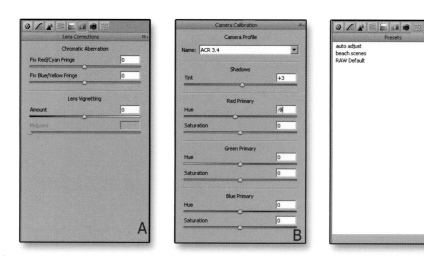

FIGURE 1.87 Lens Correction, Camera Calibration, and Presets.

When you save your new preset, you'll be asked what subsets to save with the file. From this list, you simply check the options to be included and uncheck any options that you do not want attached (see Figure 1.89).

Now, if you open any other file in ACR and access its submenu as shown in Figure 1.90, you can select a plot preset. Enlisted are all the presets that were previously created, including the recently created "High Key Dunes."

Since you are dealing with the RAW file data, you have more information to experiment with than if it were formatted. In other words, you have at your command

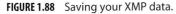

FIGURE 1.88 Saving your XMP data.

FIGURE 1.89 Select your subset options.

FIGURE 1.90 View of the custom
created presets.

the raw 1s and 0s that the camera originally captured. After your adjustments are applied and you save the file, it is formatted as a TIFF, JPEG, or PSD of your choice. In addition, the new ACR can open not only RAW format but also both TIFF and JPEG file formats as well. Just to locate a thumbnail in Bridge, right-click on it, and select Open in Adobe Camera Raw as shown in Figure 1.91. All of the camera RAW adjustments are now available to your TIFF file as shown in Figure 1.92. In this example, the highlight and shadow areas that are losing detail are immediately color mapped.

Floating Point Capabilities and CS3

Previous versions of Photoshop have made use of the 16-bit capabilities of digital images. But, technology keeps getting faster and better and photographers demand the ability to record greater amounts of information than ever before. Now, Adobe has allowed you the ability to edit 32-bit images. This is, sometimes refered to as images with floating point designations. Let's experiment.

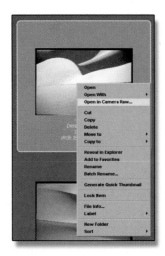

FIGURE 1.91 Right-click on the thumbnail and select Open in Camera Raw.

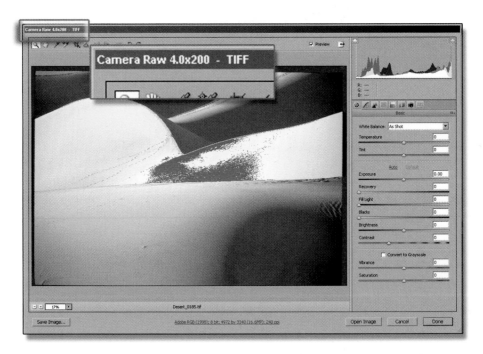

FIGURE 1.92 The TIFF file in the ACR panel.

Step 1

Open a new file that is a 5 × 5 square inch image with a resolution of 150 PPI.

Step 2

Change it to a 32-bit file (Image > Mode > 32 Bit).

Step 3

Take your mouse and single click on your foreground color on the bottom of your Tools Palette and take a look at the Color Picker as shown in Figure 1.92. You have some added content to the interface. Focus your attention on the top portion of the interface. The 32-bit version of the color picker displays the selected color in the center of the graph. To the left as well as to the right of the select a color are by default one stop increment adjustments. The right adjustments are overexposures and the left are underexposures.

FIGURE 1.93 View of the 32-bit version of the Color Picker.

Step 4

You have the ability to adjust the preview of the Stops Size increments. Take a look at Figure 1.94A-C. Each one shows the results of selecting one, two, or three stop increments. Randomly click on each color box and observe the changes in color.

FIGURE 1.94 View of the changes to the Preview Stop Size.

Step 5

Take a look at the numerical equivalents and notice that you no longer have tonal designation in numerical increments of 0 to 255. Since we are working in floating point mode we have designations from zero to one. Zero represents the absence of color and 1 being the absolute saturation of that color. Figure 1.197 to 1.101 shows the numerical representation of black, white, red, green and blue." In addition, if you want to vbiew the Gray Card 18% gray that photographers use as the value that determines proper exposure then you will simply type in its decimal equivalent which is .18 for the 32 B it RGB values.

The floating point system is working in fractions where before we were working with whole numbers such as 0, 128, 255, and so on. In 32-bit mode you are working with decimals (thus floating point) which gives you a greater ability to capture subtler shades of color and tone if your digital camera or scanner has the capability to record this amount of information.

Input the color coordinates as shown in Figures 1.95 to 1.99 to get familiar with how the floating point system works. Take notice that if you place the pixel values for each color in the RGB boxes on the lower right of the Color Picker your floating point designation is accurately displayed.

FIGURE 1.95 View of the numerical representation for Black as being 0,0,0.

FIGURE 1.96 View of the numerical representation for White as being 1,1,1.

FIGURE 1.97 View of the numerical representation for Red as being 1,0,0.

FIGURE 1.98 View of the numerical representation for Green as being 0,1,0.

Photo Downloader

To assist you with better workflow Adobe has included the Photo Downloader. This is a feature that has been part of Photoshop Elements and has found its way into the new CS3. The concept is that when you insert your storage card into your card reader it will immediately recognize the files on the card and download them to a location of your choice. In addition it will allow you to rename your photos or convert them into Adobe's new RAW file designation called DNG.

FIGURE 1.99 View of the numerical representation for Blue as being 0,0,1.

Step 1

Access the photo downloader through Bridge (File > Get Photos From Camera).

Take a look at Figure 1.199 which shows the basic interface of the photo downloader. This gives you the ability to tell the program where to retrieve the photos, where to download them to or how to name the photos.

Click on the Settings tab for "Convert to DNG " to view your options. In this example the JPEG preview is set to medium. The compression box is checked in an effort to save space on the hard drive. Also check "Preserve Camera Raw" to preserve the original data. Finally, you have the option to embed the original raw file and the DNG file during the conversion. When done click OK.

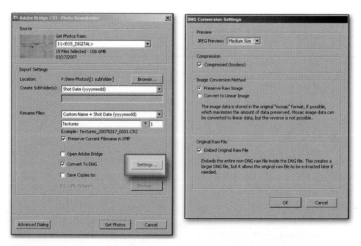

FIGURE 1.100 View of the DNG conversion preference dialog box.

Step 2

On the bottom left hand corner of the dialog box you'll see a button titled "advanced dialog". Click on this to customize how the photos are downloaded. When you access your card to preview your images you can select the photos to be processed by clicking the checkbox.

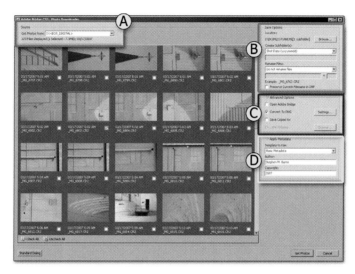

FIGURE 1.101 A gives you the location of where Photo Downloader will retrieve the photos. Figure 1.100B gives you the option to create a subfolder as well as rename your photos.

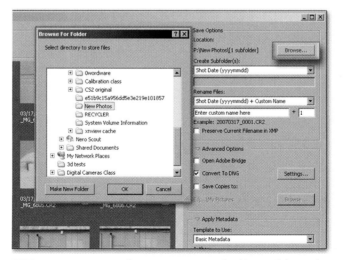

FIGURE 1.102 Gives you the option to open the file in Adobe Bridge, convert to DNG, or save a copy of the file.

FIGURE 1.103 Allows you to embed meta data as well as some personal information into the file.

FIGURE 1.104 View of the Source downloader dialog box.

What are the advantages of converting a file to DNG? When you make changes through ACR4 the data is often saved in a sidecar in a form of XMP data. With DNG all ACR data including meta data are all embedded within the file itself. This is a more organized way to work.

WHAT YOU HAVE LEARNED

In this chapter, you have learned

- How the CS3 interface is organized.
- That the interface is made of only three sections to access all of your commands.
- About the Tools Palette.
- About cascading menus.
- That the command palettes are shortcuts to what can be accessed in the cascading menus.
- That floating point is a decimal-based system.

Now let's move on to a deeper understanding of how Photoshop CS3 works.

2 Understanding The Layer Blend Modes

IN THIS CHAPTER You will Learn:
- How and why layer blend modes work
- How an 8-bit environment functions
- The importance of selections and how to create them.
- How to save selections
- The connection between masks and channels
- How to create and edit alpha channels
- The application of layer masks
- Pen Tool Fundamentals

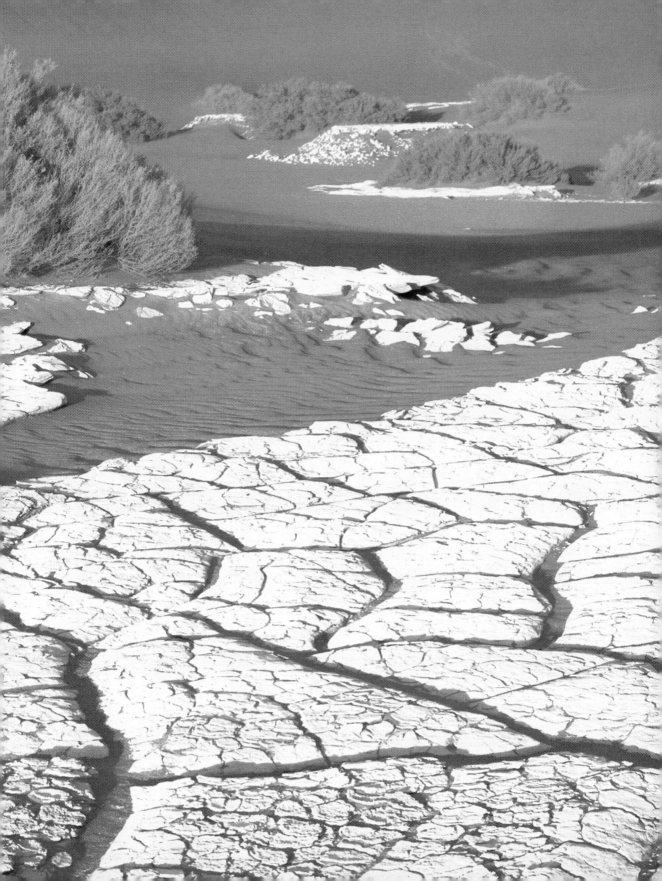

Layer Blend Modes

You can use the blend modes to take advantage of ways to blend layers to produce dynamic and creative results. The layer blend modes reside in a drop-down menu at the top-left corner of the Layers Palette. By default, it reads Normal. We will take a close look at three of the blend mode sections and discover what they can do and how they do it.

To view the blend modes, a layer, not the background, must be highlighted. The background is your base canvas. It is not a layer, so as a matter of procedure, duplicate your background (Ctrl+J/Cmd+J) so that Photoshop creates the image on its own layer. Now you will have access to your blend modes.

In Figure 2.1, notice the three large sections separated by a thick black line. The first section blends the highlighted layer with the layer underneath so that all of the blacks are maintained and the whites go completely transparent.

FIGURE 2.1 Blending the different layers.

The second section blends the highlighted layer with the layer underneath so that all of the whites are maintained and the blacks go completely transparent.

The third section blends the highlighted layer with the layer underneath so that all of the blacks and whites are maintained and the medium grays (midtones) go completely transparent. Let's prove this theory.

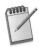

Throughout the rest of this chapter, we will work through a variety of exercises that outline important Photoshop fundamentals.

The next exercise shows two images that illustrate how the blend mode works. The first is an example of how the gradient is affected, and the second shows how the duplicate layer responds.

To use the blend mode to affect the gradient, follow these steps:

ON THE CD

1. Open the textures.jpg from the CD-ROM `Tutorials/ch 2` folder in Photoshop and create a new layer. Press the D key to set the foreground and background color to black and white.

2. Select your gradient tool. Starting from left to right, click and drag on your canvas while holding down the Shift key. The Shift key will constrain the flow to one direction. You have just created a fill made up of 256 shades of gray. The blend mode is at normal, so the integrity of the gradient is maintained (see Figure 2.2).

Now let's see the effects of each gradient as we apply the blend modes.

In the next steps, you will see two examples. One will show the effects of the blend mode applied to the gradient, and the other will show the results of the blend mode applied to a duplicate layer. This will give you both an understanding of how tonal information is altered as well as a practical view of how photographic images are affected.

The modes in the first section include the following:

Darken: Whites go transparent, however, some residual of midtone still persists (see Figure 2.3).

FIGURE 2.2 Effects of the Normal blend mode on a duplicate layer.

FIGURE 2.3 The results of Darken.

Multiply: Whites go transparent, however, all midtone is nonexistent (see Figure 2.4).

Color Burn: Whites go transparent, however, greater saturation occurs where midtones were present (see Figure 2.5).

FIGURE 2.4 The results of Multiply.

FIGURE 2.5 The results of Color Burn.

Linear Burn: Whites go transparent with a truer representation of the gradient (see Figure 2.6).

Darker Color: This has the same result as Darken. The difference is where Darken utilizes one channel chosen by the program to blend color, Darken Color utilizes a composite of all the channels (see Figure 2.7). So, whichever is the lighter color that is the one that will dominate.

FIGURE 2.6 The results of Linear Burn.

FIGURE 2.7 The results of Darker Color.

The second section has the following modes:

Lighten: Blacks go transparent, however, some residual midtone persists (see Figure 2.8).

Screen: Blacks go transparent, however, all midtones are nonexistent (see Figure 2.9).

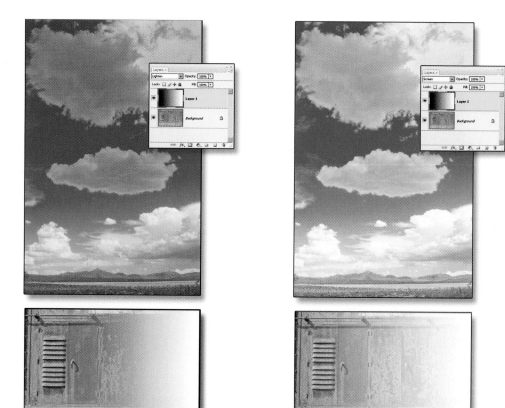

FIGURE 2.8 The results of Lighten. **FIGURE 2.9** The results of Screen.

Color Dodge: Blacks go transparent, however, greater brightness occurs where mid-tones were present (see Figure 2.10).

Linear Dodge: Blacks go transparent with a truer representation of the gradient (see Figure 2.11).

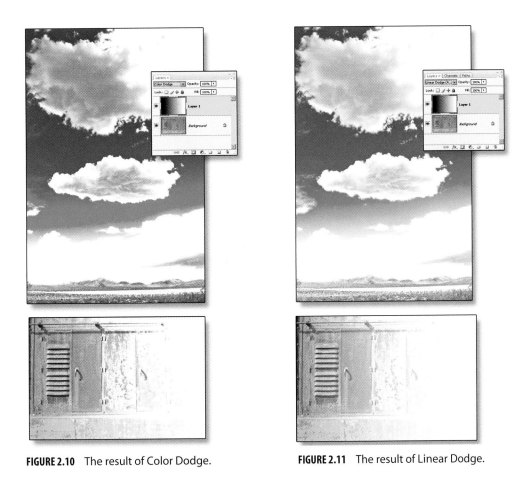

FIGURE 2.10 The result of Color Dodge. **FIGURE 2.11** The result of Linear Dodge.

Lighter Color: Blacks go transparent with a truer representation of the gradient (see Figure 2.12). This has the same result as Lighten. The difference is where Lighten utilizes one channel chosen by the program to blend color, Darken Color utilizes a composite of all the channels. With this mode, whichever color is lighter, that is the color that will dominate.

The modes in the third section include the following:

Overlay: Midtones go transparent with some increased saturation in the low tones and higher brightness in the high tones (see Figure 2.13).

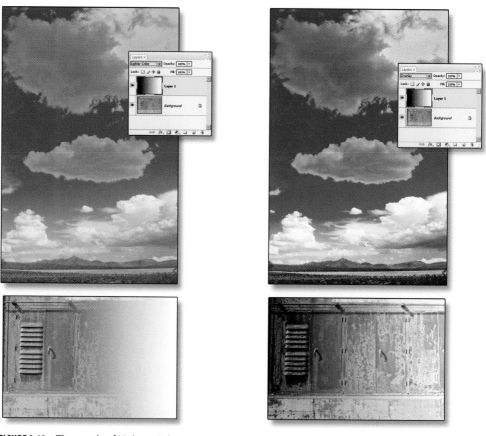

FIGURE 2.12 The result of Lighter Color. **FIGURE 2.13** The result of Overlay.

Soft Light: Midtones go transparent with subtle saturation in the low tones and subtle increased brightness in the high tones (see Figure 2.14).

Hard Light: Midtones go transparent with higher dominance of black and white (see Figure 2.15).

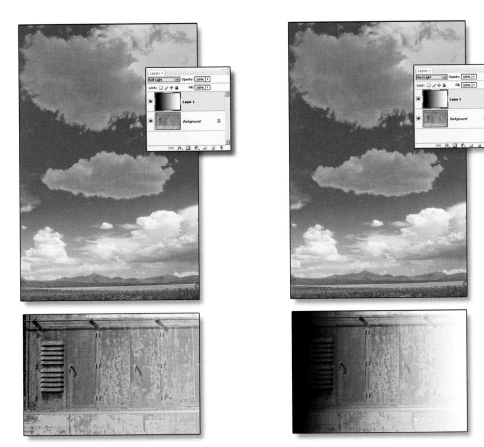

FIGURE 2.14 The result of applying Soft Light. **FIGURE 2.15** The result of applying Hard Light.

Vivid Light: Midtones go transparent with drastic dominance of black and white (see Figure 2.16).

Linear Light: Midtones go transparent with purer representation of the whites and blacks (see Figure 2.17).

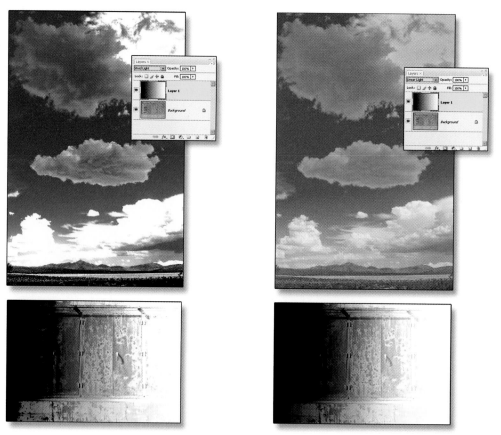

FIGURE 2.16 The result of applying Vivid Light. **FIGURE 2.17** The result of applying Linear Light.

Pin Light: Midtones go transparent with truer representation of the gradient (see Figure 2.18).

Hard Mix: Midtones go transparent with a posterizing effect (see Figure 2.19).

As your work through the tutorials, you will be given some practical applications of the use of blend modes. There are no rules about creativity. Just set your mind to achieving more dynamic results.

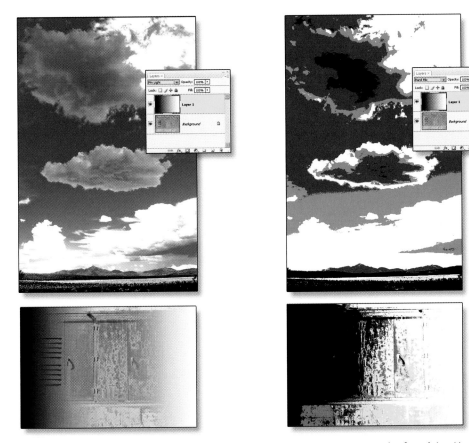

FIGURE 2.18 The result of applying Pin Light. **FIGURE 2.19** The result of applying Hard Mix.

PHOTOSHOP'S NATIVE 8-BIT ENVIRONMENT

To master Photoshop we must understand selections. They are connected to masks, and channels.

The image shown in Figure 2.20 is the key to how Photoshop manages image editing.

That's right. We are working in an 8-bit environment composed of 256 shades of gray. Let's explore this concept:

1. At the base of your toolbar, single-click on the foreground color to access the Color Picker dialog box as shown in Figure 2.21.
2. As you click and drag the Color Palette mouse, the top preview swatch changes to reflect the color you select. This gives you a comparison to the original foreground color shown underneath it.

FIGURE 2.20 Gradient of 256 shades of gray.

FIGURE 2.21 Viewing absolute white with the mouse along the top-left edge.

3. Place your mouse pointer on the top-left corner of the Color Picker dialog box, and slowly drag down the mouse vertically making sure it remains on the left edge. What happens to the preview swatch?

4. The colors should show the range of 256 shades of gray from absolute white or luminance at the top-left corner until you reach absolute black or density, as shown in Figures 2.21 to 2.23. In essence, this is where all of the grays reside devoid of hue or color.

FIGURE 2.22 Viewing medium gray with the mouse along the center of the left edge.

FIGURE 2.23 Viewing absolute black with the mouse along the bottom-left edge.

5. Now place your mouse on the top-left corner of the Color Picker dialog box, and slowly drag the mouse horizontally making sure it remains on the top edge. What happens this time?

6. The colors should show the range of 256 shades of hue from absolute white or luminance at the top-left corner until you reach absolute saturation of the single hue that is selected on the top-right corner. In this case, the hue is red. In essence, this is where your luminance and pure hue reside devoid of density. Figures 2.24 through 2.26 show a sample of this progression.

FIGURE 2.24 Viewing absolute white with the mouse along the top-left edge.

FIGURE 2.25 Progression of luminance and hue along the top horizontal edge.

FIGURE 2.26 Resulting view of luminance and hue along the top horizontal edge.

7. Now place your mouse on the top-right corner of the Color Picker dialog box to get your total saturation of hue, and slowly drag your mouse down making sure it remains along the right edge.

8. The colors should show the range of absolute saturation blended with 256 shades of density until it ends at black. Figures 2.27 and 2.28 show a sample of the progression.

9. Drag your mouse anywhere inside the Color Picker dialog box, and notice that you are accessing a combination of hue, density, and luminance (see Figure 2.29).

FIGURE 2.27 View of saturation to density.

FIGURE 2.28 Resulting view of saturation to density.

FIGURE 2.29 View of hue, density, and luminance combinations.

DEMYSTIFYING THE 8-BIT ENVIRONMENT

Photoshop CS3 allows you to view 8-, 16- and 32-bit images. The functions and tools are completely available to you in the 8-bit mode; 16- and 32-bit images will have limited capabilities.

Now, let's make the connections between the numerical equivalents of color and the color themselves.

1. Look at the numerical equivalents on the right in the Color Picker dialog box: 0 for red, green, and blue is absolute black. So type 0 in each box next to the R, G, and B boxes as shown in Figure 2.30A. Notice that the small selection circle jumps to the bottom left.

2. If 0 for the RGB values is absolute black, and if there are only 256 shades of gray, then the numerical equivalent of absolute white is 255. Type 255 into the R, G, and B boxes (refer to Figure 2.30B). Notice that the small selection circle jumps to the top left.

3. Now let's establish what the midtone will be. This is the tone that photographers worship because it gives them accurate light meter readings when they record their imagery. It is normally referred to as the 18% gray value. This value is in the middle of your absolute white and black values.

FIGURE 2.30 Numerical equivalents for black.

4. Type 128 in the R, G, and B boxes (refer to Figure 2.30C).
5. Now let's get a white that is brighter than 255 white. Type 256 in the R, G, and B boxes.

We have an error. What happened?

We just proved that Photoshop does not understand anything beyond 256 steps of gray because it's an 8-bit environment. Mathematically, that is 2 to the power of 8; 2 multiplied by itself 8 times is 256. It is base 2 because the computer only understands 2 variables: 1s and 0s (see Figure 2.31).

FIGURE 2.31 Error dialog box.

UNDERSTANDING SELECTIONS

Remember, selections, masks, and channels are identical

Keep in mind that Photoshop does not know what you are trying to achieve. You must tell it what, when, where, and how to apply its effects. This is done through selections. Let's prove this concept.

By accessing the Magic Wand tool, a selection is made around the foreground stone, as shown in Figure 2.32. Adjust your tolerance as needed. The higher the tolerance number, the greater the range of color or tone it will select. The lower the number, the less sensitive it will be in selecting tones.

As you notice, you now have what is affectionately called *marching ants*, which represents your selection. The program is communicating that any areas outside the borders of these marching ants will not respond to any of Photoshop's commands or tools.

As an example, if you apply the Hue/Saturation command while the selection is still active, all of its effects will be applied within the selected area only. In fact, all areas outside of the selection have been masked off, which supports the concept that masks and selections are the same. This approach gives you flexibility when choosing localized areas to apply Photoshop's commands or tools.

FIGURE 2.32 Applying Hue/Saturation to a selected area.

SAVING SELECTIONS

Because you work diligently to create your selections, it's a good idea to save them. Because you are about to modify a selection, access the Select menu to save it to the file (Select > Save Selection). Notice that the dialog box gives you the option to name the marching ants. If you want to gain access to your selection again, you need to know from where to retrieve it.

This is where you make the connection to an often intimidating area of Photoshop called the Channels Palette. Make sure that your channels are visible (Windows > Channels), and look at the thumbnail at the bottom, as shown in Figure 2.33. Does it look familiar?

Your selection has become an additional channel called an alpha channel to your original RGB color channels. So it is important to understand that when selections are saved, they go straight to channels. Now let's look a bit further.

To bring the selection back again, you activate the Load Selection command (Select > Load Selection). When you select the Channel drop-down menu, you will see a list of the alpha channels, as shown in Figure 2.34.

FIGURE 2.33 Saving the selection to create an alpha channel.

FIGURE 2.34 Loading the selection from an alpha channel.

In this case, you have only one. Notice that the marching ants are once again loaded into the document. The shortcut for loading the channels as a selection is simply to Ctrl+click on the channel itself.

Editing the Alpha Channel

This mask is nothing more than an image made up of 256 shades of gray. In fact, you can create selections that will have 256 levels of effects. That means you should also be able to paint directly on the mask for altering its form. Let's try it.

If you access the Paintbrush tool and make sure that the foreground color is white, you can alter the image by painting directly on the alpha channel itself, as shown in Figure 2.35. After the channel has been edited, you can load it back in as a selection. To do this, access the Select menu and choose Load Selection. Now you will see the marching ants version of your mask as shown in Figure 2.36.

You can also load this as a selection with a Ctrl+click/Cmd+click on the mask.

Just as before, you can apply Photoshop's commands and tools to this selected area (see Figure 2.37).

FIGURE 2.35 Edited alpha channel.

FIGURE 2.36 Mask loaded into the document as a selection.

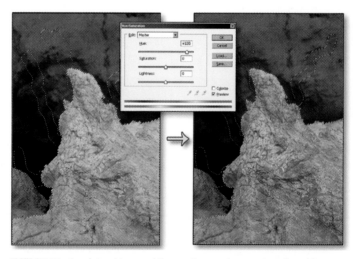

FIGURE 2.37 Applying Hue and Saturation to the newly selected area.

LAYER MASKS DEMYSTIFIED

Now that you have gained some insight into the uses of selections, let's look at some of its more important applications. Let's delve into their uses in creating layer masks. To understand layer masks, you must understand the creative necessity of layers.

One of the most widely used aspects of Photoshop is its capability to integrate gracefully almost an unlimited amount of imagery with the use of layers. What are

layers? Let's go back before the advent of digital and discover how the concept of layers was originally applied.

Let's say that your artwork was to be produced for the front cover of a magazine. The publisher's graphic department had to place the title as well as any graphic effects on the artwork. The artists did not apply the graphics to the art directly, but instead they laid a clear sheet of acetate over the artwork and placed the title of the magazine on the acetate. In turn, they placed another sheet of clear acetate on top and created the border graphic effects on that acetate. In registration, they generated the final copy from which they produced the color separations for the magazine cover.

On a creative level, layers are important because you can apply all of Photoshop's commands and tools to each object independently from the entire scene. Placing most of the elements on separate layers gives you control and flexibility. After the layers are established, you can apply layer masking to control how each object blends and integrates into the entire image.

Layer masking is an excellent way to control the opacity or transparency of local elements in an image. Traditionally, this process was done by sandwiching a litho negative with a color transparency. Sections of the litho negative were clear to allow the enlarger to expose the original image. Other sections of the negative were black, which blocked out the visual aspects on the transparency as shown in Figure 2.38. The two in registration (complete alignment), as shown in Figure 2.39, were placed into a photographic enlarger so that the image showing through the clear portion of the litho negative was exposed onto the photographic media. How do we achieve this in Photoshop?

FIGURE 2.38 The black portions of the negative block out our view of the transparency.

FIGURE 2.39 Two images in registration.

Creating the Layer Masks

To create the layer masks, follow these steps:

1. Open an image in Photoshop, and duplicate the original layer. This example uses an image of a boulder composition on the beach. You can find this image in the `Tutorials/ch 2 boulder.jpg` on the CD-ROM. The foreground stone was selected using the Magic Wand selection tool and saved as an alpha channel (Select > Save Selection).

2. Access your Channel Palette (Windows > Channels). To see the alpha channel in combinations with the image as you edit the channel, press the "\" key, and the areas that represent the black pixels on the channel will go to a transparent red (see Figure 2.40).

FIGURE 2.40 Editing the mask with a view of the layers image.

3. If you paint with black, the red is added to the mask and if you paint with white, the red is cleared from the mask. After you are done editing the mask, press the "\" key again to get the alpha channel back to the normal black-and-white mode.

4. Ctrl+click on that channel to convert it to a selection.

5. Make sure that your top layer is selected, and associate a Curves adjustment layer mask by clicking on the black and white half circle icon located dead center of your icons on the bottom of the Layers Palette. Curves is applied to alter the selected region's tonality, as shown in Figure 2.41. In this example, we are affecting the middle range tones by dragging the center of the curve upward.

FIGURE 2.41 Associating a Curves adjustment layer to alter the midtones.

6. Notice that the Curves dialog box has a slightly different look from the previous versions of Photoshop. A convenient feature is the display of the histogram behind the curves. The function of the Curves has not changed, but being able to see the total graph behind it facilitates the process of anticipating where the tones are on the graph. If you click the arrow next to the Curve Dialog Options, you will see check boxes that are selected by default.

 • Figure 2.42A show some example of how to turn off the histogram. This may be convenient for those who are used to working with the previous model of Curves.

 • Figure 2.42B gives an example of how to turn off the intersecting line, which is basically a cross hair that helps you keep track of the points as they are repositioned on a curve. If this is annoying to you, you can turn off that option here.

 • Figure 2.42C shows you how to turn off the baseline. The Baseline check box gives you a preview as to where the line was located before you started any changes.

7. You have other options as well. Figure 2.43A gives you an example of reversing the histogram, which is convenient for those who will be printing with the use of a offset printer. If you look at the base of the histogram you will notice that white starts to the left and ends in black to the right. This represents no saturation of ink to a complete saturation of ink on the paper. This example also shows the use of the larger grid to assist you in placing and moving your points. If you prefer to work with smaller grids, then select the

FIGURE 2.42 View of the new Curves dialogue and options.

option shown in 2.43B. Also shown is the option to work in the added if Collor process where black is located on the left hand side of the horizontal tonal graph and ends with white on the right. This is representative of the additive process of light where equal amounts of red, green, and blue light will become white.

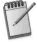

You can also use the shortcut Alt/+click/option+click on the grid itself.

8. One last feature that was included in the Curves dialog box that most users are going to find wonderful is the use of presets as shown in Figure 2.44A. B through D in that same figure show three examples from the list of presets. Scroll to all of them so that you can get familiar with what is listed.

FIGURE 2.43 You can use pigment or light options in the Curves dialog box.

FIGURE 2.44 Example of additional presets in the new Curves command.

9. Adjust the Curves to see the possibilities of using it as an adjustment layer. Figures 2.45 and 2.46 show some examples of what can be achieved.

As you can see, there is great power in the use of masks in relation to adjustment layers.

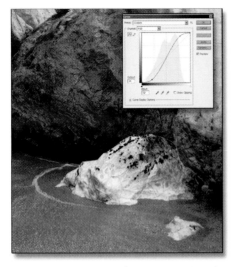

FIGURE 2.45 Increasing the contrast using the Curves adjustment layer.

FIGURE 2.46 Decreasing the contrast using the Curves adjustment layer.

Further Understanding of Masks

Earlier you learned that if you save a selection, it will become an alpha channel, and from that you can convert the alpha channel into a selection. The same is true for RGB channels:

ON THE CD

1. Open the `lone tree.jpg` (see Figure 2.47) from the CD-ROM in `Tutorials/ ch 2`.

FIGURE 2.47 View of Lone Tree.jpg.

2. Look at all the channels to get a better understanding of what they are and the type of information that is inherent in each one.

3. Click on the Red channel to view it on the canvas. If you placed black-and-white film into your camera and placed a red filter over the lens of the camera, the resulting black-and-white print would look like Figure 2.48. Notice that this channel has a greater range of contrast than the other two. This is the one that harbors all of the contrast in your digital image.

FIGURE 2.48 Red channel view.

4. Click on the Green channel. If you placed black-and-white film into your camera and placed a green filter over the lens of the camera, the resulting black-and-white print would look like the Green channel. If you look further, the contrast is the least for this channel because it is the one that contains all of the continuous midtone information (see Figure 2.49).

FIGURE 2.49 Green channel view.

5. Click on the Blue channel. If you placed black-and-white film into your camera and placed a blue filter over the lens of the camera, the resulting black-and-white print would look like the Blue channel. This is the channel that is most sensitive to the ultraviolet range of light, thus capturing much of the noise in the atmosphere. If you were to produce a black-and-white print, then the Blue channel would usually be the least desirable to use (see Figure 2.50).

FIGURE 2.50 Blue channel view.

Now let's make the connections between selection and channels:

6. Go to the Layers Palette, create a new layer, and fill it with black (Edit > Fill > Fill with Black). When you are done, click on the eyeball symbol on the left of the layer to turn it off temporarily so that you can view the channels of the tree.

7. Access the Channels Palette and Ctrl+click on the Red channel to produce a selection. With your marching ants still selected, turn on the layer filled with black. You should have something that looks similar to Figure 2.51.

FIGURE 2.51 New layer filled with black with selection from the Red channel.

8. Now fill the layer with white (Edit > Fill > Fill with White), and take a look at what you have (see Figure 2.52 for the result).

FIGURE 2.52 Fill selection dialog box.

Do you see what has happened? You have just transferred the Red channel into a layer via a selection. As we have noted, the key to mastering Photoshop is mastering selections. Selections, masks, and channels are identical.

Now let's take this one step further and use the results to enhance the image:

9. Change the blend mode of the top layer to Screen. This will give you a nice fluffy white for the flower petals. Everything else looks fine as is, so restrict the effect to the flower detail.
10. Associate a mask with the layer that you just changed to Screen mode. Notice that you have an extra white thumbnail connected to your image. This is the Layer Mask, as shown in Figure 2.53. You can paint with 256 shades of gray on this, but make sure that you click on the mask first to tell the program that you are interested in editing the mask. Photoshop is telling you that if you paint within this area with white, you will be allowed to view the image that it is associated with (in this case, the tree image that you set) to a Screen blend mode. If you paint with black, you will mask out the object; in effect, it will disappear. Make sure that you click on the mask and fill it with black (Edit > Fill > Fill with black).
11. Activate your paintbrush, and use a low opacity setting to apply white paint to the filled black mask. Apply only to the white flowers to bring out the creamy luminance that will make this image a little more dynamic, as shown in Figure 2.54.
12. Alt+click on the mask to view it in the canvas area, as shown in Figure 2.54.

Now that you have an understanding of selections, mask, and layer blending modes, let's move on to apply this knowledge to some creative applications.

FIGURE 2.53 Editing the Screen mode layer mask.

FIGURE 2.54 Mask viewed on canvas.

Using Channels to Make Masks

Let's look at another option for creating masks. Click on each channel to understand its properties.

The Red channel harbors the contrast of your image. Let's relate this to photography before the advent of digital. If you photographed this image using black-and-white film and placed a red filter over the lens and then proceeded to make a black-and-white print, then this channel is what the print would look like (see Figure 2.55).

FIGURE 2.55 View of the Red channel.

The Green channel harbors the continuous midtone grays in your image. If you photographed this image using black-and-white film and placed a green filter over the lens and then proceeded to make a black-and-white print, then this channel is what the print would look like (see Figure 2.56).

FIGURE 2.56 View of the Green channel.

The Blue channel harbors the noise from the atmosphere. This is the channel that is more sensitive to ultraviolet radiation. The same comparison pertains to this channel as well, in that if you photographed this image using a blue filter over the lens, the black-and-white print would resemble this channel (see Figure 2.57).

FIGURE 2.57 View of the Blue channel.

We are going to make a mask enhancing the whites of the sand. There is an advantage to creating a mask this way because your channels already contain all of the textural details of your image in shades of gray, therefore, you can create a more accurate mask. In fact, with much practice, you could create masks faster this way.

1. View each of your channels, and determine which one will give you the best tonal separation between the sand and everything else. In this case, the blue channel works the best. You do not want to alter the original channel because this will alter the blue hues in the image, so create a duplicate of it to create an alpha channel. By default, it will be named Blue copy. You will use this to create your mask (see Figure 2.58).

2. On the toolbar, select the Color Sampler Tool, and visually determine the darkest area and the brightest area on your Alpha channel (see Figure 2.59).

FIGURE 2.59 The Color Sampler Tool.

FIGURE 2.58 View of the Blue copy channel.

3. Press Ctrl+M for Curves and Ctrl+click on the gray grass located next to the blossom to place a point on the section of the graph that represents the selected tonality (see Figure 2.60).

FIGURE 2.60 Place point of the Curve representing the background details.

4. Now do the same thing for the crackling mud to place a point on the section of the graph that represents its selected tonality. Now that you have the two tonalities mapped, you can create some extreme contrast to make the crackling mud and the background details black (see Figure 2.61).
5. Take the point that represents the background detail and drag it to the lower extremity to send the selected midrange grays to black. Do the same for the crackling mud and send that point upwards to send its tones to pure white (see Figure 2.62).

FIGURE 2.61 Place point of the Curve representing the crackling mud.

FIGURE 2.62 Create extreme contrast using the mapped points.

6. Use the Burn Tool to take out any unwanted details toward black leaving only the crackling mud detail (see Figure 2.63). Make sure that Shadows is selected in the Options bar as shown in Figure 2.63.

7. Now that you have the mask, you can apply it to the layer that has the Screen blend mode. Ctrl+click on the Blue copy alpha channel to get your selection. Now add a layer mask, and notice that the alpha channel has been transferred to the mask. In essence, the selections were honored so that the areas selected remain white and everything else is masked out with black, as shown in Figure 2.64.

FIGURE 2.63 Edit the mask with the Paintbrush.

FIGURE 2.64 Apply alpha channel as a layer mask.

A Basic Course on the Use of the Pen Tool

Next, you're going to get a basic course on how to use the Pen tool to outline sophisticated shapes from which you're going to create a selection.

Step 1

ON THE CD

Select the Pen tool on the Tools Palette or hit "P". Then, Go to the CD-ROM in tutorials/ch 2 and open "pen tool exercise.jpg"

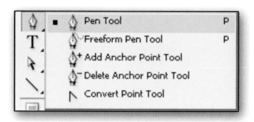

FIGURE 2.65 Activate the Pen tool.

Step 2

Select the Pen tool on the Tools Palette or hit "P". Use Figure 2.66A as a guide and place your first and second point point with the single-click between the two locations that make up the straight line of the rusted bar as shown in Figure 2.66A.

Next, assess where the curve ends from the location of the last point. Now, place another point at the location where the curve subsides (Figure 2.66 B) and click and drag while tracing the shape going forward as shown in Figure 2.66C. When you trace the shape after you lay down a point the curve behind the dragging mouse will naturally fall into position.

FIGURE 2.66 Use of the the Pen tool to trace the shape.

Step 3

Continue the same procedure by assessing where the curve ends then click and drag your mouse while tracing the shape going forward as shown in Figures 2.67 and 2.68.

FIGURE 2.68 Continuing farther along to outline the shape.

FIGURE 2.67 Continuing to outline the shape.

Now, take a look at figure 2.69 and observe that the handlebars are flowing with the outline of the object. When practicing this exercise be patient and try not to bite off more than you can chew. Remember to place your first point where the curve begins and one where it ends and simply outline the shape by dragging the mouse and as a result you're bezier shape will outline your object effortlessly.

FIGURE 2.69 The handlebars flow with the exterior of the shape.

Step 4

As you continue to outline your shape place the point where the two curves meet as shown in Figure 2.70. In Figure 2.70 your point has been placed at the intersection of two separate curves.

FIGURE 2.70 Point placed at the intersection of two curves.

If we continue normally as shown in Figure 2.71 the curve will follow in the direction of the handlebar. We do not want it to create another curve, but instead start as a fresh point. To solve this problem you need to get rid of the handlebar created by the last point. To do this simply hold down your ALT key/Option key and click on the last point. This will allow you to start fresh as shown in Figure 2.72.

FIGURE 2.71 Curve is created by the extended handlebar.

FIGURE 2.72 Use your ALT/Option key to take away the handlebar.

Step 5

Continue on to outline your shape and don't forget to trace the line as you move forward on the curve to allow the back end to fall into place.

FIGURE 2.73 Continue outlining your shape.

Step 6

Close your path by clicking on the point where you began. Open your Paths Palette (Windows > Paths) to view your shape. Make sure that you save the Path simply by double clicking on the Path layer and renaming it. This will allow you to save it to the file so that you have the option to edit it later on and it will automatically be updated.

FIGURE 2.74 Close the path.

Step 7

Once your path is complete you can go back and edit the points by moving them as well as dragging the handlebars for adjusting them to improve the outlining of your shape. In order to do this you must use your Direct Selection tool shown in Figure 2.75.

FIGURE 2.75 Close the path.

Step 8

Now that you have your path hold down your Ctrl/Command key and click on the path icon to get a selection from your path as shown in Figure 2.76.

FIGURE 2.76 Create a selection from your path.

FIGURE 2.77 Create a selection from your path to use with the Selective Color Adjustment Layer.

Step 9

Now that you have a selection you can add an Adjustment layer which in this example is Selective Color. Use this to alter the color of the handle and not affect the rest of the background.

Now that you have an understanding of selections, mask, and layer blending modes, let's move on and apply our knowledge to some creative applications.

WHAT YOU HAVE LEARNED

In this chapter, you have learned

- How and why layer blend modes work the way they do
- The key to mastering Photoshop: selections
- That you are working optimally in 8 bits
- How to create and edit alpha channels to create layer masks
- How to create masks from alpha channels
- How to edit the Alpha mask to isolate chosen details
- How to outline sophisticated shapes with the Pen Tool

3 SMART FILTERS TO AID ARTISTIC VISION.

• Powerful approaches to compositing photographic imagery
• Practical use of the new HDR Merge
• Introduction to the new Smart Objects
• How to use layer sets to organize your work
• How to use Layer Blending modes to assist with composition
• The power of the Free Transform and Distort for localized areas
• Practical applications to using layer masks
• Creating masks from channels
• The usefulness of third-party filters to enhance your creations

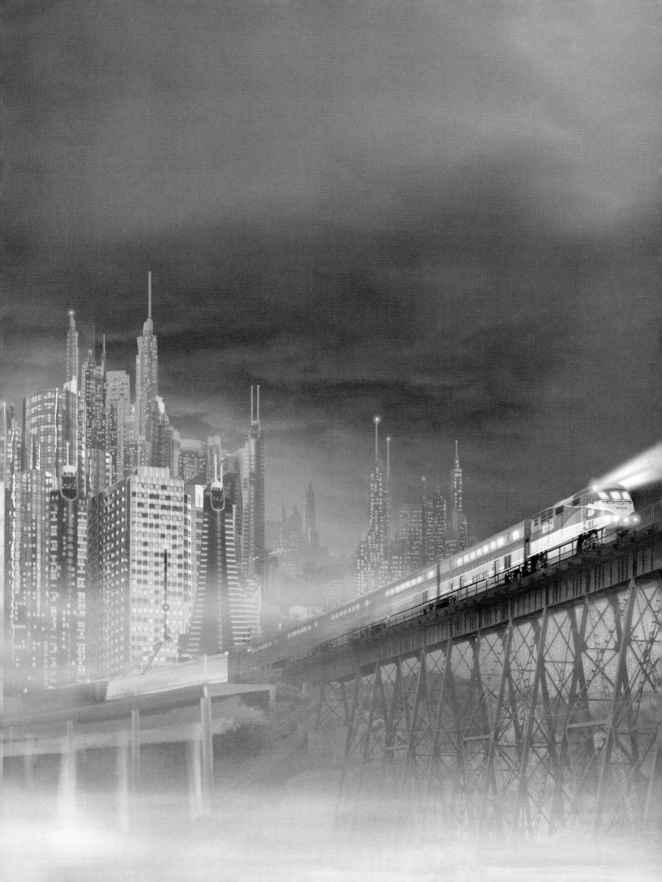

USING PHOTOGRAPHS AS A CREATIVE MEDIUM

The purpose of this exercise is to give you an insight into the possibilities of what one photographic image can do if you allow your mind to be open to alternative ways of seeing. Why honor the single shot if you can show something with a more interesting twist?

Most photographers compose for a single expressive image. This technique has been widely used because of the level of difficulty of achieving successful image blends in the traditional darkroom. It could be done but not without the aid of a series of enlargers with an impeccable registration system to ensure that the images were exposed and placed properly for a seamless integration. Now we have the advantage of Photoshop CS3 . . . the digital darkroom.

With the digital darkroom, your vision is never limited to a single composition. In this exercise, you will learn how to alter the original imagery using compositing and painting techniques. You will also get an introduction to the possibilities of using Smart Filters.

ON THE CD

1. Open a file (Ctrl+O/Cmd+O), and navigate to the CD-ROM. Access `Tutorials/ch 3` and select `Cloud001.jpeg`. You are going to use this as the base image.

FIGURE 3.1 View of `Cloud001.jpeg`.

2. In the same folder, open (Ctrl+O/Cmd+O) `train001.jpg`, and use the Magic Wand to select your sky. On the Options bar, make sure that you have Contiguous unselected. This will select all of the particular color that you have clicked on to become highlighted with marching ants everywhere in the photograph. Basically, this works globally.

3. The idea is to select the sky and mask out everything else. To facilitate this process, press the Q key on your keyboard to activate the Quick Mask. Immediately, the areas that are selected will remain clear, and the areas that have not been selected will be highlighted red. Press P to select the Paintbrush, and select black as the foreground color to add to your mask, which is in this case is a reddish color. To discard from the mask, paint with white as the foreground color.

FIGURE 3.2 Magic Wand applied to `train001.jpeg`.

FIGURE 3.3 Apply Quick Mask to the image.

If the original red color for the mask conflicts with colors in your photograph, you can change the color that the Quick Mask uses by double-clicking on the Quick Mask icon. Then click on the color swatch to open the Color dialog box. Simply select a color that you want to work with.

4. Place the train into the `Cloud001` base image, and flip the image horizontally (Edit > Transform > Flip Horizontal) to position it similar to what is shown in Figure 3.4.
5. Activate the rectangular marquee, and draw a selection around the train. Access the Warp command (Edit > Transform > Warp), and give the nose of the train a little more height as shown in Figure 3.5.
6. Access `Tutorials/ch 3` on the CD-ROM, and select `beach001.jpeg`. Select a portion of the water with the Rectangular Marquee tool (see Figure 3.6A and B). Place this into your train image, and flip the water horizontally (Edit > Transform > Flip Horizontal) so that the beach is facing the right-hand side. Apply a layer mask so that the beach detail is isolated to the base of the hill underneath the train (see Figure 3.6C).

FIGURE 3.4 Place the train image

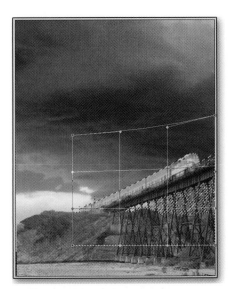

FIGURE 3.5 Warp applied to train.

FIGURE 3.6 Steps for creating the beach scene.

7. Create a new layer, and make sure that it is located on the very top of your scene. Make sure that your foreground and background color is medium gray and white. Access the Filter menu, and apply clouds (Filter > Render > Clouds). We will use this as the beginning step in creating a low-level fog bank. Now, apply perspective (Edit > Transform > Perspective) so that the area closest to the base of the photograph will be larger to give a sense of the fog getting closer to the viewer (see Figure 3.7).

8. Now you need to be able to see through the fog so that the white remains, and the gray disappears. To do this, you will use the power of Layer Blend modes. Select Hard Light so that the medium gray will disappear and the white will remain. Apply a layer mask while holding down the Alt/Option key. This will give you a mask that is filled with black by default. Now paint on the mask with a soft edge paintbrush using white as the foreground color. Paint the areas above and to the left of the train to create the effect of the fog lifting up and over the hill. You should have something that looks like Figure 3.8.

FIGURE 3.7 Create fog and apply the transform.

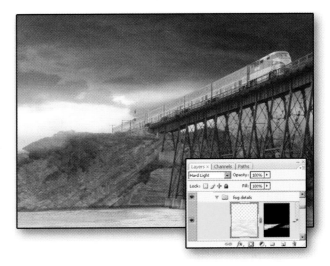

FIGURE 3.8 Layer Blend Mode applied to the fog layer.

9. Now you need to apply an effect that will help the fog look as if it is part of the color balance of the entire scene. The overall scene is going to reflect a grayish-bluish hue, and the fog needs to be integrated into that color scheme. Double-click on the fog layer that you have just created the mask for. The Layer Style dialog box appears. Select Color Overlay, and click on the color swatch on the top-right corner to open your color picker. The idea is to give the fog the grayish tinge with a hint of blue, so select something similar to what is shown in Figure 3.9. In this example, the Opacity is set at 80% so that the entire image will not become one solid color. Experiment with this to find the result that you favor best (see Figure 3.10).

10. Apply the same effect to get the fog on the ground level below the train. Duplicate the fog layer, and fill the mask with black (Edit > Fill > Fill with Black). Paint with white on the areas where you want to see the fog exposed. Don't be afraid to duplicate the layers to build the fog effect in various portions of

FIGURE 3.9 Apply the layer styles effect of Color Overlay.

FIGURE 3.10 Results of Color Overlay.

the image. This will assist you in breaking up any obvious consistency in the texture. Use Figure 3. 11 as a guide.

11. This is a good time to organize your fog layers into their own layer groups. Select all of the fog layers, and place them into a layer group by accessing the layers submenu and selecting New Group From Layers.

FIGURE 3.11 Apply the fog to lower areas.

12. The intention of the fog technique in step 10 was to give you a way to lay down a quick foundation of texture. Now create a blank layer above your fog, and use a soft edge paintbrush to paint the effect in various areas surrounding the train. Figure 3.12 shows an example of the paintbrush properties as well as the areas that the technique was applied to. (We will not discuss brushes at this time because they are covered in the next chapter.)

13. The train and bridge area should also reflect the color scheme of the surrounding areas, so apply the same Layer Style Overlay technique that was applied to the fog by holding down the Alt/Option key and dragging the layers style from the fog layer onto the train layer (see Figure 3.13).

FIGURE 3.13 Add layers styles to the train image.

FIGURE 3.12 Reflection created.

14. For a more dynamic composition, limit the layers style to the rear portion of the train to mimic any areas that will receive more of the atmospheric effect in areas that are farther away. So, the front portion of the train will have its original appearance without the effect of the overlay layer, and the rear portion will have a greater affect of the overlay layer. Duplicate the original train image, and place it above the one that you just applied layer styles to. Add a layer mask to that layer and apply a gradient to the mask using the Gradient tool with white for the front portion of the train and ending with black on the rear portion of the train. Use Figure 3.14 as an example.

FIGURE 3.14 Apply a gradient mask to the duplicated train layer.

15. Let's add some detail to the train that will help guide the viewer's eye toward the train composition. Since the background is going to take on a less saturated effect, let's add some detail to the train in the form of a red pen stripe that will lead the viewer's eye farther back into the composition and vice versa.

16. Select the Pen tool (see Figure 3.15A), and create the red decal as shown in Figure 3.15. On the Options bar, make sure that the Fill with the Foreground Color (see Figure 3.15B) capabilities are selected when you create the path. When the path is completed, you will notice a colored icon to the left side of the actual shape that you've created (see Figure 3.15C). You have just created a vector shape with the advantage that you can double-click on the Color icon to change the color to any shade of hue that you want the decal to be.

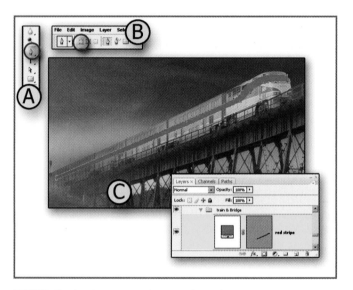

FIGURE 3.15 Apply a vector shape to the train.

17. Now, let's integrate the red stripe more accurately to the side of the train. With your vector-shaped layer selected, change the Blend Mode to Soft Light to allow the details of the train to integrate well with the vector shape. Finally, give the vector shape a layer style by double-clicking on the blank portion of the layer to bring up the Layer Styles dialog box. Next apply a stroke to the vector detail. This example uses a stroke of 1 pixel (see Figure 3.16) but vary it according to your tastes.

18. To maintain a sense of depth, apply the gradient mask to the vector shape so that the red detail is more prominent toward the front portion of the train (see Figure 3.17).

FIGURE 3.17 Applying the gradient mask to the shape layer.

FIGURE 3.16 A stroke of 1 pixel is applied to the vector shape.

APPLYING MOTION BLUR TO ACCENTUATE MOVEMENT WITH SMART FILTERS

One of the most recent additions to Photoshop CS3 is Smart Filters. This is the continuing effort to allow the artists to work in a destructiveless mode of creating. The advantage is that you now have more flexibility to apply the layer effects in any manner that you deem necessary, and you can go back and undo changes or add to accentuate your texturing without the destruction of the original image. We will get more into the concept of Smart Filters later, but for now, let's apply a simple effect to give the train a sense of motion.

1. Select the layers that make up your bridge, train, and the red decal. While holding the Alt/Option key on your keyboard, access the Layer submenu, and select Merge Layers (see Figures 3.18A and B). The Alt/Option modifier merges the selected layers into a new layer without affecting the originals. Next, go to the Layers submenu once again, and select Merge into Smart Object. The Smart Object command allows you to resize your image without losing the quality that is originally present.

2. Now apply Motion Blur. Adjust the angle to the direction of the train, and play with the distance to apply the motion blur (see Figure 3.19).

3. Notice that you now have an additional layer beneath your smart object. This layer contains the Filter commands that can be altered independent of the entire scene. You also have a mask attached to the smart filter so that you can apply the effect to localized areas of the image. On the right side of the title "Motion Blur," double-click to open the Motion Blur dialog so that you can make adjustments to the original Motion Blur settings at any time (see Figure

FIGURE 3.18 Merge layers without affecting the originals, and then create a smart object.

FIGURE 3.19 Apply Motion Blur.

3.20A and B). In addition, you can apply Layer Blend modes to the effect (see Figure 3.20C).

4. Since the mask is associated with the filter, apply a gradient so that the foreground is unaffected and the background takes on more of the effect (see Figure 3.21).

FIGURE 3.20 Make any additional changes to your motion blur.

FIGURE 3.21 Apply the gradient mask to the smart filter.

ADDING DETAIL TO THE BACKGROUND

As the train is coming forward to the foreground, let's make it appear as if it is coming from a platform from the background of the composition. This added detail will

help anchor the viewer's eye to the rear of the composition as the train gives the illusion that it is traveling forward. Afterwards, you'll add some sunset effects that will push the foreground objects visually toward the viewer.

1. Create a new layer group above the train and bridge, and title it "Bridge Platform." Create a basic shape with the use of the rectangular marquee, and fill it with the gradient from medium gray to a lighter gray on a separate layer (see Figure 3.22).

FIGURE 3.22 Basic colors shape created.

2. Place this shape vertically to represent pillars that will hold up the platform to the rear and slightly below the train as shown in Figure 23A. Make sure that you use Free Transform to make the pillars that are farther away from the foreground smaller and thinner to simulate depth.

3. Use the Warp tool to slightly bend the horizontal platform. This will give the effect that there are weighty objects sitting on the platform (see Figure 3.23B). Select the first fifth of the platform with the rectangular marquee and apply Distort to angle it so that it appears that the viewer is looking on the front section of the pier (see Figure 3.23C). Press Shift+O until you select the Burn tool. In the Options bar, make sure Midtones is selected. This option tells the Burn tool to favor the middle range of grays to become darken in tonality. Now, apply the darkening effect underneath the bridge (see Figure 3.23D). Burn down the rear portion of the platform so that it has a feeling that it is receding farther into the background (see Figure 3.23E).

4. Create a new layer beneath the platform, and create a triangular selection similar to what is shown in Figure 3.24A. This is going to become a shadow underneath the bridge. Press Ctrl/Cmd+D to deselect the selection and apply the Gaussian Blur to soften the shadow effect. Figure 3.24B gives the final result.

5. Create another layer group titled "sunset effects." In this layer group, create a new layer where the gradient starts from red and ends as a transparency (see Figure 3.25). Position the redgradient layer so that the hue fades off slightly above the head of the train. Next, duplicate this layer, and move it so that the lower portion of the original sunset takes on a slightly stronger reddish hue. Use

FIGURE 3.23 Custom create your platform.

FIGURE 3.24 Create the platform shadow detail.

Figures 3.25 as examples. In Figure 3.26, add additional gradient layers to enhance the effect and place them in their own layer group. Next, add a mask to the layer group so that the sunset is applied to localized areas in the lower sky.

FIGURE 3.25 Apply your sunset.

FIGURE 3.26 Apply the layer group mask to your sunset.

APPLYING THE FOREGROUND CITY SHAPES

You're going to create the city landscape with the use of photographic imagery from several sources. You will enhance the results with painting and special effects techniques to make them more dynamic.

ON THE CD

1. Open Adobe Bridge (File > Browse), navigate to Tutorials/ch 3 on the CD-ROM, and select building 001.jpg.
2. Select a portion of this image, and place it on its own layer (see Figure 3.27B and C).

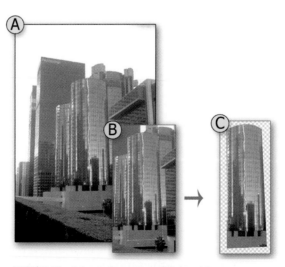

FIGURE 3.27 Selected portion of the architecture.

3. To make things a little easier to work with, turn off the bridge platform layer group. Create a new layer group titled "foreground building." Position this layer group behind the bridge platform group. Duplicate the selected architecture, and position them as shown in Figure 3.28.

FIGURE 3.28 Position the duplicated architecture.

4. In the same folder, also open `building 002.jpg`, and select the architecture as shown in Figure 3.29.

FIGURE 3.29 Isolate the architecture onto its own layer.

5. As shown in Figure 3.30, place the new building in front of the circular shapes that you created in steps 1 and 2.

FIGURE 3.30 Add the additional architecture.

6. Turn on the bridge platform layer group, and, if needed, apply the layer masks to get rid of any extraneous details (see Figure 3.31).

FIGURE 3.31 Edit the architectural details using layer masks.

ON THE CD

7. Once again, navigate to the Tutorials/ch 3 folder, and select building 003. jpg. Select the skyscrapers shown in Figure 3.32, and use the Warp tool to alter the shapes.
8. Place your new shapes in front of your foreground architectural detail. Play around with their positioning (see Figure 3.33).
9. You can create a lot of detail from just a few images. By selecting portions of other skyscrapers in the building 003.jpg, you can reposition them on top of

FIGURE 3.32 Edit the architectural details using the Warp tool.

FIGURE 3.33 Add a new shapes to the foreground architecture.

other elements to reshape the vision beyond the original photographic imagery. Experiment with this concept by taking details from existing architecture and placing them on other areas of your composition.

FIGURE 3.34 Redefine the foreground architecture.

FIGURE 3.35 Adding more Redefinements to the foreground architecture.

Figure 3.36 is an example of the final results organized in their respective layers.

FIGURE 3.36 Layer view of the foreground architecture.

CREATING THE BACKGROUND CITYSCAPE

Next, you will create the cityscape that serves as the background to the foreground city and train. This image has already been created for you and is available in the *ON THE CD* Tutorials/ch 3 folder on the CD-ROM. Just open city composite.psd, and use this

for the background cityscape detail. However, if you prefer to try your hand at creating your own city, follow the next steps.

1. In the Tutorials/ch 3 folder on the CD-ROM, select the building 004.jpg image (see Figure 3.37A). Select a portion of the architecture as shown in Figure 3.37B, and then duplicate and flip it horizontally using Free Transform (see Figure 3.37C). Place these layers inside a layer group titled "mid-distant city" beneath the Train & Bridge layer group.

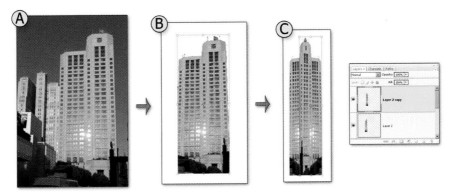

FIGURE 3.37 Selecting architectural details.

2. Add more detail by opening up another image titled building 005.jpg, and selecting a portion of its architecture as shown in Figure 3.38. Place it on its own layer, apply the Difference blend mode, and then resize it to make it tall and thin. Move this on top of the initial building detail and watch how the effects blend the two details.

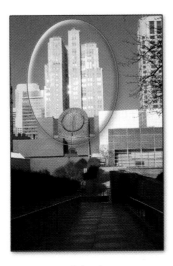

FIGURE 3.38 Selecting new texture details.

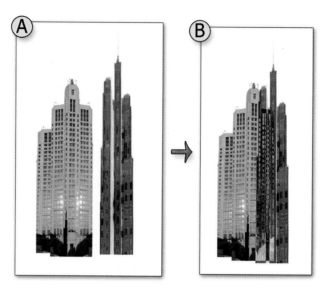

FIGURE 3.39 Allow the layer Blend Modes to alter the texture details.

3. The intention of the final result is to get architectural detail that is going to fade into the background, so you're going to use Multiply, Darken, Overlay, and Difference modes to blend various textural shapes to create the background cityscape.
4. Add more detail by using `building 006.jpg` to continue building on the cityscape structure (see Figure 3.40).

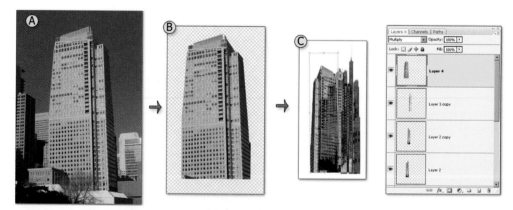

FIGURE 3.40 Continue adding more texture details.

5. Try to create something close to Figure 3.41.
6. If you create your own version of the cityscape, select all of the layers that make up the background city and merge them. The background cityscape is

FIGURE 3.41 The final cityscape.

going to be surrounded by haze and fog, so visually you will not be able to see much detail; instead, you would see mostly a colored outline of the skyline. So, double-click on the background cityscape layers, and apply a an Overlay effect that reflects the color of the surrounding atmosphere. Adjust the Opacity slider to feed the detail into the chosen color overlay (see Figure 3.42).

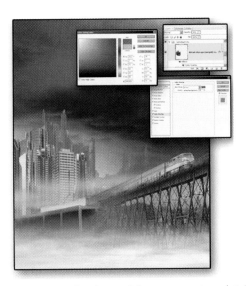

FIGURE 3.42 Continue adding more texture details.

7. Duplicate the cityscape layer inflicted horizontally so that it has some visual diversity in the composition (see Figure 3.43). Place this object lower in the horizon and directly behind the train. Now edit its layer style to have a higher opacity in the setting for the Overlay effect. Since we want this cityscape to be farther into the horizon, the detail will be more obscure than its predecessor.

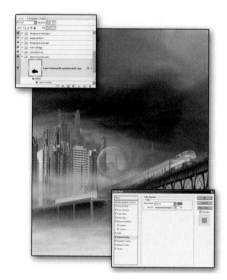

FIGURE 3.43 Duplicate and flip horizontally the cityscape.

Adding Light Details

Adding light effects to the window region is the easiest step of all. This entails using the Polygonal Lasso tool to select the basic rectangular shape and filling the shape with the color of your light source. In this example, yellow and white are used.

1. Focus in on a single building, and select one of the windows using the Polygonal Lasso tool or the Rectangular Marquee tool. Create a new layer group titled "light effects," and fill the selection on a new layer. After the layer has been filled, use the Move tool to duplicate that layer by holding down the mod-

FIGURE 3.44 Create the lighting effects on the cityscape to add believebility.

ifier Alt/Option key while you move the shape to the new location. If this selection is still active, this will move your highlight to the new location while still on the current layer. If the highlight is not surrounded by a selection, then the layer will be duplicated.

2. When you're finished, change the Blend Mode to Screen, and give the light source a slight Gaussian blur to create a slight glow. Figure 3.45 shows the final result.

3. Finally, apply the same technique to the windows of the train. This gives the moving vehicle life as shown in Figure 3.46.

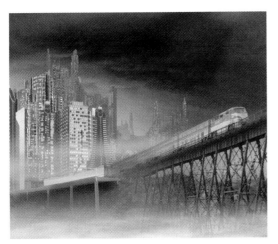

FIGURE 3.45 Final result of light technique.

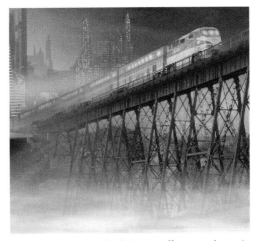

FIGURE 3.46 Create the lighting effects on the train.

4. Select the Gradient tool on the toolbar, and activate the Gradient Editor on the Options bar. You're going to custom create point lights to use as headlights on the front of the train as well as light sources on the architecture themselves. Take a look at Figure 3.47A. A custom gradient has been established to the presets by clicking the New button. This gradient will start from a white highlight, graduate toward a red hue, and then taper to transparency to create the effect of a glowing ball of light.

5. Figure 3.47B shows the upper portion of the gradient that finds the opacity of the color. The first point is given an opacity of 100%. Start the transparency falloff at the second point in Figure 3.47C, which shows the Opacity point at 91%. The last point to the right has been given a designation of 0% opacity or complete transparency.

6. With the Gradient tool still selected, select the Circular Gradient option from the Options bar. Now apply the gradient by clicking and dragging on a new transparent layer. You should have something similar to Figure 3.48.

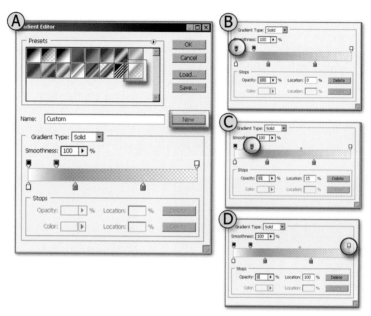

FIGURE 3.47 The Gradient tool options.

FIGURE 3.48 Create a circular gradient.

7. Take the gradient, transform it (Ctrl+T/Cmd+T), and place it over the areas of the train that will represent the different headlights. Use Hue and Saturation to alter the color of the gradient from red to yellow or orange. Create one large light on either side of the train and four smaller orange lights below the train's nose (see Figure 3.49).

FIGURE 3.49 Create the headlight flair.

8. Figure 3.50 shows several steps for creating the light beam from the main two light sources. Simply create a rectangular selection on a new layer so that the light source expands as it gets farther away from its source.

FIGURE 3.50 Create the headlights.

9. The light beam should have a feathered edge, so apply Gaussian blur to give this affect. Also, as the beam gets as farther away from the source, its intensity will dissipate, so apply a gradient mask to achieve this as shown in Figure 3.51.

10. To add more intensity to the source of the beams, select the Paintbrush, and paint on a blank layer with the Blend Mode set to Screen (see Figure 3.52).

FIGURE 3.51 Gradient mask applied to the light beams.

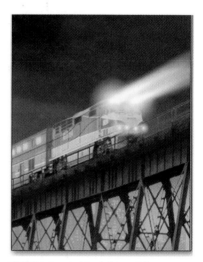

FIGURE 3.52 Add additional flare effects to the light beams.

11. Create a new layer group titled "poles." In this group, create two layers. The top layer will be for the foreground buildings, and the bottom layer will be designated to the background buildings. Using the Paintbrush, create a fine brush and paint some poles on the top of some of the skyscrapers (see Figure 3.53). To constrain the technique to move only on one axis to create a straight line, hold down the Shift key while you paint.

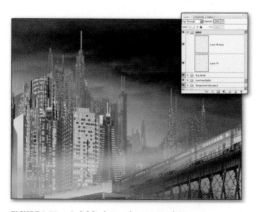

FIGURE 3.53 Add light poles to architecture

12. Use one of the point lights used for the headlights of the train to be placed on the tips of the poles. Remember to use Free Transform to make them small enough to appear as if the light sources are far in the background. In addition, use the Hue and Saturation command (Ctrl+U/Cmd+U) to change the colors.

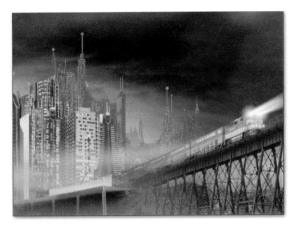

FIGURE 3.54 Place lights on the top of the poles.

Adding Finishing Touches to the Atmosphere

Too many of the colors in the image are too independent, which fights against the homogenous characteristic of the final image. Let's give the image some color effects to further accentuate the atmosphere.

13. Create a new layer, and fill it with grayish red. Bring down the Opacity setting to around 28%, and leave the Layer Blend mode at Normal (see Figure 3.55).

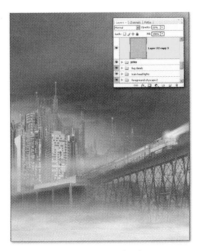

FIGURE 3.55 Create a color layer.

14. Apply a layer mask to the new color layer, and edit the mask so that the effects are greatest in the areas around the train (see Figure 3.56).

15. Add a Color Balance adjustment layer, and alter the settings in favor of Cyan (see Figure 3.57).

FIGURE 3.56 Apply the mask to the color layer.

FIGURE 3.57 Create a Color Balance adjustment layer.

16. Create a gradient with blue as a foreground color and 100% transparency as the ending color (see Figure 3.58). Duplicate and position the gradient in the lower and upper portion of the composition. This technique helps focus the viewer's attention toward the moving train.

17. The train needs extra contrasts, so apply a Curve adjustment layer to increase the contrast, and then apply the technique only to the train by filling the mask with black and painting the effects with white (see Figure 3.59).

18. To add a little more drama to the sky, create the levels adjustment layer to intensify the contrast and giver richness to the middle tone detail (see Figure 3.60).

19. The reddish hue of the sunset could use a little more pop. Apply the Selective Color adjustment layer, and select reds from the Colors drop-down menu as shown in Figure 3.61. Intensify the red by bringing down the cyan and increasing magenta, yellow, and black. Experiment with these settings to find something satisfactory to you.

FIGURE 3.58 Apply a bluish gradient.

FIGURE 3.59 Add the contrast to train.

FIGURE 3.60 Apply the Levels adjustment layer.

FIGURE 3.61 Apply the Selective Color adjustment layer.

20. The reddish background of the sunset will spill some reddish highlights on the edges of the building, so apply a Curves adjustment layer, and select Red from the Channel drop-down list as shown in Figure 3.62. Place a point in the center line, and pull it up toward the top left to throw the image into a reddish hue.

FIGURE 3.62 Apply the Curves adjustment layer.

21. Fill the mask with black to block out the Curve adjustment layer effect. Use the Paintbrush to paint in the effects on the edges of the skyscraper as shown in Figure 3.63.

FIGURE 3.63 Apply the Curves adjustment layer to the edges of the skyscraper buildings.

USING HDR AND SMART OBJECTS TO COMPOSITE PHOTOS

You will use two different photographs in this section: a sunset and a processing plant. You will start by building the backdrop using a series of exposures of a single image to achieve a greater dynamic range using the new HDR Merge (High Dynamic Range).

The problem with digital cameras is that you are limited to 8 bits of information. If you have seen a well-printed black-and-white print such as an Ansel Adams print, then you know that the brilliance of his photographs comes not only from his skill as a photographer and visionary but also from the ability of the silver in the negatives and papers to render an infinite range of grays. Adams was able to produce work with an extremely wide range of tonal grays and manipulate them to his artistic vision.

Most current digital cameras work optimally with a maximum range of 256 shades of gray. HDR Merge provides a workaround that ensures that you have proper information in the shadows and the highlights using a series of bracketed images, and it allows you to extend the amount of tonal information in a single file to 32 bits. In fact, the final file can be exported in 8 bits, 16 bits, or 32 bits.

That is the technical part of this exercise. Next, you will create the main subject in the foreground using a series of duplicates of the processing plant. However, you will give it a little different creative spin.

ON THE CD

1. Open Adobe Bridge (File > Browse), and navigate the CD-ROM to Tutorials/ ch 3 to preview the work imagery.
2. Bridge will give you a thumbnail of all the images in this folder. Select sunset 001.tif to sunset 005.tif, as shown in Figure 3.64.
3. In the Adobe Bridge menu, select Tools > Photoshop > Merge to HDR.
4. The images that are about to be merged were scanned with a Nikon 8000 at one-stop exposure increments, meaning each one was given double the exposure of the previous, which can give a nice 4000 ppi scan. If these images were taken with a digital camera, you would not get the Manually Set EV dialog box, as shown in Figure 3.65. The HDR Merge command does not understand what exposures were used with each of these images because they were scanned with a professional scanner, and there is no metadata embedded in the files. Most scanners do not embed aperture and shutter speeds since none are used in the creation of the digital file. So the program asks you to organize the exposure hierarchy manually.

FIGURE 3.64 Adobe Bridge layout.

FIGURE 3.65 The Manually Set EV dialog box.

5. Each file was given a one-stop exposure adjustment with the exception of `sunset 005.tif`, which was given two stops less exposure from `sunset 004.tif`. This was done to favor more details in the highlights. In essence, the shaded areas will look very dark, but the brighter areas will have the texture and detail that is appealing for sunset shots. Set the shutter speeds to reflect one-stop increments.

6. When finished, click OK.

7. You should now see the main HDR interface where you can make adjustments to merge the high and low tones. The greatest issue with 8-bit images is the lack of dynamic range, that is, the lack of the current camera's capability to record a large number of colors and tones. This interface allows you to fake the process of gaining greater dynamic range. By recording a series of images that will record extreme shadow detail as shown in `sunset 001.tif` toward images that give you great detail in the highlights as shown in `sunset 005.tif`, Merge to HDR will merge all of the images in such a way that you will not lose detail in either the shadow or highlight regions.

8. On your left, note the series of images that you loaded in. The center preview image is the result of the merged data. The histogram allows you to make subtle adjustments as well

9. Above the histogram, you have the option to allow it to export the file as an 8-bit, 16-bit, or 32-bit format. Select the 32-bit option so that you can maintain as much information as possible when you commit your changes (see Figure 3.66).

FIGURE 3.66 Bit depth options.

10. Uncheck the top image to see what happens. Because you deselected the image that supplied most of the luminosity, the preview goes slightly darker (see Figure 3.67A and B).

11. Reselect the top image, and deselect the last one to see what happens. Did you see the preview get brighter? Because you deselected the image that supplied most of the density, the preview is brighter (see Figure 3.67B).

12. Now deselect both the first and the last image properties to see the outcome. Notice that with both extremes uninvolved, the resulting preview is dominated with mostly midtones and brighter values (see Figure 3.68A).

FIGURE 3.67 A) First view is deselected. B) Last view is deselected.

FIGURE 3.68 A) First and last view are deselected. B) Last view is deselected.

13. Make sure that all of the thumbnails are selected, and focus on the histogram to the right. Slowly move the slider to the left so that you can see where the tonal information of the image is shifted (see Figure 3.69B).
14. Next, move the slider to the right and notice how the tones are shifted to the lower tonalities, as shown in Figure 3.69.
15. The richer result works great for the background since you are trying to portray depth, so click OK.
16. After committing the changes, look on the lower-left corner of your file. Photoshop CS3 gives you a slider to allow you to adjust the density in your 32-bit image (see Figure 3.70A). If you pull to the right, your image will become brighter as shown in Figure 3.70B; if you pull to the left, the image will become denser as shown in Figure 3.70C.
17. Change the image to 8 bits by accessing Image > Mode > 8 bit. You will see the HDR Conversion panel, as shown in Figure 3.71, which will give you options for making subtle contrast adjustments before it converts the file to 8 bits of information. So make sure that you save your file under a different

FIGURE 3.69 Tonal information of the image is shifted.

FIGURE 3.70 HDR conversion sliders.

name such as "sunset 8bit" to preserve your original 32-bit file. Printers and software packages are quickly adapting to the need for higher dynamic range, so think toward the future and save as much information as possible.

FIGURE 3.71 HDR Conversion panel.

18. The controls seem limited at first, giving you only Exposure and Gama compensations, but look at the lower-left corner and notice another option called Toning Curve and Histogram, as shown in Figure 3.72. Click on the dropdown arrows to view additional editing options. You now have the histogram in combination with Curves. You also have a visual layout of the 256 shades of gray listed in the lower window, representing absolute black to absolute white. Take a look at the higher tones of gray, and notice that the mound in the graph is much higher above those grays. The higher the mound, the more information exists for that particular gray.

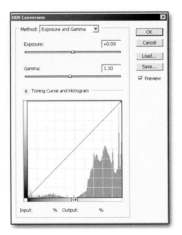

FIGURE 3.72 Toning Curve options.

19. By clicking on the diagonal line, you will apply a point that you can drag to make changes to any of the grays in your image. If you shift higher, they will become brighter; if you shift lower, they will become darker.

It is necessary to alter the file to 8 bits of information because most of Photoshop's functions are not available in 32-bit mode.

20. In the expanded view, you have the curves that are related to several presets under the Method menu. Click on the drop-down menu to view each setting. Exposure and Gamma is the first option available to you (see Figure 3.73A). Highlight Compensation shifts the tones to favor brighter highlights, as shown in Figure 3.73B. Equalize Histogram balances the tones to favor acceptable highlight and shadow detail (see Figure 3.73C).
21. Unlike the other presets, the Local Adaptation allows you to edit the curve to achieve the tonal results of your choice. Figure 3.73D shows the results of the preset before you make changes to it.

FIGURE 3.73 A) Exposure and Gamma. B) View of Highlight Compensation. C) View Equalize Histogram. D) View of Local Adaptation.

22. Add points by clicking on the curve just as if you were working in the Curves command, and adjust the tonal information in the image to your liking (see Figure 3.74).

This example keeps as much detail in the highlights as possible and allows the midtones to take on a rich tonality to prevent the sky from competing with the foreground image.

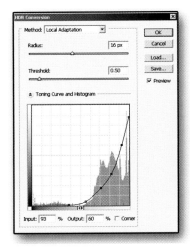

FIGURE 3.74 Click on the curve to adjust the tonal information.

CREATING THE FOREGROUND

It's time to start creating the foreground structure. This is where you will take one image and composite multiple copies to produce a much more interesting structure than the original.

ON THE CD

1. Using Bridge (File > Browse), navigate to the `Tutorials/ch 3 industrial` folder on the CD-ROM, and open `sunset architecture.tif`.
2. The first step is to create a mask so that the sky will go transparent and the structure remains. You will do this with the aid of your channels (Windows > Channels). Click on each channel to view their tonal properties and determine which one will give you the best tonal separation between the foreground and the sky.
3. After inspecting your channels, it's obvious that the blue channel gives the best results, so duplicate this one by clicking and dragging it on top of the new Channels icon, which is located to the left of the garbage can symbol on the bottom of the Channels Palette.
4. Access Curves (Image > Adjustments > Curves) to begin editing the tones in your image. The goal is to separate the tones so that the background is completely white and the foreground structure is solid black. From this, you will create your mask. Ctrl+click on the sky to place a dot on the curve that represents the position of that tone.
5. Ctrl+click on the pipe region to place a dot on the curve that represents that midtone position (see Figure 3.75).
6. Start with the center dot, and pull it straight down to the base to alter all of the midtone information into black.

FIGURE 3.75 Midtones are established on the curves.

7. Do the same for the highlights by dragging the top dot all the way up. As a result, the highlights will change to white (see Figure 3.76).

FIGURE 3.76 Midtones change to black and highlights are brightened.

8. Use Levels (Image Adjustments > Levels) to fine-tune your mask further, as shown in Figure 3.77. Don't forget to use the Paintbrush to edit the mask to completion if needed. There are no rules to how this is done. All that you are concerned with at this stage is producing a black-and-white image that will define your sky and foreground object.

9. Now invert the tones by pressing Ctrl+I so that the foreground elements are selected.

FIGURE 3.77 Completed mask.

Although there are many other ways to do this, the channels will provide you with the bulk of the information that you need to mask your shapes. So be patient; as you practice this approach, it will become a fast process.

10. Ctrl+click on your new mask to convert it into a selection. Make sure that you are in the Layers Palette (Windows > Layers), and click the Create Layer Mask button, which is the third button from the left on the bottom of the palette. This will create a mask to isolate the background (see Figure 3.78).

FIGURE 3.78 Inverted tones.

11. Add Hue and Saturation, Color Balance, and Curves. Adjust the layers to shift the blue saturated image toward a warmer color image.
12. You will use the results of this layer to create the new foreground architecture. To make the process easier, merge the three adjustment layers with the image by Ctrl+clicking on the right side of all four layers to select them. Access the Layers submenu, and click Merge Layers.

CREATING THE NEW ARCHITECTURE

To give the composition a vertical format, follow these steps:

1. Access Image > Canvas Size, and resize the canvas to 7.5 × 10 inches.
2. Starting with the merged layer, duplicate it and transform the new one by stretching upward about two-thirds of the way up into the image, as shown in Figure 3.79. Additionally, flip the canvas horizontally (Image > Rotate Canvas > Flip Horizontally).
3. Add a layer mask to the duplicate layer, and edit out portions of the image so that the result doesn't look too repetitive (see Figure 3.80).

FIGURE 3.79 Transform the new image by stretching upward.

FIGURE 3.80 Mask associated with the layer.

4. Duplicate the layer again, but this time, offset it slightly to the left, as shown in Figure 3.81.
5. Duplicate the top layer, but this time, change the Blend Mode to Hard Light (see Figure 3.82).
6. Duplicate the top layer again, and change the Blend Mode to Normal, but this time, move toward the bottom so that the peak tower appears just above the lower-right corner (see Figure 3.83).

ON THE CD

7. On the CD-ROM in the `Tutorials/ch 3 industrial` folder, open `background final.tif`, and place it below the architecture layers so that it fills the entire background. Use the Free Transform tool to achieve this (see Figure 3.85).

FIGURE 3.81 Offset the layer slightly to the left.

FIGURE 3.82 Duplicated layer's Blend Mode is set to Hard Light.

FIGURE 3.83 Duplicated layer's Blend Mode is set to Normal.

FIGURE 3.84 Duplicated layer's Blend Mode is set to Normal.

8. As a result of transforming each layer, pixel information beyond the borders of your composition is taxing on your RAM. Use the Crop tool to select the entire image, and press Enter on your keyboard to discard any unseen imagery. This will discard the unseen pixels beyond the borders of your image and therefore save memory.

FIGURE 3.85 Background placed below layers.

9. Next, you will give the image better perspective to help the viewer's eye travel from the foreground into the background. Make sure that the background sunset is still selected, and give it a little perspective. Use the Perspective tool (Edit > Transform > Perspective), and drag the points on the top corners apart from one another, as shown in Figure 3.86.

FIGURE 3.86 Applying the Perspective tool.

10. Open the `Tutorials/ch 3 industrial folder, select clouds.tif`, and place it above the background sunset layer. Next, change the blend mode to Multiply (see Figure 3.87).

FIGURE 3.87 Clouds placed above background layers.

11. The darker tones in the cloud image now dominate the background, giving the brighter region a little more detail and interest. However, the effect makes the top region a little muddy visually, so restrict the effect of this layer by adding a gradient mask. To accomplish this, add a standard layer mask, and make sure it is selected. Access the Gradient tool (G), and press the D key on your keyboard to make the foreground color black and the background color white. Place your mouse on the top edge of your canvas, and hold the Shift key to restrict the effect to one axis. Now drag your tool to the bottom edge of your page, and release the mouse. Your gradient mask will allow a subtle transition from no effect at the top portion of your background to the complete effect of the cloud layer in Multiply mode (see Figure 3.88).
12. Fine-tune your mask with the Levels command to restrict the span of the gradient (see Figure 3.89).

ADDING LIGHTS TO ARCHITECTURE

Now you will add some life to the refinery by adding structure lights and lighting details.

1. Start by creating a new layer and filling it with medium gray (Edit > Fill > Fill with 50% Gray).
2. Apply a Lens Flare of your choice to the medium gray layer, and change the Blend Mode to Hard Light.

FIGURE 3.88 Adding a gradient mask.

FIGURE 3.89 Levels applied to the gradient mask.

3. On the bottom of your Layers Palette, click the third icon from the right to create a layer group. Call this set "flares." Highlight the flares layer set and create another called "reds." This one will appear inside the flares layer set. Now drag your lens flare layer into the reds folder (see Figure 3.90).

FIGURE 3.90 Placing the Lens Flare.

4. Free Transform (Edit > Free Transform) the Lens Flare, and place it along the side of one of the towers, as shown in Figure 3.91.

FIGURE 3.91 Lens Flare transformed.

5. Hold down the Alt key, and with the Move tool selected, drag to duplicate the Lens Flare. Repeat the process and place Lens Flares throughout different locations of the architecture. All of the duplicated layers will appear in the reds layer set.

6. Merge all of the Lens Flares into one layer by selecting all of the duplicate layers. Access the Layers submenu, and click Merge Layers. After they are merged, make sure to change the Blend Mode back to Hard Light (see Figures 3.92 and 3.93).

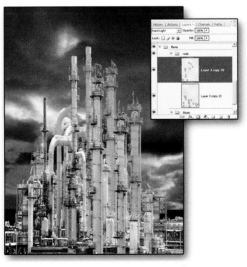

FIGURE 3.92 Lens Flare layers merged.

FIGURE 3.93 Lens Flare layers transformed.

7. Now we will create the fiery smoke extending to the sky. Follow steps 2 and 3 to create another Lens Flare. Use Free Transform to stretch the Lens Flare upward (see Figure 3.93).
8. Let's give it some motion and softness by adding some motion blur (Filter > Blur > Motion Blur), as shown in Figure 3.94.

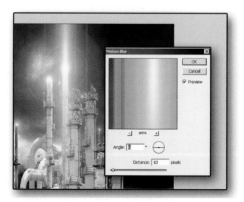

FIGURE 3.94 Adding motion blur.

9. Use the Perspective tool (Edit > Transform > Perspective) to distort the flare upward and out, as shown in Figure 3.95.

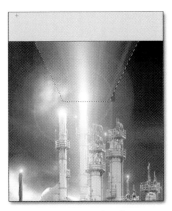

FIGURE 3.95 Distorting flare.

LOADING CUSTOM BRUSH PALETTES

In Chapter 1, you learned how to save Brush Palettes. Now you are going to load a custom brush palette.

1. Activate the Paintbrush, and expand the brush presets to view the variety of brush styles with their thumbnail views.
2. Click the black triangle in the top-right corner, and select the Load Brushes submenu. Navigate to the `Tutorials/Custom Brushes` folder, and load `Smoke Brushes.abr`.
3. Create a new layer above the architecture with a low Opacity of 12%, and then use Smoke Brush 4 from the Options bar to paint in your smoke (see Figure 3.96).

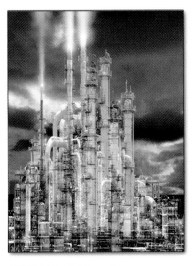

FIGURE 3.96 Add smoke.

GIVING THE SCENE A SENSE OF NIGHT

Creating a nighttime atmosphere for this scene not only gives it depth, but also it is an opportunity to allow the tower lights to jump forward.

1. Create a new layer set that is positioned above the architecture layers but below the flares layer set. Inside it, create a new layer and fill it with a rich blue of your choice.

2. Change the new layer's Blend Mode to Color Burn to get a beautiful blue overlay with rich deep shadows (see Figure 3.97). You will need to do some editing to the blue fill, so give it a layer mask as shown in Figure 3.98.

FIGURE 3.97 Layer filled with blue.

FIGURE 3.98 Layer mask applied.

3. The objective is to isolate the blue effect to the background. Since the architecture is on a series of layers, you will create a selection for each one for the purpose of editing the mask of the blue-filled layer. Ctrl+click on the first architecture layer to convert the object to a selection. Make sure that you are in the layer mask of the blue-filled layer, and fill the selection with black, as shown in Figure 3.99.

4. Repeat step 3 for all of the architecture layers. Don't forget to edit the mask with the Paintbrush to fine-tune it. Figure 3.100 shows the final results of the edited mask.

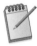

You could also Ctrl+Shift+click on each of the layer masks to select them all and then fill the blue-filled layer with black as well.

FIGURE 3.99 Layer mask edited.

FIGURE 3.100 Final result of the edited mask.

5. The next step is to create the blue effect for both the architecture and the background. Duplicate the blue-filled layer, and invert the tones of the mask (Ctrl+I), as shown in Figure 3.101.
6. Select the effect for the background, and reduce its Opacity to 41%. Select the effect for the foreground, and reduce its Opacity to 30% (see Figure 3.102).

FIGURE 3.101 Invert the tones.

FIGURE 3.102 Reduce the foreground opacity.

7. The architecture seems a little flat, so let's give it some contour. Duplicate the foreground color fill layer.

8. Apply the Minimum command (Filters > Other > Minimum) to the mask, and give it a radius of 28 pixels. This will shift the black inward to expose the lighter colors around the edges of the architecture and provide a rim lighting effect (see Figure 3.103).

9. The rim lighting effect is pixilated; therefore, it appears blocky around the perimeter of the architecture. Apply some Gaussian blur (Filters > Blur > Gaussian Blur) to the mask, as shown in Figure 3.104.

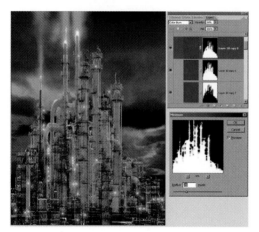

FIGURE 3.103 Minimum applied.

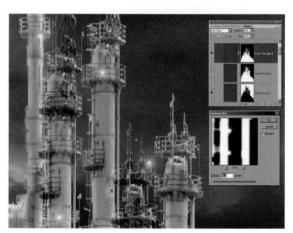

FIGURE 3.104 Additional Gaussian blur applied.

10. The image is taking on a more dramatic look, but it could still use a little more interest. Create a new layer beneath the two blue-filled layers. Fill it with a gradient of blue to gold starting from the top to the bottom (see Figure 3.105).

11. Click and drag the layer mask of the blue-filled layer above it, and drag it while holding the Alt key on top of the new gradient-filled layer. Your gradient layer now has the layer mask used to outline the architecture.

12. You want the gradient to be isolated to the back region of your scene, so make sure that the mask is selected by clicking it once and pressing Ctl+I to invert the tones. The result should be similar to that shown in Figure 3.106.

13. Now edit the blue-filled layer's masks with the Paintbrush to allow the fiery smoke to become more prominent (see Figure 3.107).

So far, everything looks great, but the rim lighting on the architecture could be a little more dynamic. Next, you will make modifications to enhance this area.

14. Start by merging all of the layers that make up the architecture image into one. Select the first architecture layer, and as you hold down the Shift key, select the last one. You have just selected multiple layers. Now hold down the Alt key, access the Layers submenu, and select Merge Layers. You have just merged the selected layers into a new layer without affecting the originals (see Figure 3.108).

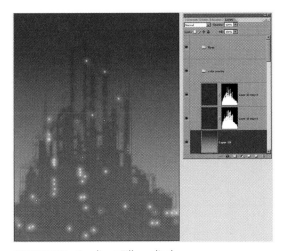

FIGURE 3.105 Gradient Fill applied.

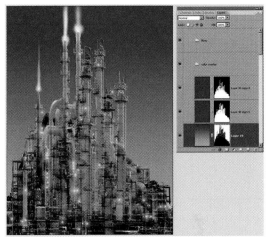

FIGURE 3.106 Selection applied to Gradient Fill.

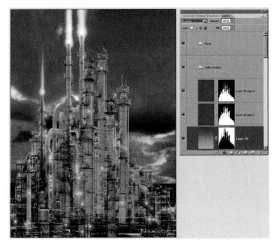

FIGURE 3.107 Mask applied to Gradient Fill.

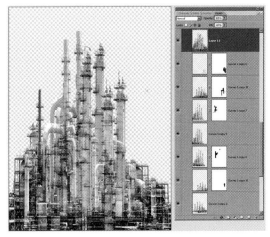

FIGURE 3.108 Merged architectural layers.

15. Change this new layer's Blend Mode to Color Dodge (see Figure 3.109).
16. Alt+drag on the mask that was used for the gradient fill on top of the new architecture layer. Then apply the Maximum command (Filters > Other > Maximum) to the mask. Give it a radius of 8 pixels to expand the white and decrease the black (see Figure 3.110). This places a stronger highlight around the architecture.

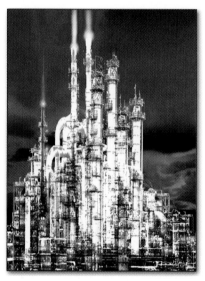

FIGURE 3.109 Color Dodge applied.

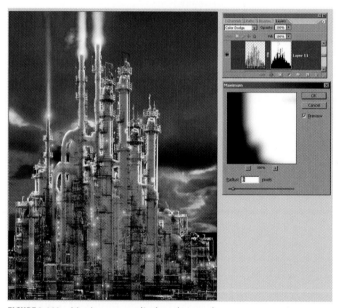

FIGURE 3.110 Maximum applied to the mask.

17. As before, apply a slight Gaussian blur to the mask to soften the effects of the Maximum filter (see Figure 3.111).

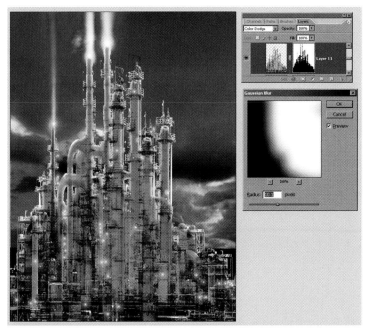

FIGURE 3.111 Gaussian blur applied to mask.

ADDING THIRD-PARTY FILTERS

Now you will add some finishing touches to give the image a little more visual inter-est by using Nik Color Efex Pro 2.0. Nik Software, the company that introduced Nik Sharpener, has some wonderful filters for Photoshop that cater to the photographic community. The newest is the Nik Color Efex Pro 2.0. Their filters are ideal for a situ-ation like this one—especially for the final enhancements: the Graduated Fog and the Color Stylizer Filter.

ON THE CD

1. Go to the CD-ROM, and install Nik Sharpener 2.0 and Color Efex Pro 2.0 from the Demos folder.
2. When it is activated, navigate to File > Automate > Nik Color Efex Pro 2.0, and a panel floats over the Photoshop interface listing all of the plug-in filters alphabetically. Select Graduated Fog. Experiment with the settings, and choose what you like best (see Figure 3.112).
3. In addition, select Color Stylizer. Experiment with these settings as well (see Figure 3.13A). Finally, Nik Color Efex Pro 2.0 gives you a layer with a mask that represents the changes you made with its filter. Reduce the Opacity of the Color Stylizer layer to allow some of the blue tones to come through (Fig-ure 3.13B).
4. With just two photographic images, you can produce some dynamic results. Practice and experiment to come up with your own challenges.

FIGURE 3.112 Graduated Fog panel.

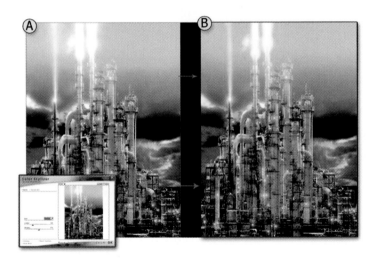

FIGURE 3.113 Final view of image after step 3.

WHAT YOU HAVE LEARNED

In this chapter, you have learned

- How to composite photographic imagery
- The practical uses of the new HDR Merge
- How to use smart objects
- How to use layer sets
- How to use Layer Blending modes
- How to use Free Transform and Distort for localized areas
- About the third-party filters to enhance your creations

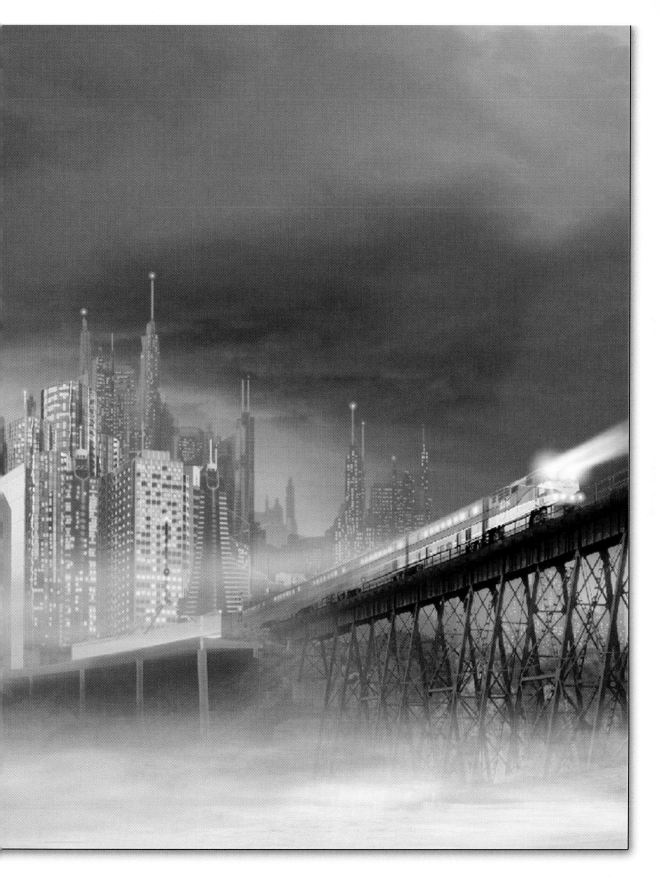

4 CUSTOM CREATED CONCEPTS

In this chapter you will learn:
- How to use the animated brush engine to custom create smoke effects
- How to use the animated brush engine to custom create debris
- FX tricks to create motion
- Stroke a path with animated brushes
- How to use Quick Mask to define shape

CUSTOM-CREATED METEOR FIELD

Working from photographic content is always less challenging than creating spontaneously because the image speaks to the artist to create in a certain direction. To create from scratch is always much more challenging. Not only do you have to come up with a theme, but you also have to render the shapes and textures that will be most convincing to the audience. There are many rendering approaches to consider. This chapter is intended to challenge you to create a meteor field that is convincing to the onlooker.

You will create the entire meteor scene from scratch with the exception of one image scanned on a flatbed scanner.

Whenever using the Cloud command make sure that the foreground and background color is what you want. Photoshop will use this to create the cloud effect.

1. Create two shades of brown, and fill the layer with a cloud pattern (Filter > Render > Clouds).
2. Apply difference clouds (Filter > Render > Difference Clouds) to this layer.

The handy shortcut Ctrl+F will apply the last filter.

3. Press Ctrl+F to apply the last filter three separate times. The goal is to gain an aggressive-looking texture (see Figure 4.1).

FIGURE 4.1 Difference clouds applied a third time.

4. Access the Channels Palette (Windows > Channels), and inspect the black-and-white images to determine which one has the most contrast. You will use this to create a displacement map. The highlight will display height, and the shadows will display depth. You will achieve this with the use of the Lighting Effects command. In this example, the Red channel gives you the most contrast (see Figure 4.2).

The Lighting Effects panel will use your channels and alpha channels to produce texture.

FIGURE 4.2 View of the Red channel.

5. Use a displacement map to create a textured surface that resembles a rocky surface. The Red channel will be the basis for creating this texture. In other words, the tonal information in the Red channel will be the basis for creating the peaks in the valleys of the meteor texture. You're going to create this with the aid of the Lighting Effects filter.
6. Not only will the lighting effects apply a variety of styles of lighting on the image, but also it will allow you to use the channels as well as alpha channels to render the texture. The highlight areas in the channel are going to create the peaks. The shadow detail in the channel will create the valleys in the texture.
7. Always duplicate your original texture layer just in case a mistake is made; it is easy to delete the working layer and duplicate the original layer to begin working again. So, duplicate your textured layer (see Figure 4.3), access the Layer submenu, and select Convert to Smart Object.

FIGURE 4.3 Duplicating the texture layer.

8. Now that the layer is a smart object, you can create Smart Filters in association with it. Once your object is in a nondestructive state or smart object, then any filter associated with it will also be committed to the same nondestructive mode of working and be displayed as a linked mask underneath the affected layer as shown in Figure 4.4.

9. Make sure that your smart object is selected and then access Lighting Effects (Filter > Render > Lighting Effects). Adjust the light source so that the light starts from the upper left and falls off in the lower right. Make sure that the Red channel is selected in the Texture Channel box. The tonal information will produce the textured effect w are looking for. Click OK. By applying a Smart Filter, you can now edit the texture independent from the object it is attached to.

10. Take a look at the rendered texture file. This will serve as the basis of the meteor texture (see Figure 4.4).

FIGURE 4.4 Result of Lighting Effects with Smart Filters.

11. Now give the meteor some craters with the use of Liquify. One of the disadvantages of working with smart objects is that you cannot edit the transformed image directly. Smart objects are basically two layers built into one. One image is the original maintaining all of the original pixel information, and the other is the transformed image. What you see on the canvas is that transformed image. However, Photoshop CS3 gives you the ability to edit the original image, which will update the transformed one. Since the Liquify command cannot be applied as a Smart Filter in this current version of Photoshop, you have to edit the original image. To do this, double-click on the smart object, which brings up the original texture image before you applied

Lighting Effects. Now apply Liquify (Filter > Liquify) to the original. Use the Forward Warp tool, the Bloat tool, and Liquify to create craters on your texture. You don't have to create craters over the entire pattern because you will use just a small part of this image. When you are done, commit true changes so that you have something that looks similar to Figure 4.5.

Although most filters can be applied as a Smart Filter, Liquify cannot. So it is necessary to edit the original image in your smart object to apply this command.

FIGURE 4.5 Liquify applied using the Forward Warp tool and the Bloat tool.

12. While still editing the original image, use your Lasso tool to create a rough outline for the first meteor. Press Ctrl+J to apply what's in the section to its own layer (see Figure 4.6). Turn off the background layer so that the only layer visible is the new meteor shape just created.

FIGURE 4.6 Meteor created.

13. Create more meteors in the same way on their own layers, as shown in Figure 4.7.

FIGURE 4.7 New meteors created.

14. When you create each meteor, don't forget to make the meteors into smart objects by right-clicking on each layer and selecting Group into New Smart Objects. Remember, resizing smart objects has no effect on the original resolution. Resize them so that the ones that you want to give the illusion of distance will be smaller and the ones that are coming forward will be larger (see Figure 4.8).

FIGURE 4.8 Smart objects applied.

15. When completed, select all of the layers by Ctrl+clicking/Cmd+clicking to highlight them simultaneously, and place them into their own layer group by accessing the Layers submenu and selecting New Group From Layers. Call the new group "meteors" just to be organized (see Figure 4.9).

FIGURE 4.9 Result of layer changes.

ON THE CD

16. From the CD-ROM, access `Tutorials/ch 4 meteor/stone-1.tif`. If you choose to photograph or scan your own stones, then use Quick Mask (Q) to select the rock's background to isolate it, as shown in Figure 4.10.

When using Quick Mask, it is often helpful to start with a basic selection using a Magic Wand on the background. When you activate Quick Mask, you will have an initial mask to work with so that your job of isolating the main subject from the background is easier.

FIGURE 4.10 Quick Mask applied to the background to isolate the stone.

17. Now go back to the Normal Selection mode (Q) to view the result, and drag the stone into the meteor layer group (see Figure 4.11).
18. Distort the stone to create the effect of the foreground going slightly out of focus due to extreme pixel enlargement. For this reason, do not commit it as a smart object. Use Perspective (Edit > Transform > Perspective) to simulate the stone extending into the foreground. This will become the planetary body that will be composed underneath the rest of the meteors (see Figure 4.12).

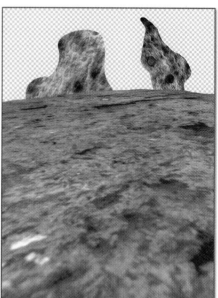

FIGURE 4.11 Stone dragged into meteor file.

FIGURE 4.12 Result of using Perspective.

19. Give the stone a texture with more of a surface relief to it. Access the Lighting Effects panel (Filter > Render > Lighting Effects), and apply the same lighting used for the initial meteor. Select the Red channel for your texture, and click OK (see Figures 4.13 and 4.14).

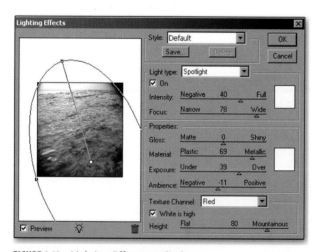

FIGURE 4.13 Lighting Effects applied.

FIGURE 4.14 Result of Lighting Effects.

20. Add some depth to the planet by establishing some very rich total detail with the help of the layer blend modes. Duplicate this layer, and set the Blend Mode to Multiply. Reduce its Opacity to around 75%. To get more control over layer positioning, place the planet layers into their own layer group titled "surface" (see Figure 4.15). Place this layer group below the "meteor" layer group.
21. Duplicate the planet layer again, and set the Blend Mode to Color Burn. Give it a layer mask filled with black, and edit it by painting with white to create the effect of deep crevices in the rock, as shown in Figure 4.16.

FIGURE 4.15 Blend Mode set to Multiply to create a new layer group.

FIGURE 4.16 Result of editing the mask.

22. Start with the larger meteor in the foreground, and duplicate it (Ctrl+J/ Cmd+J). Apply some Motion Blur to the layer (Filter > Blur > Motion Blur), as shown in Figure 4.17.
23. Create two new adjustment layers: Curves and Levels. Adjust the tonal information so that the deeper tones will dominate the image. Isolate these adjustments to the foreground meteor layer by holding down the Alt/Option key and clicking between the meteor layer and the adjustment layer.
24. Now edit the masks with your paintbrush to allow the peaks of the meteor to become more highlighted. Keep in mind that the light source will come from the rear; you will add that effect later (see Figure 4.18).

FIGURE 4.17 Motion Blur applied.

FIGURE 4.18 Add highlighting detail to meteors to create a stronger sense of texture.

25. Select the meteor layer in the top-left corner, and apply Liquify (Filters > Liquify) to give it additional crater detail, as shown in Figure 4.19.

FIGURE 4.19 Liquify applied.

26. Apply the Curves and Levels adjustment layers to enhance contrasts as well as the textures as you did in step 22. Be creative and don't be afraid to experiment with other tonal adjustments (see Figure 4.20).

FIGURE 4.20 View of Curves and Levels adjustments.

27. Apply the the same process to the meteor layer in the top-right corner of the composition (see Figure 4.21).

FIGURE 4.21 Applying the same process to the top-right meteor.

Now let's move on to creating the sun and the planet atmosphere.

ADDING THE LIGHT SOURCE

You have added lighting details on the asteroids, and now it's time to create the source from which the light emanates. To achieve this, you're going to use a system of gradients.

1. In the "surface" layer group, create a new layer (Ctrl+Alt+Shift+N/Cmd+ Option+Shift+N). Press G on the keyboard to select the Gradient tool. Click on the sample gradient in the Options bar to activate the Gradient Editor. You will see several thumbnails of sample gradients given to you by default in Photoshop. You're going to create and add a new gradient to your palette that will be used to create the sun in the upper-right corner of the composition.
2. Take a look at the gradient bar on the lower portion of the editor. You will see a series of nodes on the gradient line. The nodes below the gradient represent the colors that you will establish from one gradient to the next. The top nodes establish transparency, which is designated by 0% to 100% opacity settings. In this example, 100% opacity is established from the left to the center portion of the gradient. As you move to the far right, a transparency node of 0% opacity is established. In essence, this allows you to maintain solid color up

until the midpoint of the gradient, and then the yellow color toward the end will slowly fall off to complete transparency.

3. Place two node that represents pure white to the far left that will establish the inner core of the sun, and then place a node three quarters of the way toward the right that will represent the yellow glow of the sunlight.

4. When you're done, make sure that the Circular gradient option is selected on the Options bar. Click and drag a short distance to establish the circular highlight as shown in Figure 4.22. Place the sun in the top-right corner of your composition.

5. Apply Lens Flare to the medium gray layer, and change the Blend Mode to Hard Light.

6. Now it's time to create the atmosphere for the planet. Ctrl+click/Cmd+click on the planet to get a selection. Fill the selection with a light blue color. Add a mask to this layer so that the entire bottom portion is hidden and the top portion gradients to a solid blue toward the edge of the planet (see Figure 4.23). Use the Gradient tool on that mask to accomplish this using black as your foreground color and white as the background color.

FIGURE 4.22 Using the Gradient tool to create the sun.

FIGURE 4.23 Creating the atmosphere for the planet.

7. Since warm sunlight is coming from the sun, the yellow will shift some of the blue toward a slight greenish hue. Duplicate the blue layer with the gradient mask twice, apply Hue & Saturation to the color, and move the Hue slider until the blue becomes yellow. Next, edit the gradient so that the yellow color

provides subtle shading across the upper portion of the planet by applying Gaussian Blur at the various intensities to the layer mask (see Figure 4.24).

FIGURE 4.24 Yellow highlight applied to the planet.

8. Just to add a little visual interest to the planet, custom create some simple geometric shapes that will represent settlements on the planet surface. Select the circular marquee, hold down the Shift+Alt keys, and create a circular selection. Create a border from the circular marquee (Select > Modify > Border) with a thickness of 15 pixels as shown in Figure 4.25. Finally, fill the selection with white (Edit > Fill > Fill) as shown in Figure 4.25.

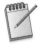

As a rule with resizing or moving objects in Photoshop, the Shift key constrains movements to one axis or constrains the proportions to prevent distortion. The Alt/Option key resizes from the center.

Step 6

1. Create a thin line on a separate layer using the rectangular marquee. Duplicate and transform the line to create a cross shape over the circle as shown in Figure 4.26A
2. Duplicate the circles, resize them, and place them at the ends of the lines as shown in Figure 4.26B. Select all of the layers, and place them in a new layer group called "station."

FIGURE 4.25 Create a circular selection and fill the border with white.

FIGURE 4.26 Create planetary detail.

3. To give the station a sense that we are looking down on top of it from a slight angle, use Free Transform to alter its shape. With the "station" layer group still selected, apply Free Transform to the shape, and skew it as shown in Figure 4.27A.

4. Open the layer group, select the lines, and apply the Warp tool to give them a slight bend that reflects the curvature of the planet's surface. When you're finished, select the layer group, hold down the Alt/Option key, and select Merge Layer Group. This will merge all of the contents inside the layer group into its own layer without affecting the group itself (see Figure 4.27C).

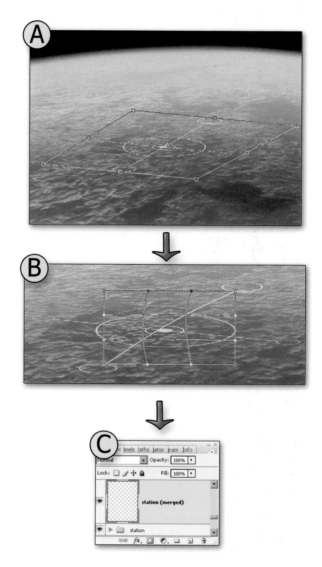

FIGURE 4.27 Alter and merge the station group.

5. To make the shape look as if it's sitting on the ground, you need to give it a base to set on. Ctrl+click/Cmd+click on the merged station layer to get a selection of the shape. Access Filter > Modify > Expand, and set the expansion to 10 pixels (see Figure 4.28A). Create a new layer, and make sure that you place it beneath the station. Fill this layer with black (see Figure 4.28B).

6. Go back to the station layer and double-click on it to open the Layer Styles dialog box. Give the station a slight 3D effect by selecting the Bevel and Emboss check box and the Drop Shadow check box under Styles (see Figure 4.29).

FIGURE 4.28 Create a base for the station.

FIGURE 4.29 Apply layer styles to the station.

7. Now go back to the station base, and apply the settings shown in Figure 4.30. The platform of the station needs a sunken effect, so three layer effects are applied: Inner Shadow, Stroke, and Gradient Overlay. For the Gradient Over-

lay, take a darker and lighter green selected from the planet itself. Gradient the colors so that the lighter area begins to the rear of the shape, and the darker color ends the shape. To make things easier, merge the station and platform toward the front.

FIGURE 4.30 Apply layer styles to the station platform.

8. To make it easier to manage both the station and the platform, duplicate the station and place it throughout different sections of the planet (see Figure 4.31). Since the planet will be covered with much atmosphere, you don't need to put too much detail into it. Just use the station to add a sense of interest to the background.

FIGURE 4.31 Duplicate and place the station on the planet surface.

USING THE LENS BLUR COMMAND TO CREATE DEPTH OF FIELD

To guide the viewers in and around the composition, you will use depth blurs to soften the focus of the objects farther away from the camera lens. The two meteors that need the greatest blur include the one near the sun and the one in the lower-left corner of the frame. This will be accomplished with the use of a depth map. The *depth map* determines the focal point based on tonal grays in an Alpha channel. We will use the Lens Blur command with the aid of a depth map to establish the scene. All s depth of field.

So let's create a new alpha channel to be used as a depth map to establish the locality of the blur:

1. Go to the Channels Palette, create a new alpha channel, and inverse it (Ctrl+I/Cmd+I) to get white as the overall color.
2. Merge all of the meteorites into one layer. Lens Blur will not work as a Smart Filter in this version of Photoshop, so you must apply the effects directly to the object on a layer (see Figure 4.32).
3. Ctrl+click/Cmd+click on the merged meteorite layer to get your selections. Go to the Channels Palette, and create a new alpha channel, which in this example is called Alpha 2. Edit the alpha channel with the use of your Paint Bucket to fill each shape with varying shades of gray. The two foreground meteors should take on darker shades of gray to differentiate them from the two in the background. Although the two in the foreground should have a darker shade than the ones in the background, make each one a slightly different shade to give the appearance that they are in different locations in space.

FIGURE 4.32 Create a depth map to be used in Lens Blur.

4. Activate Lens Blur (Filter > Blur > Lens Blur). In the Depth Map section, select Alpha 2 from the Source drop-down list (see Figure 4.33). Figure 4.34 shows a view of the Lens Blur dialog box with all settings set to zero.

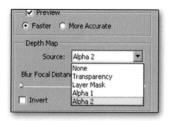

FIGURE 4.33 Select the Alpha 2 depth map.

FIGURE 4.34 View of the Lens Blur dialog box.

5. The results from step 4 are too harsh. Add some subtlety by increasing the brightness of the mask so that you will get the effect of different densities of fog in the background as well as in the foreground, as shown in Figure 4.35.

FIGURE 4.35 Brighten the mask.

6. Pull the radius slider to the right to apply the blur effect. Figure 4.36 shows the effect on the background meteorites.

7. Adjust the Blur Focal Distance to determine which one of the objects will receive the blur the most (see Figure 4.37).

FIGURE 4.36 Adjust radius.

FIGURE 4.37 Adjust the Blur Focal Distance slider.

8. Continue to adjust your settings so that the two foreground meteors are in sharper focus than the ones to the rear (see Figure 4.38).

FIGURE 4.38 Fine-tune your settings.

9. Now play around with your specular highlights as shown in Figure 4.39. This feature will come in handy especially if you're using photographic imagery with reflective subject matter. The Noise setting is also provided for instances when you are using high speed ISOs on your digital camera or fast-speed film, and you want to stay consistent with the grainy quality.

FIGURE 4.39 Adjust Specular Highlights.

10. Add a light streak effect as a compositional element to guide your viewers toward the rear of the image to give it a greater sense of depth. Start by creating a new layer and fill it with white. Adjust the Opacity to 77%, then associate a layer mask with this layer, and edit the mask as shown in Figure 4.40 to create the streaks that will come out toward the viewer.

FIGURE 4.40 Lens Blur final image.

CUSTOM-CREATED TORNADO

In this section, you'll use a custom-animated brush that you will create from scratch to create most of the tornado effects. Once you understand the Brush Palette, what you can create is limited only by your imagination. *Photoshop CS Trickery and FX* introduced the animated engine to create smoke. Now you will use the tool more extensively to create several brushes to produce the tornado scene.

1. Open a new layer that is 2 × 2 inches with a resolution of 200 ppi. You will use this new file as your scratch pad to create your custom brushes. Make sure that your Paintbrush tool is selected. Create a new layer, and paint a smoke shape in a circular pattern on this layer (see Figures 4.41 and 4.42).

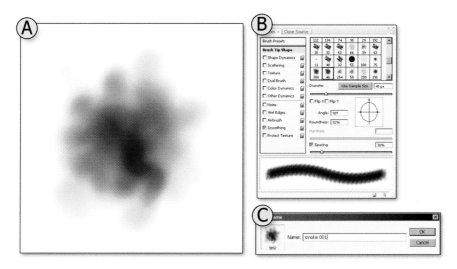

FIGURE 4.41 Create a new layer and initial brush pattern.

FIGURE 4.42 Continue to edit the smoke pattern.

2. Create a new brush from this shape (Edit > Define New Brush Preset). Call it what you like, for example, "Smoke 001" (refer to Figure 4.41C).

3. Take a look at your Brush Preset options (Windows > Brushes). This gives you a visual of what the stroke will look like when it's applied to the canvas. Let's make some changes (see Figure 4.43).

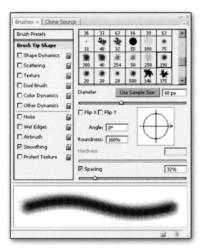

FIGURE 4.43 Brush Presets.

4. Click the Shape Dynamics box to view options for changing the size of the brush over the length of the stroke. Adjust them to get something like that shown in Figure 4.44, and do the same for Scattering. Remember to experiment. These are only suggestions.

FIGURE 4.44 Scattering.

The Shape Dynamics option is great for adding a sense of animation to your brush shapes.

5. The Color Dynamics option will blend the foreground and background colors as you paint over time. Use of this option is very helpful for smoke-like atmospheres. Since the colors that you will be working with are shades of gray, you only need to adjust the Foreground/Background Jitter and Brightness Jitter. Take note that there is no visual update for this. You will have to paint on the canvas to view the results.

6. Tell the program to use the WACOM pen's pressure to apply opacity. If you don't have a WACOM pen, you can still achieve these effects by manually adjusting the Opacity slider on the Options bar (see Figure 4.45).

7. After you create the new dynamics for the brush, save it as a new brush or you will lose it when you close Photoshop. Access the submenu, and click New Brush Preset.

8. Delete the original brush shape, and paint with the new one in a circular pattern using the new Tornado Smoke 001 brush as shown in Figure 4.46.

FIGURE 4.45 Apply Other Dynamics.

FIGURE 4.46 Brush test used in step 7.

9. Now define this shape as a New Brush Preset, and call it Tornado Brush2. Give it the same dynamics as the Tornado Smoke Brush 001.

10. Delete the original brush shape on the layer, and paint with the new Tornado Brush 2 in a circular pattern as shown in Figure 4.47.

11. Give this the same dynamics as the Tornado Brush 2, but this time, open the Dual Brush dialog box and select the Tornado Smoke Brush 001. Now the brush places two different brush dynamics into one. Adjust your scattering to become a little tighter to give you more control (see Figure 4.48). Save this as a new brush called Tornado Smoke Brush 003.

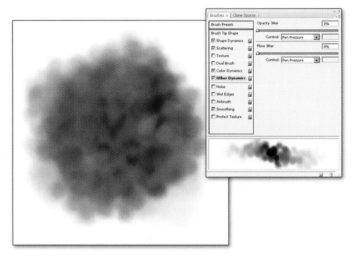

FIGURE 4.47 Brush test used in step 10.

FIGURE 4.48 New brush scattering adjusted.

Starting the Tornado

Now that all of the brushes are defined, let's develop the funnel of the tornado.

1. Create a new file that is 10×12 inches at 300 ppi. Make sure that the Paintbrush is selected, and paint a smoke pattern over the entire image, as shown in Figure 4.49.

FIGURE 4.49 Paint image with smoke pattern.

ON THE CD

There are some custom brushes on the CD-ROM in the `Tutorials/Custom Brushes` *folder that you can use instead of creating your own. Load* `Tornado Brushes.abr`*, if you prefer to use our premade brushes.*

2. Change the brush blend mode of the brush to Multiply, and paint a series of vertical darkened cloud streaks as shown in Figure 4.50.

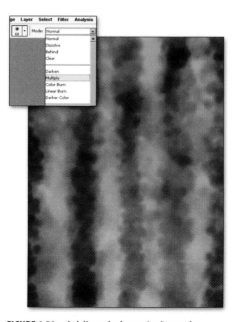

FIGURE 4.50 Adding dark vertical streaks.

3. Apply the Twirl filter (Filter > Distort > Twirl) to the layer to start the funnel shape.

4. In the `Tutorials/ch 4 tornado` folder on the CD-ROM, open the `road & sky.tif` image and drag it into your tornado file. Resize the image to fit the entire screen. Place this image into a layer set called "road and sky" underneath the Tornado layer.

5. Use the Transform command (Ctrl+T) to truncate and offset the beginnings of the tornado shape into the sky portion of your image. Use Figure 4.51 as a guide.

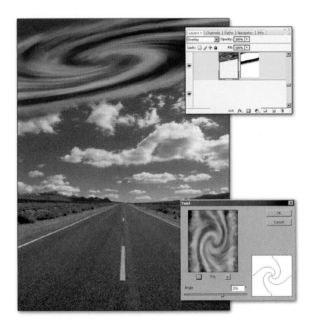

FIGURE 4.51 Twirl Filter and Transform applied.

6. Create a new layer. On this layer, reduce the size of your brush using the bracket key ([), and paint smaller cloud patterns while following the shapes of the twirl. Place both of these layers into a new layer set called "Tornado" (see Figure 4.52).

7. Repeat step 6, and change the Blend Modes from Multiply to Lighten to build contour to the shape, as shown in Figure 4.53.

8. Next, add a sense of wind effects. Duplicate the current layer (Ctrl+J) to apply the next effect to it. Use the Elliptical selection tool to outline the cloud shape. Add a Radial Blur with a slight zoom. Figure 4.54 shows the result of the Radial Blur.

9. Duplicate this layer, and add some more cloud detail as you did in step 6. If necessary, add layer masks to assist you in shaping your image.

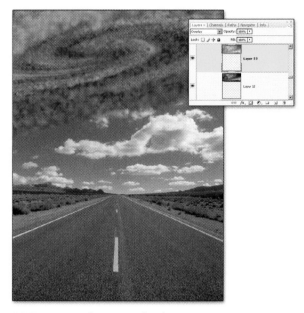

FIGURE 4.52 Twirl pattern edited.

FIGURE 4.53 Final twirl contour.

FIGURE 4.54 Result of the Radial Blur.

Adding the Tail to the Tornado

You will now add the custom paintbrush effect to a defined path using the Pen tool. This shape will be edited to define the shape and feel of a tornado tail.

1. Select the Pen tool on the toolbar and apply a shape that starts from the center of the twirl and ends near the midsection of the road.
2. Select the Paintbrush again. You should still be using the last brush that you used to created the cloud swirl. You can use this one for the tail as well. Place your brush along the path near the center of the swirl. Adjust the size of the mouse to match the size that you want the tail to be using the bracket keys ([and]) (see Figure 4.55).

FIGURE 4.55 Adjust the size of the mouse.

3. Take a look at the Path Palette (Windows > Path), and locate a series of icons in the lower section. Click the second icon from the left to stroke the path with the brush dynamics.
4. Figure 4.56 shows the result of the stroke that you have just applied. You can experiment using some of the other custom brushes. In fact, apply a variety of the custom brushes on top of each other, and view how they blend with one another.
5. Use the Perspective tool (Edit > Transform > Perspective) as shown in Figure 4.57.
6. Use the Shear command (Filter > Distort > Shear) to add more flow to the tail (see Figure 4.58).
7. Apply a layer mask to the tail to shape it. Press the \ key to change the mask to a Quick Mask, and then view and edit the shape using the Paintbrush.

Insisting on absolute control in the early stages can stagnate the creative process and can keep you from seeing alternative approaches. Work fairly loose in the beginning and later allow alternative possibilities to complete your final vision.

8. Remember, to add to the red mask, you paint with black, and to subtract from the mask, you paint with white. Figure 4.59 shows the finished result. Press \

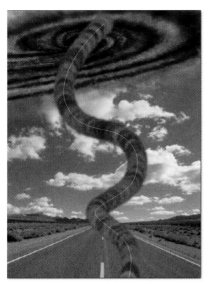

FIGURE 4.56 Result of the outline.

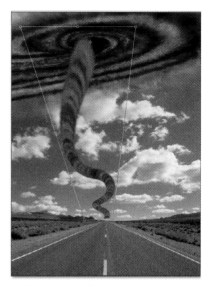

FIGURE 4.57 Apply Perspective.

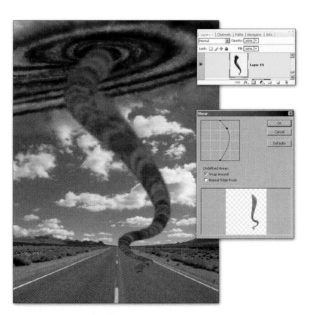

FIGURE 4.58 Apply Shear.

again to return to the Normal view. At this stage, the shape is a basic "S" curve. Natural tornados have many variations, however. Some have funnels that are very linear and thin, and others have funnels that are fat and short. Try not to place too much effort in getting the perfect shape because later you are going

to transform it into a modified curve. Often we spend too much time trying to control the creative process because we are too attached to our creative technique. For now, simply use the mask to paint in the basic shape of your choice.

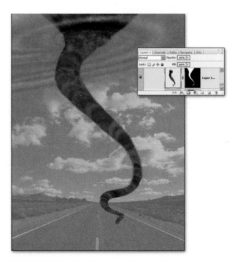

FIGURE 4.59 Final result of step 8.

9. Moving forward, duplicate the tail layer and add some noise. This is necessary for the next step (see Figure 4.60).

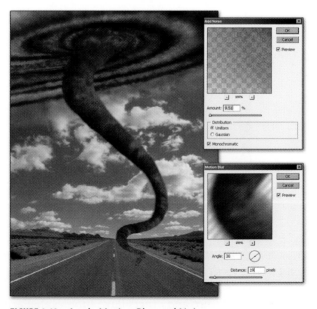

FIGURE 4.60 Apply Motion Blur and Noise.

10. Apply Motion Blur (Filter > Blur > Motion Blur), and match the angle shown in Figure 4.60. As you can see, the noise from the previous step helped to give the blur some textural grooves.
11. Create a new layer, and apply some dust effects around the tail with the smoke brushes (see Figure 4.61).
12. Create another layer, and apply the same effects to the foreground of the swirl. Additionally, add some Motion Blur to simulate the rotating motion (see Figure 4.62).

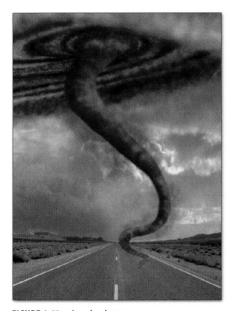

FIGURE 4.61 Apply dust.

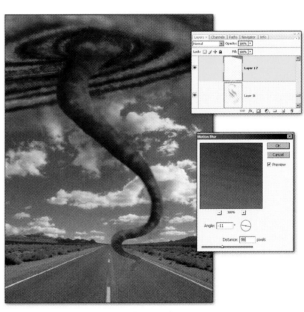

FIGURE 4.62 Apply dust to the swirl.

13. Select another custom brush, and on another layer, apply cloud effects on the background of the tornado. Use a small brush size to achieve this since anything in the background will appear smaller. Now, just as you did in step 12, apply Motion Blur to accentuate the theme of movement (see Figure 4.63).
14. Duplicate this layer twice, and change the Blend Mode to Darken to obtain a deeper tonality that will portray a greater sense of depth (see Figure 4.64).
15. Select all three of the layers and merge them, as shown in Figure 4.65.
16. Access the CD-ROM, and open `Cloud 01.tif` from the `Tutorials/ch 4 tornado` folder.
17. Place this image into the road and sky layer group above the road and sky image.

ON THE CD

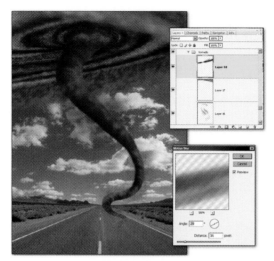

FIGURE 4.63 Apply Motion Blur.

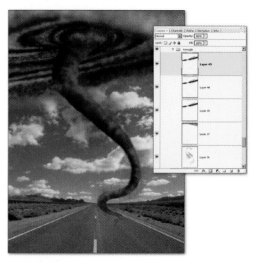

FIGURE 4.64 Duplicate layers.

FIGURE 4.65 Result of merging.

18. Press Ctrl+T to resize your clouds a bit larger (see Figure 4.66).
19. Turn off the Tornado layer set so that you will have fewer distractions for the next steps. Apply the clouds only above the horizon on the mountain range. Use Quick Mask to achieve this (see Figure 4.67).
20. When completed, apply this as a layer mask to the cloud image (see Figure 4.68).

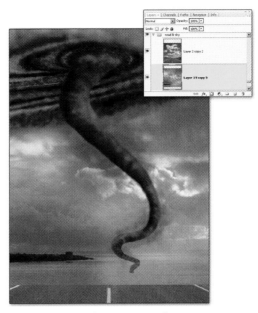

FIGURE 4.66 Cloud image resized.

FIGURE 4.67 Quick Mask applied.

FIGURE 4.68 Layer mask applied.

21. Turn on the Tornado layer set to view the results, then duplicate the Cloud layer, and add noise (see Figure 4.69).

22. Add some Motion Blur (see Figure 4.70).

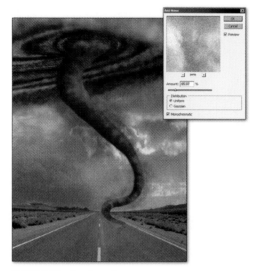

FIGURE 4.69 Apply noise.

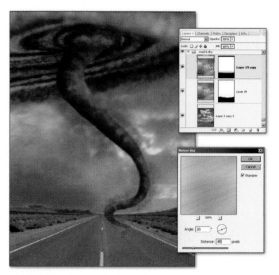

FIGURE 4.70 Apply Motion Blur.

23. Add a Gradient Mask to the Motion Blur to allow the effects to become isolated to the foreground of the image, as shown in Figure 4.71.

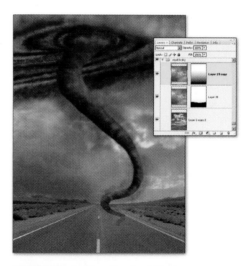

FIGURE 4.71 Apply a Gradient Mask.

Adding Ground Effects

When the tail of the tornado touches the ground, it whips up an aggressive display of dust twirling around the tip of the tail. You will use some of the elements that you have already created to achieve this effect.

1. Select one of the spiral effects in the Tornado layer set, and duplicate it. Place it on top, and then rotate it and place it at the base of the tail (see Figure 4.72).
2. Place an oval selection on it, and apply a Zoom Radial Blur (see Figure 4.73).

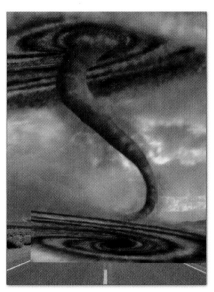

FIGURE 4.72 Rotate spiral effect layer.

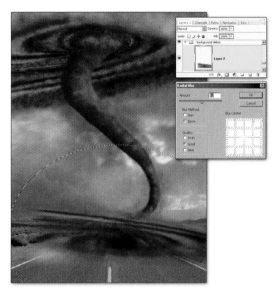

FIGURE 4.73 Apply a Zoom Blur.

3. Use Distort (Edit > Transform > Distort) to force the fringed tips upward (see Figure 4.74). Figure 4.75 shows the end results.

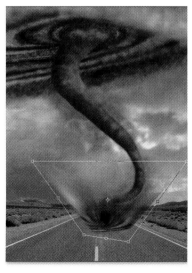

FIGURE 4.74 Apply Distort.

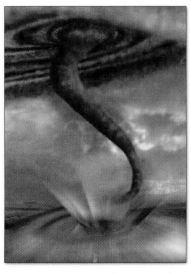

FIGURE 4.75 Apply Mask to Zoom Blur.

Adding Debris

The ground effects are complete, so let's add some debris to our scene.

You will create another custom brush for the debris. This will assist you with making a selection to create the debris from the road image.

4. Create the basic shape of your debris, and define it as a brush preset with scattering and sizing options turned on (see Figure 4.76).

FIGURE 4.76 Debris effect defined.

5. Turn off all of the layers except the road and sky layer, and create a new layer above it. Paint with black on the road location. Ctrl+click on this layer to create a selection of the brush pattern you have created (see Figure 4.77).

FIGURE 4.77 Debris applied.

6. Select the road layer, and press Ctrl+C to copy and Ctrl+V to paste its information into a new layer (see Figure 4.78).

7. Turn on the other layers, and place the new Debris layer into its own layer set. Title it "Foreground Debris" (see Figure 4.79).

FIGURE 4.78 Copy and paste debris.

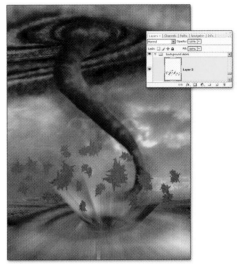

FIGURE 4.79 Foreground Debris layer set.

8. Flip this layer vertically (Edit > Transform > Flip 90 Degrees CW), and add Motion Blur (see Figure 4.80) and Shear to give the illusion that the debris is rotating around the tornado. Shear only works vertically. This is why it was necessary to flip the debris.

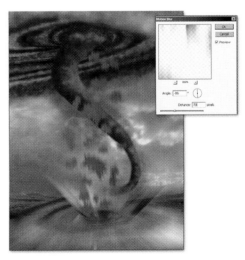

FIGURE 4.80 Add Motion Blur.

9. Use Distort to create depth from the background to foreground, as shown in Figure 4.81.

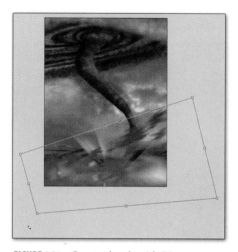

FIGURE 4.81 Create depth with Distort.

10. Double-click on the right empty portion of the layer to bring up the Layer Effects dialog box, and then add Bevel and Emboss. Experiment with these settings to achieve a 3D effect. When you are finished, increase the contrast using levels (see Figures 4.82 and 4.83).

FIGURE 4.82 Add Bevel and Emboss.

FIGURE 4.83 Apply levels.

1 1. Adjust the scattering on the Debris brush so that it is tighter, and reduce the brush size for the background debris. Paint some debris vertically down the center to give the image a slightly circular shape

1 2. When you are done, give it a vertical motion blur, as shown in Figures 4.84 and 4.85.

FIGURE 4.84 Paint debris.

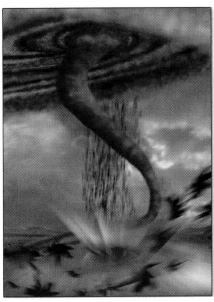

FIGURE 4.85 Add Motion Blur.

13. Use Transform (Ctrl+T) to reposition the debris horizontally along the base of the tail (see Figure 4.86).

14. Duplicate the layer, resize the debris, and place them into the scene. This will not only add more debris but also will offset it. Use layer masking to blend them with the rest of the scenes so that they are not too visually dominating (see Figure 4.87).

15. Add a little more form to the funnel of the tornado. Select the Smudge tool, and under Mode, choose Lighten on the Options bar.

16. Select one of the texture brushes, and turn off all of the dynamics so that you can apply the Linear Smudge stroke. Smudge the lighter tone into the darker ones to accentuate motion and texture (see Figure 4.88).

17. Select several portions of the funnel, and apply more Motion Blur, but apply the angle according to the direction of the funnel, as shown in Figure 4.89.

18. Let's add an explosive effect to the base of the funnel. Select the Shape tool, and make an oval horizontal ellipse.

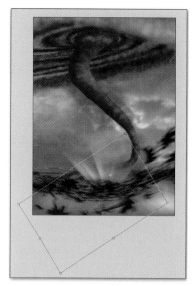

FIGURE 4.86 Transform the background debris.

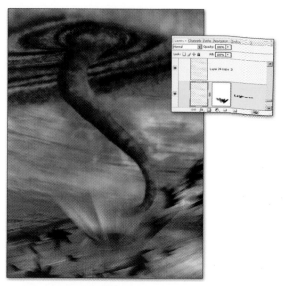

FIGURE 4.87 Add Motion Blur with layer mask.

FIGURE 4.88 Apply the Smudge tool.

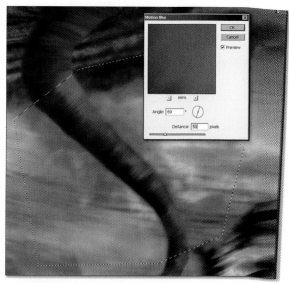

FIGURE 4.89 Apply Motion Blur.

19. Now, we will add some color and contrast effects to make the final image more dynamic. Apply a Hue/Saturation adjustment layer, and click Colorize. In this example, the settings give the image a sepia effect. Additionally, the mask is edited to allow the original color of the sky to show through the background (see Figure 4.90).

FIGURE 4.90 Hue/Saturation adjustment layer applied.

20. Remember when we talked about being open to other possibilities? This is where you are going to apply another look to the funnel. Now that you have all of the detail and color alterations established for the tail, apply the Perspective tool (Edit > Transform > Perspective), and narrow the base of the funnel, as shown in Figure 4.91.

21. Use your Tornado brushes to apply more clouds to the upper portion of the tornado, and apply some Radial Blur to give them a sense of motion (see Figure 4.92).

FIGURE 4.91 Apply Perspective to the funnel.

FIGURE 4.92 Apply more clouds to the upper tornado.

22. For the final touches, open the Nik Color Efex Pro 2.0 Selective, and choose Bicolor Warm. Apply the effects as shown in Figure 4.93.

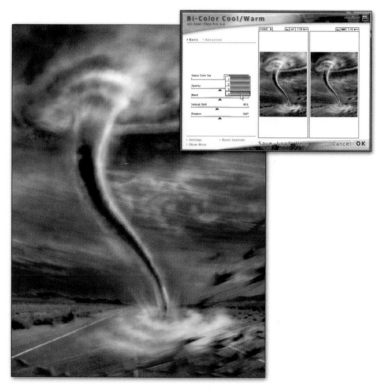

FIGURE 4.93 Nik Color Efex Pro 2.0 Bicolor Warm.

23. When done, change the layer's Opacity to 62%, and edit the mask with the Paintbrush to bring in the original whites of the lower dust cloud below the tail.

Figure 4.94 shows the completed image. It's okay if yours looks slightly different. The steps provided here are only suggestions. Feel free to elaborate on them.

WHAT YOU HAVE LEARNED

In this chapter, you have learned

- How to utilize the animated brush engine to custom create smoke and debris
- How to use FX tricks to create motion
- How to stroke a path with animated brushes
- How to use Quick Mask to define shape

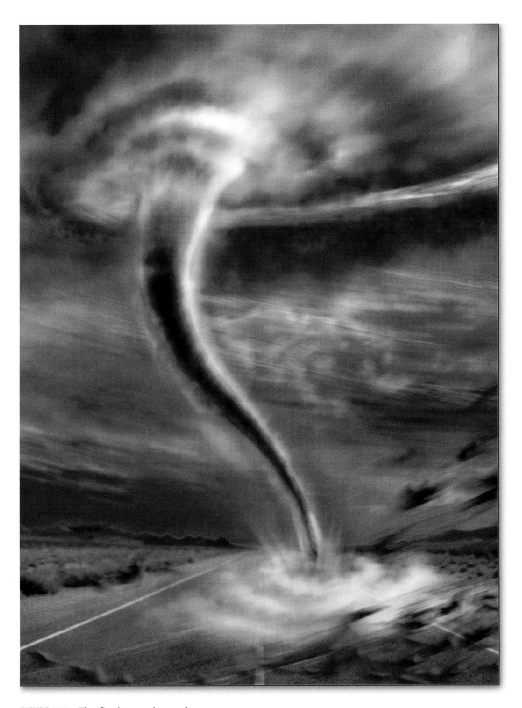

FIGURE 4.94 The final tornado result.

INTEGRATING PHOTOGRPAHY AND 3D OBJECTS

- Intergrating Photographic images with 3D objects
- Creative application Of The New Auto Blend Layers.
- Using 3D objects as bitmaps
- Using 3D objects in a 3D layer
- FX tricks to create lighting
- Creative Application of the Warp tool
- Tricks to Building Cityscapes

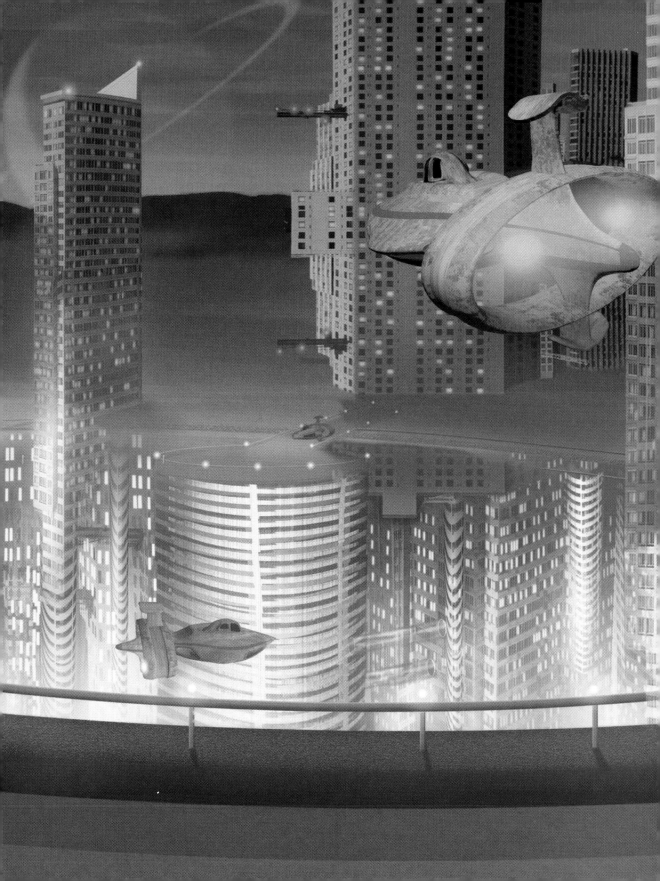

I n this chapter, we're going to start by exploring two different approaches to integrating 3D objects into your Photoshop environment. We will start with the use of the new 3D layers and then progress toward using bitmaps in the next exercise. We will not go into great depth as to all of the capabilities and features of 3D layers in this chapter primarily so that we can just have fun creating. We will cover those features in greater depth in Chapter 6.

CREATING THE INITIAL LANDSCAPE USING AUTO ALIGN LAYERS

In this exercise, you'll use a panoramic formatted image consisting of three images, and you'll apply Auto Align Layers and Auto Blend Layers to create a landscape.

This landscape will be the backdrop for a futuristic scene where you will create an underground city within a desert-like landscape. After creating the city, you will then apply the light source emanating from beneath as well as provide ambient lighting provided by the sunset.

You will also learn about the wonderful new Photoshop CS3 feature called 3D layers. The new *3D layers* allow you to import 3D objects created from third-party programs into Photoshop to integrate into your digital workflow. So, let's go have some fun.

1. Create a new file that is 8.5 × 15 inches wide (see Figure 5.1).

FIGURE 5.1 Create a new file.

ON THE CD

2. Access the `Tutorials/ch 5` folder on the CD-ROM, and open `desert1.tif`, `desert2.tif`, and `desert3.tif`. Place these three images into your new file (see Figure 5.2).

3. These three images are of a desert expanse taken in three separate shots. They are basically the left side, the midsection, and the right side of the composition. These images were not shot with a tripod but with a handheld to test

FIGURE 5.2 Place the three desert images into the new file.

how well the new Auto Align Layers feature worked in Photoshop CS3. Auto Align Layers is basically a version of Photomerge that allows you to merge images on a selected layer horizontally.

4. Select the three desert layers, and go to the Auto Align Layers command (Edit > Auto Align Layers). A dialog box appears with four options as to how you would like your layers to be aligned (see Figure 5.3):

Auto: Tells a program to make all of the important decisions for you and give you the best results.

Perspective: Gives you a result where the horizontal and bottom lines are parallel to one another in an effort to provide a nondistorted image that is good for HDR alignment.

Cylindrical: Tapers left in the right portion of the image but rounds the horizontal and vertical edges so that it will be stitched in a 360-degree fashion.

Repositioned Only: Does not distort your photographic images but instead repositions them to align the images.

5. Click OK, and take a look at the results in Figure 5.4.

6. The landscape has been blended fairly well, and if you take a look at your layers, you can see how each image has been positioned so that they are overlapped in such a way that the landscape takes on a continuous flow. We have a few problems. First, each photograph seems to have a slightly different exposure because the digital camera was set on auto exposure, which means each image has its own exposure settings. Another problem is that the edges

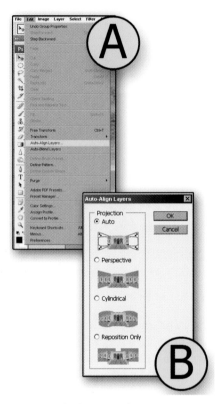

FIGURE 5.3 Apply the Auto Align Layers command.

FIGURE 5.4 Results of the Auto Align Layers command.

of the images are prominent and need to be removed. You could do that with masking, or Photoshop can do it for you with the Auto Blend Layers command (Edit > Auto Blend Layers) as shown in Figure 5.5.

7. This command blends the edges of your photographs and adjusts the brightness and color balance so that the overall results look consistent as shown in Figure 5.6.

FIGURE 5.5 Access Auto Blend Layers in the Edit menu.

FIGURE 5.6 Results of the Auto Blend Layers command.

When the layers are merged, Photoshop expands the canvas size to fit the three images. Since we want to retain the original dimensions of 8.5 x 15 inches, merge all three of the layers and place the merged object into the new canvas that you created earlier (see Figure 5.7). Afterwards, simply Free Transform (Ctrl+T/Cmd+T) the image to fit within the dimensions of the new file. Place these files into their own layer group titled "merged landscape" (see Figure 5.8).

8. Use the Quick Selection tool to select the sky as shown in Figure 5.9. When you are finished, press Delete to cut out the sky.

FIGURE 5.7 Merge all layers.

FIGURE 5.8 The results of merged layers.

9. Now you will create the location where the underground city will be built. In addition, you will resize the mountain range so that the viewer's attention can be focused on the underground city structures. Use the Circular Marquee tool (M) to make a selection similar to what's shown in Figure 5.10A. Select a mountain range with the Rectangular Marquee tool (Shift+M), and use Free Transform to reduce its height toward a more narrow result (see Figure 5.10B).

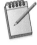

The shortcuts for Photoshop's tools are often designated by a single character; in this case, it is "M" for Marquee. However, there are other options within the same palette. To toggle through these options, hold down the Shift key and press M to access the other hidden tools. This is standard procedure for all tools on the Tools Palette.

FIGURE 5.9 Apply the Quick Selection tool, and remove the sky.

FIGURE 5.10 Apply selections and transform the mountain range.

10. Now, create the sunset dominated sky by using the Gradient tool. Make sure your foreground color is of a bluish nature and your background color is more of a reddish nature. Use the Gradient tool (G), and apply the blue for the upper portion of the photograph with a gradient toward a red in the lower portion of the photograph.

11. Add a new layer, and place it above the gradient layer. Create a gradient by making sure your foreground color is yellow. Select the Gradient Editor, and make sure the Foreground to Transparency option has been selected. Now apply the yellow gradient so that it tapers off to transparency near the upper portion of the mountain range as shown in Figure 5.11. Figure 5.12 shows the options that were used to create the gradient for the yellow highlight.

FIGURE 5.11 The results of the applied gradient.

FIGURE 5.12 Gradient options for the yellow highlight.

12. Let's get the landscape to reflect the ambient light coming from the sunset. You use layer styles to help do this. Double-click on the landscape layer to bring up the Layer Styles dialog box (see Figure 5.13). Select a gradient from the menu, and use the foreground color that is close to a reddish hue that was used for the sunset. In addition, set the background color to the blue that was established for the sunset layer.

FIGURE 5.13 [author: please add caption]

13. On the top portion of the gradient, set the left portion to have some sort of transparency that will gradiate to the solid opacity of the colors you have chosen. You do this because if you leave the foreground color as solid red in the background, the earth landscape will take on the dominance of that color, so you control that by applying transparency. As a result, some of the red will be established, but it will be controlled. It is important to play with these settings to get the results that you are satisfied with. There is no replacement for pure experimentation (see Figures 5.14 through 5.16).

FIGURE 5.14 Apply the gradient using the Layer Style dialog box.

FIGURE 5.15 Establish the red foreground color for the gradient.

FIGURE 5.16 Establish the blue background color for the gradient.

ON THE CD

14. In the `Tutorials/ch 5` folder on the CD-ROM, open the `clouds 001.tif` file. Place the clouds in the upper portion of the sky. Place the clouds beneath the orange highlight layer (see Figure 5.17). Resize the clouds so that they fit into the lower half of the horizon.

15. Give the clouds a slight motion blur. Since the clouds image is a smart object, the filter for motion blur will become a Smart Filter (see Figure 5.18).

16. Figure 5.19 displays the settings used for the motion blur. Experiment with different angles and blur effects to come up with something that you will like better.

17. This is where the real fun begins. Let's start creating the underground city. Go to the CD-ROM, navigate to the `Tutorials/ch 5` folder, and open `architecture 001.tif` (see Figure 5.20A).You will apply quite a bit of distortion to these images, so you will not commit them as smart objects. Select the sky as you did with the landscape image using the Quick Selection tool (see Figure 5.20B). Then invert it, and apply perspective so that the lower portion of the image is slightly shorter than the top. This will make the buildings look as if they're extending downwards (see Figure 5.20C).

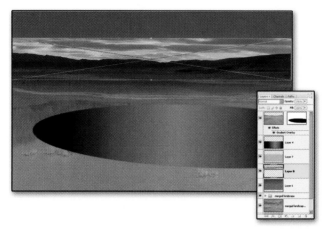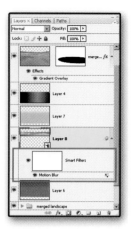

FIGURE 5.17 Commit the clouds as a smart object, and reposition them into the horizon.

FIGURE 5.18 Apply motion blur to the clouds.

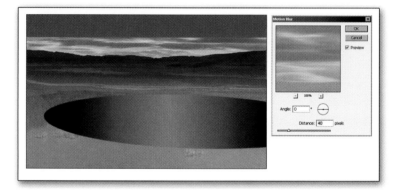

FIGURE 5.19 Settings for the motion blur applied to the clouds.

18. The whole concept of this tutorial is to apply some trickery to the eye, and sometimes working in more of an abstract fashion can help convey a figurative concept. So, we will lay out a series of buildings, which will not take on any definite shape until later in the tutorial. To make sure that things don't get too visually busy on the canvas, turn off the landscape layer and work with the visual aspects of the architectural images for the time being.

19. Duplicate the architecture layer several times, resize the layers, and position them so that they look similar to Figure 5.21. Place these layers into a layer group titled "underground city."

20. Continue to duplicate and add portions of the architecture, but this time, change the layer Blend Mode to Darker Color (see Figure 5.22). This will allow the texture information that is darker to dominate the blend. In effect, the concrete texture and window patterns will become even more prominent throughout the underground cityscape portion of the final object.

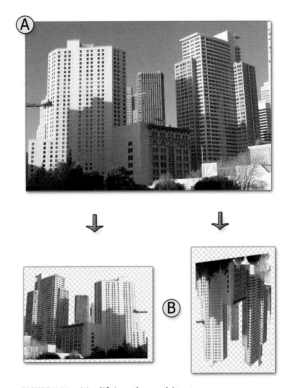

FIGURE 5.20 Modifying the architecture.

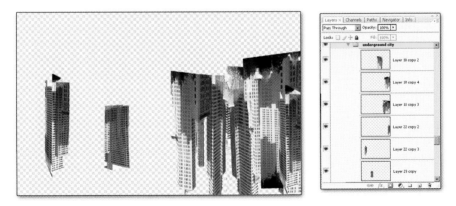

FIGURE 5.21 Add a series of buildings for the underground cityscape.

21. When you're finished, turn on the landscape layer, which should look something like Figure 5.23.
22. Create some extra detail by adding a platform supported by a circular-shaped building. Create the platform on top of the landscape layer using the Circular

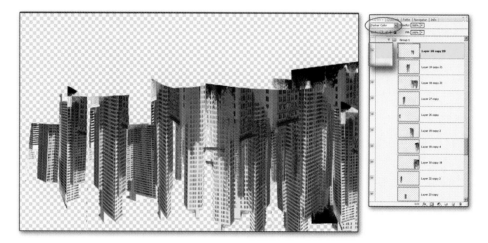

FIGURE 5.22 Duplicating the architecture patterns and changing the Blend Mode to Darker Color.

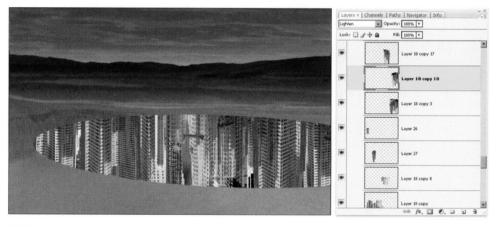

FIGURE 5.23 View the landscape and city together.

Marquee tool and the Polygonal Lasso tool to get a shape similar to what you see in Figure 5.24.

23. The Warp tool in CS2 has proven to be invaluable to digital artists, and it continues to be so in Photoshop CS3. On the CD-ROM, open the `Tutorials/ch 5` folder and open the `architecture 002.tif` file (see Figure 5.25A). You need to make sure the lines are going to be fairly straight to make it easy to apply the next step. So, make sure that the rulers (View > Ruler) are turned on, place your mouse in the left side of the vertical ruler bar, and click and drag to place three guides as shown in Figure 5.25C. This will assist you in lining up the vertical lines for the new piece you're about to create.

24. Use the Free Transform tool (Ctrl+T/Cmd+T) to narrow the image downward vertically (see Figure 5.25B). While still in Free Transform, hold down the

FIGURE 5.24 Create the platform.

Ctrl/Cmd key, select the middle handlebar on the top portion of the transform box, and move the point to the right so that all of the architecture's vertical lines match up with the guides that you have laid down. Holding down the Ctrl/Cmd key while still in Free Transform is the shortcut for applying Distort.

25. The goal is to give the building some height but maintain the short horizontal grid patterns that you have established when the size of the image is reduced. So duplicate this layer three times, and use the Move tool (V) to position the layers on top of one another (see Figure 5.25D). Next let's give it a rounding affect with the use of the Warp command.

FIGURE 5.25 Create the rounded architecture.

26. Merge all the layers used to create the rounded architecture, and apply the layer styles gradient. Use this setting as shown in Figure 5.26 as a starting point.

FIGURE 5.26 Apply a gradient to the rounded architecture.

27. Position the completed image below the platform. Use Figure 5.27 as a guide.

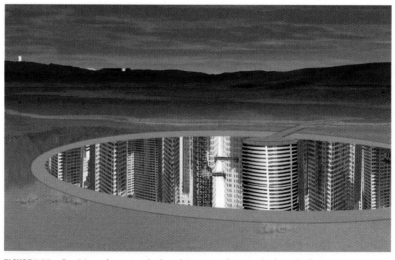

FIGURE 5.27 Position the rounded architecture beneath the platform.

28. Add some warm color to it using the Hue and Saturation command, and duplicate the procedures from steps 1 through 7 to create another platform on the left side of the composition (see Figure 5.28).

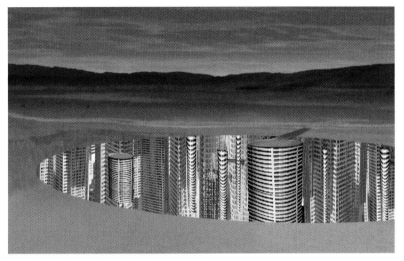

FIGURE 5.28 Recreate the rounded architecture, and place it on the left side.

29. In the "mountains" layer group, you will establish a shallow depth of field with a mountain range in the background that blurs out slightly. In addition, you'll establish a slightly stronger atmospheric haze that reflects the ambient color in the environment.

30. Make sure that the mountain layer is committed as a smart object. Next, apply Gaussian Blur to effectively blur the entire landscape scene. Since the Gaussian blur is a Smart Filter, restrict the effects of the blur to the upper portion of the landscape by editing the mask that is associated with the Smart Filter. Create a gradient where black dominates the lower half of the image and gradiates toward white in the upper portion of the image. This will restrict the blur effect to the background of the composition, which is in this case the mountain range.

31. Now, let's create the atmospheric haze. Make sure that your foreground color is a similar color to the reddish hue in the sunset area. You can do this by using the Eye Dropper tool to select a color from any area on your image (see Figure 5.29A).

32. Use the Gradient tool (see Figure 4.29B) to apply that color to the mountain range only by using the Reflect a Gradient option on the Options bar (see Figure 4.29C).

33. This is a good time to add the beginnings of a light source to the underground city. Do this by way of a gradient that uses blue for the top portion of the city

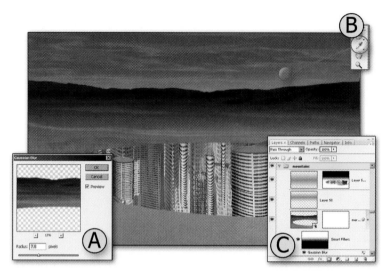

FIGURE 5.29 Create atmospheric aides and a shallow depth of field.

and yellow on the lower half of the city. To blend these colors in with the architecture, change the Blend Mode to Multiply. Then follow up by adding two more layers using the yellow as the foreground color that will gradiate to a complete transparent pixel as shown in Figure 5.30. Use layer masking to edit the layer to restrict the effects to various locations of the landscape. This breaks up the perfect shading pattern so that you can give the illusion that the lighting is affected by the geometry of the unique shape of each building.

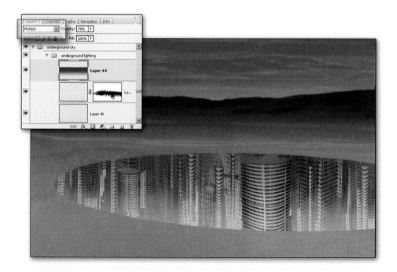

FIGURE 5.30 Add some light source to the architecture.

Creating the Upper Architecture

The approach to creating the upper architecture will be more controlled than the previous steps for the underground city. The following techniques are useful when you have a definite idea about how you want your image to look in the final result. You will take portions of a single building to reshape and use textures to create other compositional elements for the concept.

1. On your CD-ROM, open `architecture 003.tif` in the `Tutorials/ch 5` folder (see Figure 5.31A). Select a portion of the image as shown in Figure 5.31B, and use Free Transform (Ctrl+T/Cmd+T) to distort the image and make the horizontal lines of the architecture a little more horizontal.

2. To give this building a more straight-on view to the camera, select the left portion that makes up the right face of the building, and apply Free Transform to shorten it as shown in Figure 5.31C. Duplicate the image, and flip it vertically (Edit > Transform > Flip Vertically) to create a mirrored image of the original. Use layer masks to blend the two shapes. In this case, the blending does not have to be perfect because much of it will be obscure data landscape. Try to get your image to look like Figure 5.31D.

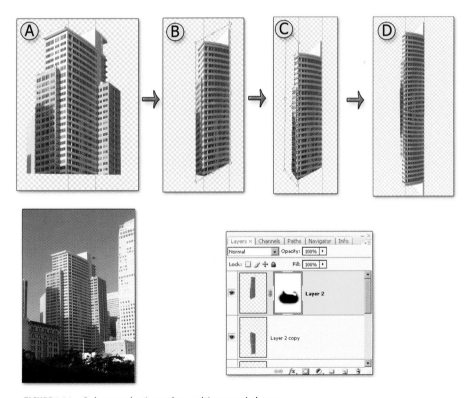

FIGURE 5.31 Select and mirror the architectural shape.

3. Now open the original `architecture 001.tif` file, and apply the same technique to the entire image (see Figure 5.32).

FIGURE 5.32 Select and mirror the complete architectural scene.

4. Position the architectural shapes in the right section of the circular cavern, and use layer masks to isolate the buildings in such a way that they look like they are extending through the surface of the landscape and into the underworld of the city (see Figure 5.33).

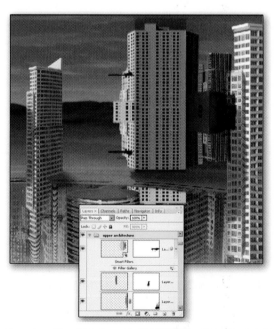

FIGURE 5.33 Use layer masking to integrate the buildings into the landscape.

5. To add visual interest, add some support around the edges of the cavern. Create a selection around the mouth of the cavern, and give it a border (Select > Modify > Border) that reflects what is shown in Figure 5.34A. Fill the border with the brownish color similar to the landscape by using the Eye Dropper tool. Add some noise (Filter > Noise > Add Noise) to give it a sense of texture, and then finalize it by applying Crystallize (Filter > Pixelate > Crystallize) to give it some extra character.
6. Use the Pen tool to select a shape that will form the vertical lip of the cavern (see Figure 5.34B). Part of the landscape has a watery feel, so validate the concept that water dominates half of the scene by adding a reflection. Duplicate the lip, place it below the original one, and then bring down its opacity so that it takes on a reflective appearance (see Figure 5.34C).

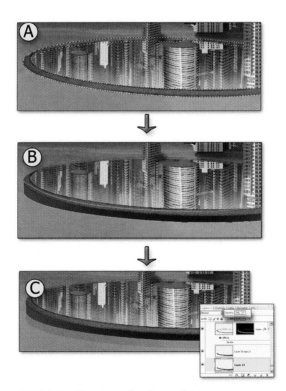

FIGURE 5.34 Creative reflection and the water.

7. Add some extra interest by adding a support rail around the mouth of the cavern (see Figure 5.35). Do this by creating an elliptical marquee and giving it a border. Fill the marquee with medium gray, and apply a Bevel and Emboss using layer styles.
8. After creating the support rail, apply the same technique to vertical supports along the rail as shown in Figure 5.36.

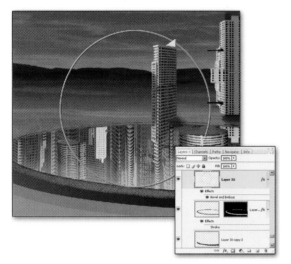

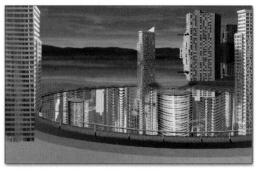

FIGURE 5.36 Create vertical support for the rail.

FIGURE 5.35 Create the support rail.

9. In the next exercise, you'll create additional architecture to meet with the composition. To get a better feel of how well all of the cityscape elements will work together, turn off the highlights for the underground city segment and continue working.

Creating Additional Architecture to Frame the Composition

A powerful compositional technique is to use foreground, middle ground, and background elements to establish a greater sense of depth. The balance should also be created so that the composition is not weighted to favor one side of the frame over the other. Currently most of the objects are placed on the right hand side. To add depth as well as a sense of balance, you will create additional architectural elements to the foreground as a framing device to guide the viewer's attention toward the city and the landscape. You will use existing elements to assist us in this effort.

1. From the image that you have already opened titled `architecture 003.tif`, select the front face with the Rectangular Marquee tool, and copy the texture onto its own layer (see Figure 5.37). Use Free Transform and Distort to align the horizontal shapes so that they are parallel to the horizontal edge of the image frame. You'll come back to this particular texture later on.
2. Select one of the textures from the right side of the building in `architecture 001.tif` (see Figure 5.38).
3. It is sometimes very helpful to draw in exactly how you want your shape to look. Create a new layer, and paint in a line drawing how you want the shape to look (see Figure 5.39). In this example, the color white is used to stand out from the darker colors in the scene.

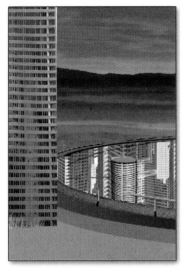

FIGURE 5.37 Create a new texture.

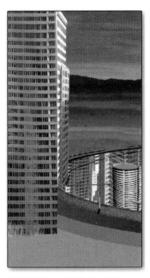

FIGURE 5.38 Add the right side portion of the building.

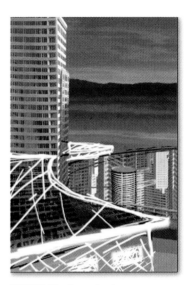

FIGURE 5.39 Draw in the new compositional element.

4. Use the Pen tool to outline the area that will represent the roof of the building. Then fill it in with a gradient consisting of black for the background and gray for the foreground (see Figure 5.40).

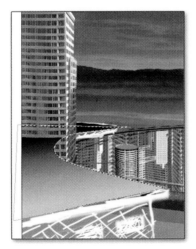

FIGURE 5.40 Utilize the Pen tool to create the roof of foreground architecture.

5. Apply the same technique for the front face of the new building where the gradient will be applied vertically with black in the top half and gray in the bottom half (see Figure 5.41).

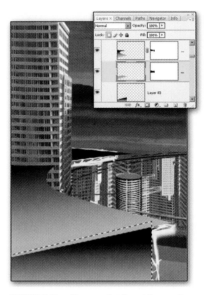

FIGURE 5.41 Create the front face of the new building.

6. Copy the texture that you used for the new building in step 1, and position it over the roof that you've just created. Using Free Transform and Distort, transform the texture on top of the roof so that the lines fan outward into the foreground. Use a layer mask to isolate it to the shape of the roof (see Figure 5.42).

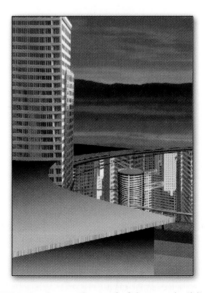

FIGURE 5.42 Create the roof of the new building.

7. Copy the texture that you used for the new building connecting to the roof that you've just created. Using Free Transform and Distort, place the texture on top of the roof, and use a layer mask to isolate it to the shape that you established (see Figure 5.43). Do the same thing for the front face of the new architecture, but resize the texture so that the windows are double the size of the ones in the background.

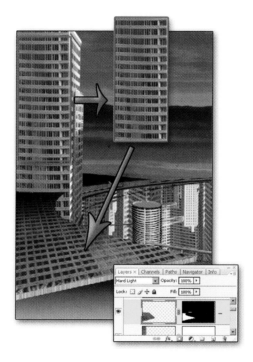

FIGURE 5.43 Create the roof of the new building.

8. Now let's establish some light sources (see Figure 5.44). Turn on the light source for the underground city, create a new layer, and then apply window highlights just as you did in Chapter 3. Place the window highlights into a layer group titled "Window light source," and place it on top of the underground city layer group.

9. Besides the faces of the buildings, the sides should reflect the reddish orange lighting coming from the sunset. To simulate this effect, create a new layer and change its Blend Mode to Hard Light. Select the Paintbrush tool and hold down the Alt/Option key as a shortcut to activate the Eye Dropper tool. Select a reddish orange hue, and paint over the side faces of the buildings. Also apply the same technique to the top of the new roof that you've just created (see Figures 5.45 and 5.46).

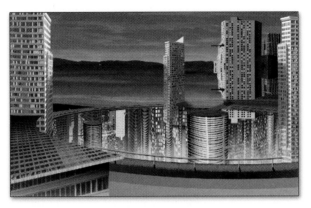

FIGURE 5.44 Create the window light source for the new building.

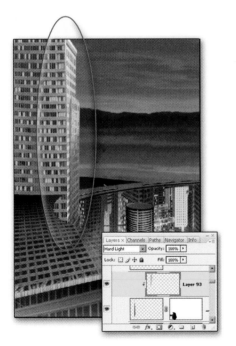

FIGURE 5.45 Apply a reddish highlight to the side of the buildings.

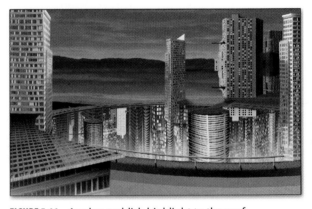

FIGURE 5.46 Apply a reddish highlight to the roof.

10. Continue to use the same texture to apply a curved surface to the rounded portion of the roof. Use Free Transform as well as Warp to create a curved vertical edge to the new architecture as shown in Figure 5.47.

FIGURE 5.47 Apply a curved surface to
the new section of the architecture.

11. Now you can add additional light sources to the underground city. Create a
new layer group called "city lights detail," and place it above the Window light
source layer group. Inside the layer group, create a series of new layers with the
layer Blend Mode set to Screen. Use a series of circular gradients on their own
layers to be placed within certain areas of the underground city. Use Figure
5.48 as a guide. Also use Free Transform to alter the shape of the light source.

 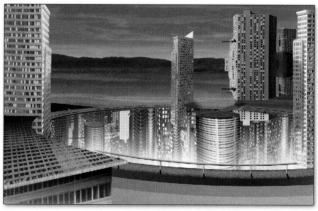

FIGURE 5.48 Apply the light source to the underground city.

12. All of the light sources emanating from underneath the cavern should have a
unified glow. Create the glow as a circular gradient based on a bluish color,
and transform it so that the circular shape sits over the cavern. Use layer
masking to isolate the blue color to the edges of the lip. Duplicate the layers if
necessary to isolate the effect to the parameter as shown in Figure 5.49.
13. Create small light flares sitting above the rail supports (see Figure 5.50).

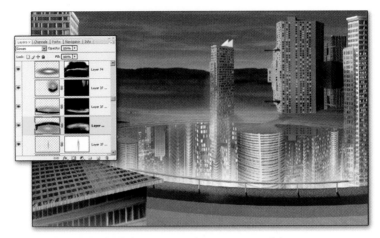

FIGURE 5.49 Apply the light source to the parameter of the cavern.

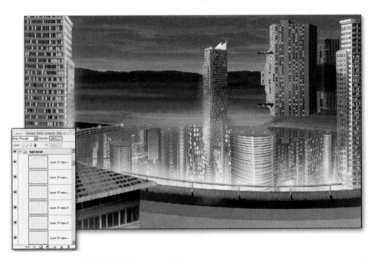

FIGURE 5.50 Apply light flares to rail supports.

Adding 3D Layers to the Scene

The ability to bring in 3D objects from third-party modeling programs is a huge addition to Photoshop. 3D modelers and animators use a wide variety of formats, but currently the two file formats that are most widely use and supported by CS3 are 3D Studio Max (has a .3ds extension) and Alias Wavefront's Object format (has an .obj extension). Photoshop CS3 will also read Collada, Google Earth 4, and U3D.

1. Go to the CD-ROM to Tutorials/ch 5, and open the racer.psd file. You have just opened a file that has a 3D layer. The 3D object was created in Newtek's LightWave 9 modeling and animation program.

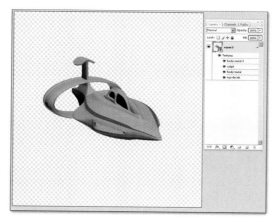

FIGURE 5.51 The 3D file.

2. Double-click on the 3D Layer icon, and take a look at the Options bar. You will see several options that allow you to rotate (see Figure 5.52), roll (see Figure 5.53), pan (see Figure 5.54), and zoom in on the 3D object (see Figure 5.55).

FIGURE 5.52 Rotate the 3D file.

FIGURE 5.53 Role the 3D object.

3. We will cover in depth the tools of 3D layers in the next chapter, but for now, let's insert the hovering ships over the entrance of the underground city. Duplicate the layer to create several objects, and utilize the positioning commands shown in Figures 5.52 through 5.55 to place them as shown in Figure 5.56. Your scene will have stronger impact if you always consider the concept of gaining more depth throughout the process of creating. So, when you use your 3D tools to position as well as zoom into your objects, create the ones in the foreground

FIGURE 5.54 Pan the 3D file.

FIGURE 5.55 Zoomed view of 3D file.

so that they are larger and reduce them if you want them to recede toward the background to give an impression of greater distance into the landscape.

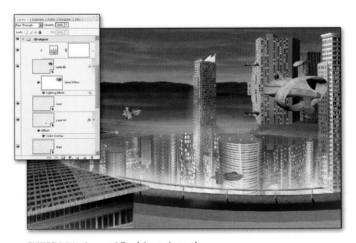

FIGURE 5.56 Insert 3D objects into the scene.

4. To unify the visual color throughout the scene, add additional color overlays and place them into a layer group titled "ambient lighting." This layer group should be placed on top of all the groups that you have already created. Sample red hue from the sunset location as well as a blue from the underground city location. Create a gradient using these colors on their own layer, and change the Blend Mode to Hard Light. Apply a layer mask and edit it so that the color has little or no effect on the underground city details. You can also

add additional layers if you want the sky to take on a richer reddish hue or apply a blue wash gradient to the foreground area. Figure 5.57 shows the gradient activated with the other three layers turned off. So, let's see what it looks like with the other two layers turned on.

5. As you can see, the entire image starts to take on some color harmony with the addition of the ambient light layers. Visually, the center of interest becomes clear, and the surrounding elements, in conjunction with the color, guide the viewer's eyes straight to the underground city architecture.

FIGURE 5.57 The ambient light gradient.

FIGURE 5.58 Use a gradient to harmonize the color scheme.

6. To add one final touch, create a new layer with a Blend Mode of Screen. Using the Paintbrush, sample the bluish highlights around the entrance of the city. Next, paint with this color to accentuate the blue glow around the perimeter of the cavern. Now, take a look at the final image (see Figure 5.59).

FIGURE 5.59 The final view of the underground city.

3D Objects as Bitmaps

Even with the power of the new 3D layers, they have their weaknesses. One of them is that you cannot add or reposition light sources in your layered enviroment. This would be ideal for matching the lighting direction as well as the lighting style to integrate your object more completely into your scene. Having access to such controls would give you not only the ability to control the intensity of the main light source but also its ambient color and saturation properties. Another disadvantage is that you cannot directly edit surface textures that are common to 3D programs, such as reflections for water or reflective surfaces, bump maps for textured surfaces, or specular maps for glossy surfaces. So, due to these limitations, we will experiment with two different directions in which to apply 3D objects to your 2D environment. One way is through the 3D layers, which we already covered in the previous tutorial. The other is to create the entire surface quality in the 3D program and apply the object in the form of a bitmap to be placed into a layer in Photoshop CS3. Let's experiment with that approach.

Creating the Initial Landscape

In this section, you will use digital RAW images created with the Canon 10 D. All of the images were shot along Highway 1 on the Carmel, California coastline. The lighting was overcast, which made it perfect for scenic photographs. The diffused lighting allowed all of the details to show through wonderfully.

You will use several of these images to create a composited landscape as the backdrop of the 3D android crouched in the river underneath the bridge. The surrounding landscape will be reflected in the body of the droid that has already been created for you in LightWave 8.0.

In addition, you will create the reflections in the riverbed to make the scene more convincing.

ON THE CD

1. Go to the `Tutorials/ch 5 landscape` folder on the CD-ROM, and open `pfiefer beach river.crw`, `Coastal Bridge.crw`, and `pfiefer beach.tif` in Photoshop (see Figures 5.60 through 5.62).

FIGURE 5.60 Pfiefer beach river.crw.

2. Open the files in the Adobe Raw interface, and apply the settings that work best for you. The example here is only a suggested starting point. Save the settings that you apply to the first image, and apply them to the other two for consistency. Commit your settings (see Figure 5.63).

FIGURE 5.61 Coastal Bridge.crw.

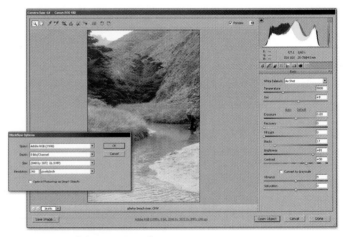

FIGURE 5.62 Pfiefer beach.tif.　　**FIGURE 5.63** Adobe Raw interface.

3. Enlarge the image using Free Transform (Ctrl+T) to allow the river to dominate the lower third section of the composition (see Figure 5.64).
4. Duplicate this layer, and change the Blend Mode to Multiply to add some richness to the overall scene. Add a layer mask filled with black by Alt+clicking on the Layer Mask icon. Edit it using the Paintbrush so that the Multiply effect is isolated to the river, as shown in Figure 5.65.
5. Place the Pfiefer Beach image into this file, and apply it as a smart object, as shown in Figure 5.66.

FIGURE 5.64 Image enlarged.

FIGURE 5.65 Apply a mask and use the Multiply Blend Mode.

FIGURE 5.66 Smart object applied.

6. You have applied a smart object so that the detail and quality is maintained as you adjust the size of the image. If it is reduced and enlarged again with Free Transform, the image quality is maintained as it was originally (see Figures 5.67 and 5.68).

FIGURE 5.67 Smart object reduced.

FIGURE 5.68 Smart object enlarged.

7. For now, reduce the image so that the stone sits in the lower-right corner of the screen. Apply a mask so that it integrates with the existing sand (see Figures 5.69 and 5.70).

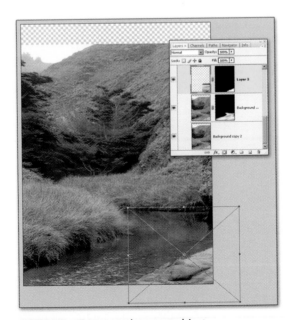

FIGURE 5.69 Compose the smart object.

FIGURE 5.70 Apply a mask to the smart object.

8. Apply a Curves adjustment layer to increase the contrast a bit to match the overall contrast of the scene, as shown in Figure 5.71.

FIGURE 5.71 Apply the Curves adjustment.

ON THE CD

9. Access the `Tutorials/ch 5 landscape` folder on the CD-ROM, and open `Carmel fence.tif`. Place the fence image above the river. After committing it as a smart object, resize and position the fence above the grassy bank on the lower left, as shown in Figure 5.72.

10. Apply a layer mask to integrate the fence into the river scene. Use a soft-edge paintbrush to achieve this. Remember, if you press the \ key, the black portions of the mask will show up as red. This makes it easier for you to see where you are working in relation to the image (see Figures 5.73 and 5.74).

FIGURE 5.72 Smart object applied.

FIGURE 5.74 Layer view of the mask.

FIGURE 5.73 Apply a mask to the fence.

11. Make contrast changes to the transformed fence by linking a Curves adjustment layer as you did to the stone image (see Figure 5.75).
12. Place the bridge image you opened in step 1 on top of the river and fence layers, and place all of them into their own layer set titled "bridge." Don't forget to designate it as a smart object (see Figure 5.76).
13. Resize the bridge as shown in Figure 5.77 for a more dynamic appeal.

FIGURE 5.75 Contrast alterations to stone.

FIGURE 5.76 Bridge placed into the file.

FIGURE 5.77 Bridge resized.

14. Apply a layer mask, and use a soft-edge paintbrush to edit the mask so that the areas underneath the arch allow the detail from the river scene to come through (see Figure 5.78).
15. Now that the bridge is over the water, you need to add its reflection. Duplicate the bridge layer (Ctrl+J), invert the layer vertically (Edit > Transform > Flip Vertical), and position it so that the tip of the arch is in the river. Associate a black-filled layer mask, and paint with white to reveal the reflection in the river. Use Figure 5.79 as a guide.

FIGURE 5.78 Bridge layer is masked.

FIGURE 5.79 Reflection of bridge in the water.

16. The color balance of the bridge doesn't quite match up to the rest of the scene. It needs to take on the greenish ambient light that is being bounced from the foliage. To do this, apply Color Balance adjustment layers to the bridge only (see Figure 5.80).

FIGURE 5.80 Apply Color Balance to the bridge.

17. The overall scene is tonally a little flat, so we will improve it with the use of Curves, as shown in Figure 5.81.

FIGURE 5.81 Apply Curves to the bridge.

ON THE CD

18. Go to the `Tutorials/ch 5` folder on the CD-ROM, and open the `spider droid final.tif` image. Place it into its own layer set called "spider droid" (see Figure 5.82).

FIGURE 5.82 Apply the spider droid image.

19. Apply a layer mask, and edit out the tips of the feet so that the droid appears to be submerged in the water (see Figure 5.83).

FIGURE 5.83 Apply the layer mask to the spider droid image.

20. Duplicate the spider droid layer, and flip it vertically to use as the reflection. Apply the same technique as you did in step 15 (see Figure 5.84).

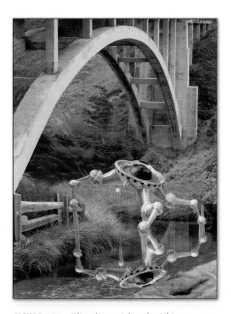

FIGURE 5.84 Flip the spider droid image.

21. Duplicate the inversed spider droid layer to apply the reflection of the rear leg in the back section of the river. Make sure that you align the two correctly. Apply the same mask technique as you did in step 15 (see Figure 5.85).

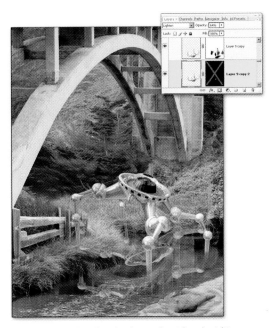

FIGURE 5.85 Flip the duplicated spider droid image.

22. Fill the mask with black, and allow only the rear leg image to manifest itself in the water, as shown in Figure 5.86. Although you can select a portion of the legs and cut and paste them into their proper location, it is advantageous to have the complete image and use masks to allow only what you choose to show through. If you should ever want to go back to improve upon your image or include other parts of it, the entire image will still be at your command.
23. Duplicate the inversed spider droid layer again, and fill it will black (Edit > Fill > Fill with Black). Make sure the Preserve Transparent Pixels box is selected so that the shape of the droid is filled with black and not the entire layer (see Figure 5.87).
24. When complete, reduce the transparency of the layer, and set its Blend Mode to Multiply (see Figure 5.88).
25. Now give this a mask to restrict the shadow to the grassy region (see Figure 5.89).

Creating the Laser Effect

The spider droid is emitting a particle beam from its snout. When the beam causes a glow as it hits the water, steam lifts from the heated area.

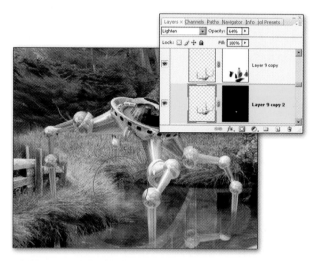

FIGURE 5.86 Mask edited.

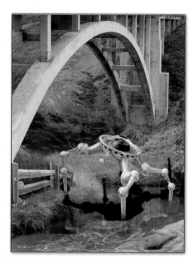

FIGURE 5.87 Fill spider droid with black.

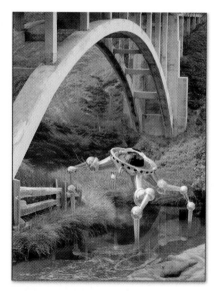

FIGURE 5.88 Spider droid shadow is reduced in opacity.

FIGURE 5.89 Mask applied to the shadow.

1. Start by creating the Flare Effect. Apply Lens Flare to a new layer filled with 50% gray (see Figures 5.90 and 5.91).
2. Change the 50% gray layer's Blend Mode to Hard Light (see Figure 5.92).
3. Resize the flare to fit the spider droid's snout, as shown in Figure 5.93.

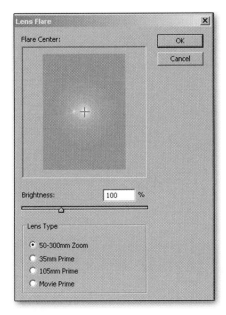

FIGURE 5.90 Lens Flare dialog box.

FIGURE 5.91 Lens Flare applied to a 50% gray layer.

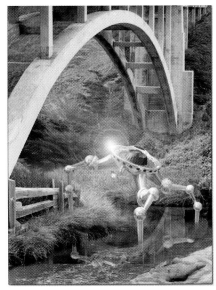

FIGURE 5.92 Change the Blend Mode of the lens flare layer to Hard Light.

FIGURE 5.93 Lens Flare resized.

4. Change your foreground color to yellow. Select the Paintbrush, and change its Blend Mode to Dissolve (see Figure 5.94).

5. With a soft-edge brush, paint a vertical beam starting with the snout down to the bottom of the image (see Figure 5.95).

FIGURE 5.94 Paint options set to Dissolve.

FIGURE 5.95 Particle beam applied.

6. Give the beam some Motion Blur (see Figure 5.96).
7. To add a denser core to the laser, place a rectangular selection as shown in Figure 5.97.

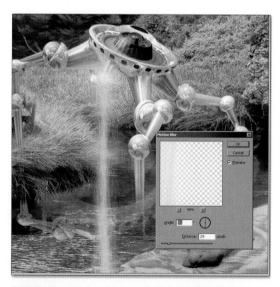

FIGURE 5.96 Motion Blur applied to particle beam.

FIGURE 5.97 Selection applied to particle beam.

8. Deselect the selection (Ctrl+D), create a new layer, and fill the selection with white (see Figure 5.98).
9. Apply some Gaussian Blur (Filter > Blur > Gaussian Blur), as shown in Figure 5.99.

FIGURE 5.98 Selection filled with white.

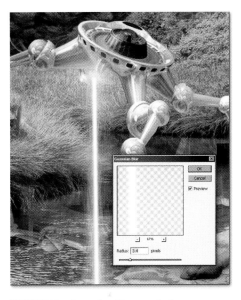

FIGURE 5.99 Gaussian Blur applied.

10. Select both the layers for the laser, apply some perspective to the shape (Edit > Transform > Perspective), and rotate it approximately 45 degrees to the left. When done, merge them (see Figures 5.100 and 5.101).

FIGURE 5.100 Perspective applied to laser.

FIGURE 5.101 Rotations applied to laser.

11. Associate a mask to the laser layer to block out the lower third of the laser. Duplicate the Lens Flare, place it where the laser hits the water, and transform it so that it is a horizontal oval shape. Use Hue/Saturation to intensify the color (see Figure 5.102).

12. Create a new layer, and paint the steam effects on it using one of the animated smoke brushes that you created in the second half of Chapter 4 (see Figure 5.103).

FIGURE 5.102 Further editing to the laser layer.

FIGURE 5.103 Apply steam.

13. Make the steam look as if it is rising quickly by applying a slight Motion Blur (see Figure 5.104).

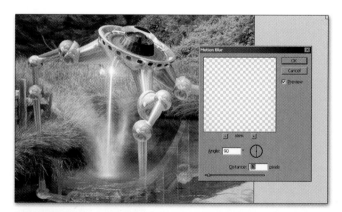

FIGURE 5.104 Apply Motion Blur to the steam layer.

14. Now you will add some depth-of-field techniques so that the viewer's attention focuses on the spider droid. Make sure that you have selected the very top layer of the bridge layer set. In this case, it's the adjustment layer. Simultaneously

press Ctrl+Alt+Shift+N, and then press E. This command merges all of the visible layers into a new layer above the one you had selected (see Figure 5.105).

15. Apply Gaussian Blur to cut down on the sharpness of the image. Experiment with the settings to get what you like best (see Figure 5.106).

16. Now you will apply the depth of field. Create a Gradient Mask to the Gaussian Blur layer where white dominates the top and graduates to black at the bottom (see Figures 5.107 and 5.108).

FIGURE 5.105 Merge layers.

FIGURE 5.106 Apply Gaussian Blur.

FIGURE 5.107 Apply a Gradient Mask to the Gaussian Blur layer.

FIGURE 5.108 View of the Gradient Mask.

17. Now you will add the finishing touches to the image. On the CD-ROM, go to `Tutorial/ch 5 landscape`, and open `reflection 2.tif`. You are going to add another reflection that shows the belly of the spider droid. The others worked well because they were duplicates of the original shape, but they did not show the underbelly of the droid. Place it underneath the spider droid layer, and add a mask. Edit the mask with your Paintbrush so that only the circular underbelly shows through. In addition, duplicate your laser layer, and flip it vertically to include it as a reflection as well.

18. Access the Nik Color Efex Pro 2.0 Selective, and choose Graduated Neutral Density, as shown in Figures 5.109 and 5.110.

FIGURE 5.109 Nik Color Efex Pro 2.0 Selective.

FIGURE 5.110 Graduated Neutral Density dialog box.

19. After the filter is applied, reduce the opacity, as shown in Figures 5.111 and 5.112.

FIGURE 5.111 Graduated Neutral Density applied.

FIGURE 5.112 Graduated Neutral Density image reduced in opacity.

20. Look ahead to Figure 5.121 to see the final image; however, another version of the bridge, called `Bridge 2.crw`, is included on the CD-ROM in the `Tutorials/ch 5 landscape` folder. Figure 5.120 shows a version using that one. If you feel a little ambitious, try this tutorial with both versions. But before we conclude, it is a good idea to get some quick insight into how the reflections were applied to the 3D model.

REFLECTIONS APPLIED IN LIGHTWAVE 8

Keep in mind that this book is not deeply involved with 3D. However, this section provides some possibilities of what you can done with LightWave to enhance your work.

The 3D environment is a challenging one. Not only do you have to be concerned with the x- and y-coordinates, which most of us already understand as 2D space, but also you need to be aware of the z axis that defines depth. This is the axis that throws most 2D artists off. The wonderful thing about 3D space is that you can specify textures and details anywhere on your model. The following shows how you achieved the 3D effects of the spider droid. Figure 5.113 is a view of the model in 3D space.

In LightWave, there is an option to apply images as reflections to any surface of a 3D model. A JPEG image was made of the bridge landscape and imported into Light-Wave's compositing engine located in the Effects panel (see Figure 5.114).

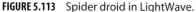

FIGURE 5.113 Spider droid in LightWave.

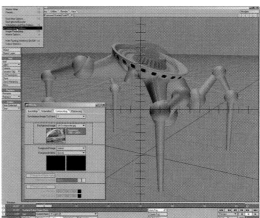

FIGURE 5.114 LightWave's compositing engine.

After the necessary data is loaded, the Image World command is activated. This takes the JPEG image of the bridge scene and maps it around the 3D object to be reflected onto its surface (see Figure 5.115).

All that's left to do is to tell LightWave what surfaces you want this to reflect in. Pressing F5 activates the surface panel where you can view all of the surface attributes.

We are interested in the base surface, which will represent the silvery outer surface of the spider droid. It has a reflection property of 74%. This tells you that the base surface will reflect the background onto its surface at 74% strength (see Figure 5.116).

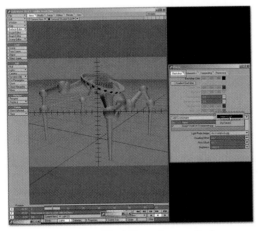

FIGURE 5.115 Image World function applied.

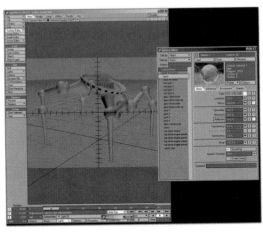

FIGURE 5.116 Surface properties.

To render the image, you press F9. The background image has been condensed to fit the view of the camera dimensions, but that is okay because you just need to retrieve the object with the colors of the scene reflecting into the surface (see Figure 5.117).

You can save the image in a variety of formats in the panel of the rendered image. We chose the TGA format because it will export with its own alpha channel (see Figure 5.118). You can save the image to anywhere on your hard drive (see Figure 5.119).

FIGURE 5.117 Rendered image.

FIGURE 5.118 Rendered image is exported.

FIGURE 5.119 Save the image to your hard drive.

As you have done, you can import the image into Photoshop to apply other creative alternatives, like the ones you did in this tutorial (see Figures 5.120 and 5.121). Take your time and have fun.

Let's move forward to the next chapter where we will cover in depth the tools and capabilities of 3D layers.

FIGURE 5.120 Alternative bridge view.

WHAT YOU HAVE LEARNED

In this chapter, you have learned

- How to use the animated brush engine to create steam.
- That 3D layers have limitations
- How to create bitmaps of 3D objects as a workaround to the limitations of 3D layers
- That creating foreground compositional objects gives the scene greater depth
- How to create ambient light sources
- How to create a shallow depth of field

FIGURE 5.121 Final image.

6 3D Layers, Refine Edge & The B&W Command

IN THIS CHAPTER You will Learn:
- about the new 3D Layers.
- how to intergrate 3D objects with Photography.
- How to Create a custom grass brush .
- the basics of the 3D invironment.
- how to create atmospheric haze that give the scene a scense of realism.
- about the new Black & White command
- Learn How to use Vanishing Point.

CREATING THE INITIAL LANDSCAPE

In this exercise, you will combine three different landscape-type images to serve as a backdrop for the emerging figure coming forth from beneath the depths. You will start by combining the landscape image. Then you will add custom-created clouds to enhance the scene. Next you will add the human figure, which you will later clothe in a series of textures. Be patient and take your time with this fun exercise.

ON THE CD

1. Create an 8.5 × 15-inch file with a resolution of 300 ppi. Access the `Tutorials/ ch 6` folder on the CD-ROM, and open `Bridge.jpg`.
2. Position the bridge as shown in Figure 6.1, leaving some space for sky along the upper edge as well as space to the left for extending the foliage. Select a large portion of the hillside to the lower left and to assist you in rebuilding the hillside.
3. Copy (Ctrl+C/Cmd+ C) and paste (Ctrl+V/Cmd+V) the selected area onto a new layer, and apply Free Transform (Ctrl+T/Cmd+T) to produce something that resembles Figure 6.2.

FIGURE 6.1 Position the bridge and the lower-right corner.

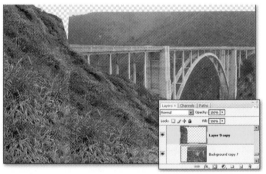

FIGURE 6.2 Transform the foliage to cover the right side of the composition

4. Create a new layer (Ctrl+Alt+Shift+N/Cmd+Option+Shift+N). Activate the Stamp tool (S). Now you will blend the two layers together so that the entire foreground appears seamless. It is usually a good idea to apply editing techniques that will make it as easy as possible for you to make changes if your client desires them. So, apply the clone technique onto a separate layer. Make sure that Aligned is checked, and in the Sample drop-down list, make sure that All Layers is selected. You have now told Photoshop to allow you to apply the Stamp tool onto the blank layer but utilize the visual information of all layers underneath and apply the technique to the current layer selected (see Figure 6.3).
5. In the `Tutorials/ch 6` folder on the CD-ROM, open the sky002.jpg file. Place and position it into the scene as shown in Figure 6.4.

ON THE CD

FIGURE 6.3 Use the Stamp tool to blend the grassy areas.

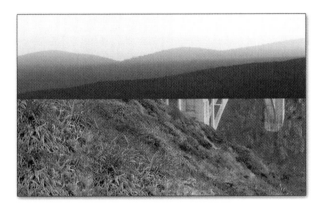

FIGURE 6.4 Add the sky to the scene.

6. Duplicate the bridge layer and apply a layer mask that isolates the bridge (see Figure 6.5). Place the bridge layer on top of the sky. To create a mask, use the channels techniques that you've learned in Chapter 3.

7. Now, apply a layer mask to the sky and use your paintbrush with your WACOM Pen to isolate its visual aspects to the areas behind the hill as well as the bridge (see Figure 6.6).

8. The goal is to apply a hazy atmospheric effect to the background of the scene. That means the bridge will lose detail as it becomes more dominated by haze. Use the technique of applying a layer style of overlay to the bridge and the sky layer. When you select overlay, make sure that the color you designate for the overlay is a color that already dominates the sky area. Bring down the opacity of the color fill so that the bridge isn't completely void of detail (see Figures 6.7 and 6.8).

FIGURE 6.5 Duplicate the bridge layer, and apply a mask to isolate the bridge.

FIGURE 6.6 Apply a layer mask into the sky.

FIGURE 6.7 Apply a layer style of Overlay to the bridge.

FIGURE 6.8 Applied layer styles to the clouds.

9. The bridge is coming toward the foreground at an angle and should reflect less distortion from the fog than the right side. To give this appearance, duplicate the bridge layer, and double-click on it to open the Layer Styles dialog box. Pull the Opacity slider for the Overlay effect to the left to reduce the haze and reveal more texture detail in the bridge overall. Apply the layer mask to restrict the results to the left side of the bridge, leaving the right to maintain its ghostly appearance (see Figure 6.9). Let's continue on and give the image some warmth.

10. So far, the image looks a little blue and drab, so use a Curves adjustment layer and select blue as the color that you want to alter. If you push the curve upward, it will become dominated by the blue hue to a greater degree. In other words, the Blue channel is being directly affected. To warm up the scene, use yellow, which is the opposite of blue. Pull out some blue near the lower tonal area of the curve as shown in Figure 6.10.

11. Merge all of the layers into a new layer by holding down the Alt/Option key, accessing the Layers submenu, and selecting Merge Visible. Next, commit this new layer to a smart object. Apply Gaussian Blur (Filters > Blur > Gaussian

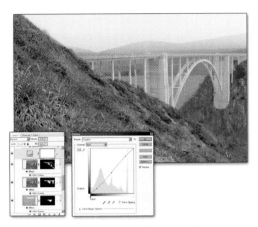

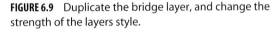

FIGURE 6.9 Duplicate the bridge layer, and change the strength of the layers style.

FIGURE 6.10 Apply a Curve adjustment layer to adjust color.

Blur) to the smart object, and set the radius to around 21 pixels as shown in Figure 6.11. The idea is to establish a shallow depth of field so restrict the blur effect to the upper portion of the image using a gradient on the mask. Make sure that you apply white to the upper portion of the mask and black in the lower portion.

12. Apply the same technique of adding a layer styles color overlay, but this time, set the layer Blend Mode in the Overlay panel to Luminosity as shown in Figure 6.12.

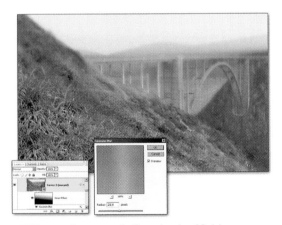

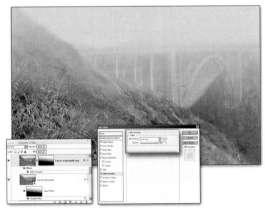

FIGURE 6.11 Creates a shallow depth of field.

FIGURE 6.12 Apply the Overlay layer style and the Luminosity Blend Mode.

13. Add some subtlety to the atmospheric fog by using the Gradient adjustment layer. Apply a Gradient layer that establishes a gray with a slight greenish cast on the left and gradiates toward white on the right. This is to give the appearance of

the ambient color being more dominant in the foreground due to the fact that the foreground is closer to the viewer's perspective. The human eye will be able to perceive subtle colors in its immediate vicinity. The farther away you get, the denser the fog will become, which will take on a more neutral effect visually; therefore, any objects in the background will lose their identity and take on the soft luminance of the fog. To duplicate this effect, we have applied a more greenish fill to the areas that are closer to the camera, which are in the left portion of the composition.

14. Use a layer mask to restrict the effects of the gradient to the upper portion of the image. Notice that in Figure 6.13, an initial gradient has been established applying black in the lower half and white in the upper half. The computer often applies clean, predictable results but this often makes your image easily recognizable as being computer generated. To break up this predictability, edit the mask with your Paint tool by hand to remove the effect from the areas that are closer to the foreground. Use your own creativity to establish the final result.

ON THE CD

15. The sky looks a little boring and needs a sense of life, so go to the CD-ROM, navigate to the `Tutorials/ch 6` folder, and open the birds in flight image. Select one or more of the flying birds, and place them into the sky. Now you are ready to add the futuristic land patroller.

FIGURE 6.14 Apply birds to the sky.

FIGURE 6.13 Edit the gradient mask.

WORKING WITH 3D LAYERS

The wonderful feature of importing 3D objects into LightWave will save illustrators quite a bit time from having to render and rerender their models in the exact positioning and perspective desired to fit into the initial creation.

Let's take a look at the features and capabilities that you now have for a adding 3D objects to your illustration. Until now, Photoshop has been primarily a two-dimensional program in that it utilizes an X axis (left to right) and a Y axis (up and down). This information is consistently displayed in the Info Palette (see Figure 6.15).

FIGURE 6.15 The Information Palette displays the X and Y location of your cursor.

CS3 adds a new dimension to the 3D layers. This dimension displays the Z depth (foreground to background), which now gives you 3D capabilities, where the positive X axis is to the right of 0, and the positive Y direction is heading above 0 and vice versa (see Figure 6.16). The Z axis, often referred to as Z depth, has a positive direction going into the scene.

FIGURE 6.16 The Information Palette displays X, Y, and Z vectors.

To view 3D objects, CS3 uses a special layer called 3D layers. To view the objects, follow these steps:

ON THE CD

1. Access the `Tutorials/ch 6` folder of the CD-ROM, and open `ch 6 3D model.psd` (see Figure 6.17).
2. If you click on the layer, the Option bar remains displaying the current se-lected tool from your Tools Palette. To display the 3D options, double-click on the layer's thumbnail and take a look at your Options bar.

FIGURE 6.17 Opening the 3D file.

3. There are two different ways to view your 3D scene. One way is by viewing the object as you move it around in 3D space to resize or reposition it. You can access this view by clicking on the 3D Object icon on the Options bar (see Figure 6.18A). The other way is to view everything through the camera. On the Options bar, click on the camera, which is next to the 3D Objects option button (see Figure 6.18B). Select the object view.

FIGURE 6.18 Viewing the camera and object options.

4. Look at the navigational commands for your 3D model. Start by selecting the rotation command, and navigate 360° around the model (see Figure 6.19).
5. Select the Roll command, and roll the model on its pitch (see Figure 6.20).
6. Use the Slide command to move the model closer or farther away from the camera (see Figure 6.21). The object distorts as it gets closer to the camera. This is similar to using a wide-angle lens on a photographic camera.
7. Select the Drag command to move your object anywhere in your frame (see Figure 6.22).
8. Finally, you can Scale your object so that it takes on a larger or smaller size (see Figure 6.23). In addition, you can position the object. Use this for placing your object throughout Racine without getting lens distortion.

FIGURE 6.19 Rotate the model.

FIGURE 6.20 Roll the model.

FIGURE 6.21 Slide the model.

FIGURE 6.22 Drag the model.

FIGURE 6.23 Scale the model.

Orthographic Views

You also can use orthographic views, which are views from a single location. They are as follows:

- Custom 3D view (Figure 6.24)
- Left view (Figure 6.25)
- Right view (Figure 6.26)
- Top view (Figure 6.27)
- Bottom view (Figure 6.28)
- Back view (Figure 6.29)
- Front view (Figure 6.30)

FIGURE 6.24 Custom view.

FIGURE 6.25 Left view.

FIGURE 6.26 Right view.

FIGURE 6.27 Top view.

FIGURE 6.28 Bottom view.

FIGURE 6.29 Back view.

FIGURE 6.30 Front view.

Lighting Options

Although you can't add and reposition lights in the 3D file, CS3 does give you some lighting options. Following are a few of those options, but be sure to go through all of them on your own time and take a look at their potential.

Lights from File: Displays the original lighting style from your 3D modeler (see Figure 6.31).

No Lights: Turns off the light source and gives you a black filled shape (see Figure 6.32).

FIGURE 6.31 Lights From File Option.

FIGURE 6.32 No Lights Option.

Day Lights: Simulates daylight lighting by adding greater intensity and contrast to the final result (see Figure 6.33).

Primary Color Lights: Adds red, green, and blue lighting styles to your 3D object (see Figure 6.34).

FIGURE 6.33 View of Day Lights Option.

FIGURE 6.34 Primary Color Lights.

CAD Optimized Lights: Simulates the lighting style in a CAD program (see Figure 6.35).

Single Light From Eye: On-camera style lighting that illuminates the object face on (see Figure 6.36).

FIGURE 6.35 Optimized Lights.

FIGURE 6.36 Single Lights From file.

Cross Section Feature

For artists who do mechanical illustrations, the Cross Section feature is a godsend. On the Options bar, select the downward triangle next to the Cross Section button to take a look at this feature's capabilities. Cross Section allows you to slice your model to view its interior, add other features and details to illustrate the function of a mechanical instrument, or apply slices to give an inside look of architectural interior. The possibilities are endless.

As you can see, you can isolate the slice along the X, Y, or Z axis. You use the sliders to adjust positioning or rotate the slicing plane (see Figure 6.37). You can also flip the cutting plane by checking the Flip check box (see Figure 6.38).

FIGURE 6.37 View of a cross-sectioned image.

FIGURE 6.38 View of a cross-sectioned image with Flip activated.

A Creative Way to Integrate the 3D Model

Over the the landscape comes a futuristic military vehicle speeding toward the camera with great determination. As it's moving forward, its powerful tires kick grass and dirt skyward.

In this exercise, the 3D object has already been textured and committed to a smart object to facilitate the creation of this tutorial. If you want to try your hand at texturing the model in your own 3D program, the `land patroller.obj` 3D file has been provided for you on the CD-ROM. For now, use a smart object derived from the 3D file to complete the tutorial.

ON THE CD

1. Go to the `Tutorials/ch 6` folder on the CD-ROM, and open `land patroller.tif`. Drag this image into the new file, and resize and position it similar to what you see in Figure 6.39.

FIGURE 6.39 Place the land patrol into the landscape scene.

2. Now you need to modify an existing brush in your Brush Palette. Select the Grass brush shown in Figure 6.40.

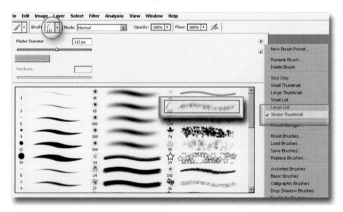

FIGURE 6.40 Select the Grass brush.

3. Modify the brush properties to match what you see in Figure 6.41A through 6.41D.

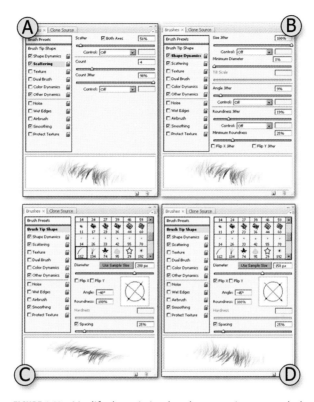

FIGURE 6.41 Modify the existing brush properties to match the grass.

4. In essence, you are adjusting the scattering, its rotation, and its shape dynamics to match the grass configuration of the hillside.
5. Apply a layer mask to the smart object, and use your newly created brush with the foreground color set to black to edit the mask so that the grass shows through. Immediately, you can see the advantages of creating a brush that duplicates the appearance of the grass. Although you could paint the grass on a separate layer, this is a down and dirty trick for getting quick results.
6. Use the gradient technique to make a circular flare on a new layer above the vehicle. Resize it if necessary to match what you see in Figure 6.43. This will represent the headlight source for the land vehicle.
7. Create a rectangle selection on a new layer, and fill it with white. Use Free Transform (Ctrl+T/Cmd+T) to modify the shape that will represent the light beams (see Figure 6.44).

FIGURE 6.42 Edit the mask with the newly created brush.

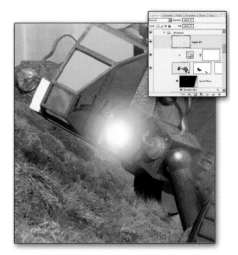

FIGURE 6.43 Create a headlight source.

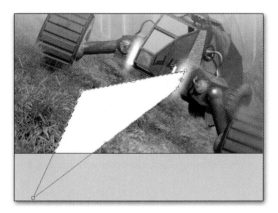

FIGURE 6.44 Create the light beams.

8. Add some Gaussian Blur to the beams as well as a layer mask to apply transparency to the section that is further away from the light source (see Figure 6.45).

9. Now you can add a slight vibrating motion to the vehicle. Duplicate the smart object, and apply Motion Blur (see Figure 6.46). You now have a Smart Filter, that has a mask associated with it. Use your paintbrush to apply the blur to the wheels, the axles, and the rear part of the vehicle. This helps establish which parts are vibrating the most.

10. Now you have another use for that Grass paintbrush that you created in step 3. Select the Grass paintbrush, and make sure your colors match two extreme greenish hues in the landscape area. Use the Eye Dropper to set the foreground

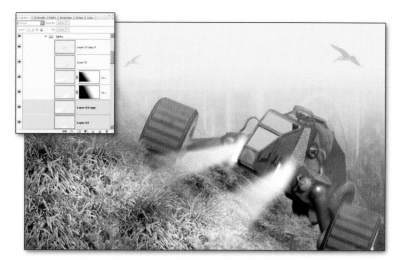

FIGURE 6.45 Apply Gaussian Blur and layer masks.

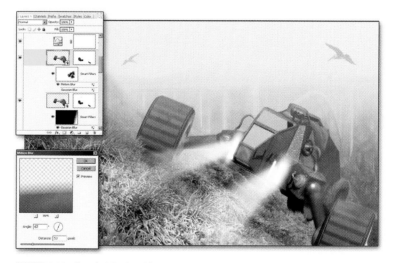

FIGURE 6.46 Apply Motion Blur.

color to a light green and the background color to a darker green. Make sure that you check Color Dynamics in the secondary paint options so that the paint engine will utilize the two colors. Also, give your brush some scattering to represent the grass flying in different directions. Finally, activate Other Dynamics, and select Pen Pressure if you are using a pen and tablet. Use your own creativity, but try to get close to what you see in Figure 6.47.

Figure 6.48 shows the final results of this tutorial.

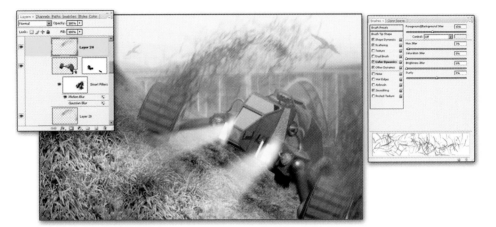

FIGURE 6.47 Paint in the flying grass.

FIGURE 6.48 Final results.

3D Layers for Products

Just a share a more practical application of the use of three the layers, were going to update a label on a barbeque product. In this case we have a barbecue sauce product from a company based in Memphis Tennessee. The client, Lamont's BBQ Inc. (*www.lamontsbbq.com*) which is a leader of fine barbecue products and cooking sauces intends to use this 3D product on their brochures and promotional materials; however, they have several labels that they would like to display on the jar. A 3D object of the jar was created in LightWave 3D version 9, however, you can use any modeling program to create your object.

The current label represents the Marinade for fish and poultry. The goal is to swap out that label for another one that will represent the barbecue sauce.

Step 1

Create a new file that is 5 × 5 inches with a resolution of 150 pixels per inch. Fill the layer with a gradient that matches what you see in Figure 6.49.

FIGURE 6.49 Create a file with the gradient as the background.

Step 2

Import into this file the 3D object (Layers > 3D Layers > New Layer From 3D File).

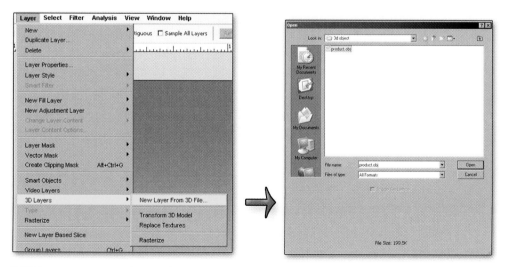

FIGURE 6.50 Navigate to the 3D object.

FIGURE 6.51 View of the imported 3D object.

Currently the two professional formats that Photoshop CS3 Extended recognizes are the Alias Wavefront's .Obj and 3D Studio Max's .3DS file formats. If you would like an option to read and render NewTek's LWO and other file formats then you can try "Rendition For Photoshop".

"LightWave Rendition for Adobe Photoshop will ship with its own 3D model art library and works with models from other sources, such as Google SketchUp's 3D Warehouse or any of these readily available common 3D interchange formats: 3DS, OBJ, U3D, KMZ, and COLLADA, allowing each to be fully rendered in high-resolution with all of their properties."

To learn more about this new and exciting plugin for Photoshop CS3 Extended go to *www.newtek.com*. Now, let's continue on.

Step 3

Everything is a little flat tonally so let's add a little change. Add a Levels adjustment layer to improve the contrast.

Step 4

Just so we can get familiar with what the object looks like without texture, turn off the visual aspects of the texture by clicking on the eye next to the texture symbol below your layer.

Step 5

To edit the texture double-click on the texture layer. Figure 6.54A displays what you'll see on the canvas. If you take notice of the Layers Palette you will also see the

FIGURE 6.52 Apply a Levels adjustment layer to improve the contrast.

FIGURE 6.53 Display of the update without texture.

flattened image on a single layer (Figure 6.54B). It is beneficial to separate the label from the colored background so that it will be easier for you to make changes to the current content as well as to add additional adjustment layers (Figure 6.54C).

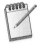

The 3D layer has embedded within it a standard Photoshop file that can be edited in the same manner as a layered image.

FIGURE 6.54 Edit the texture file.

Step 6

ON THE CD

Now we're ready to bring in another label. In the Tutorials/ch6 folder open `bbq label.psd` (Figure 6.55A). Place the barbecue sauce label on the layer above the marinade and commit it as a smart object. Use free transform(Ctrl-t/Command T) to reposition and the resize the new label as close as possible to the previous one (Figure 6.55B).

FIGURE 6.55 Reposition the new label.

When you are done, save the file by hitting CtrlS/Command-S on your keyboard and this will automatically update the 3D image. You should have something that looks like Figure 5.56.

FIGURE 6.56 The updated 3D product.

CREATING THE APPEARANCE OF 3D BY USING THE VANISHING POINT

To create the appearance of 3D with the help of the Vanishing Point, follow these steps:

ON THE CD

1. Create a new file that is 7.5 × 10 inches with a resolution of 300 ppi. Once again, navigate to the CD-ROM to the `Tutorials/ch 6` folder, and open `beach 003.jpg`. Also open `clouds_003.jpg`. Place the clouds beneath the beach image. Apply a mask to the beach, and edit it so that you can see that sky in the upper third portion. Use Figure 6.57 as a guide.
2. Use a Levels adjustment layer to enhance the highlights in an otherwise drab scene (see Figure 6.58). By enhancing the highlights, the image takes on a greater sense of depth.
3. Continue to establish stronger depth by bringing out the detail in the foreground wash to a greater degree through using the Curves adjustment layer. Apply a gradient mask so that the lower half of the image will receive most of the adjustment. You can use Figure 6.59 as a reference to play around with other possibilities as well.

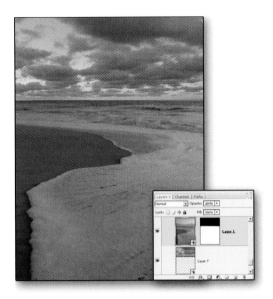

FIGURE 6.57 Composite the beach in the sky.

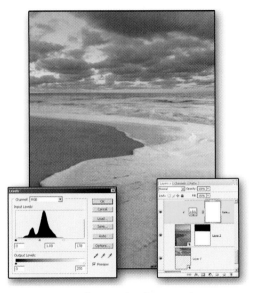

FIGURE 6.58 Apply a Levels adjustment layer.

FIGURE 6.59 Apply a Curves adjustment layer.

4. In the spirit of applying subtlety, duplicate the Curves adjustment layer and brighten the highlights just a little bit as shown in Figure 6.52. This time edit the mask so that only the lower fourth of the image receives most of the effect. Using multiple adjustment layers along with gradients is a great way to apply finer transitions from one effect to the next.

FIGURE 6.60 Apply a second Curves adjustment layer.

5. Apply some color balance to the overall image where we will affect the highlight, midtone, and shadow regions of the image. Use Figure 6.61 as a reference and apply the settings in the shadows, midtone, and highlight areas of the image.

6. Merge all layers into a new layer without affecting the rest by holding down the Alt/Option key and selecting Merge Visible from the Layers submenu. In the same menu, convert the layer into a smart object. Now let's establish a more shallow depth of field. Apply Gaussian Blur, and edit the mask of the Smart Filter so that the blur is restricted to the horizon location with the use of the gradient.

7. To create a strong base for the next object, use a Curves adjustment layer to reduce the density in the lower tonal information of the image. Figure 6.55 and Et Le you can see the background recede farther visually. Place all of the layers into a layer group, and title it "beach" to keep organized. Now let's add some more interesting subject matter.

ON THE CD

8. In the CD-ROM, open `bridge 001.tif`. Place the bridge image into the layer to file and resize it with Free Transform to look something like Figure 6.64. Start by placing these images immediately into a new layer group. Title the group "bridge."

FIGURE 6.61 Apply a Color Balance adjustment layer.

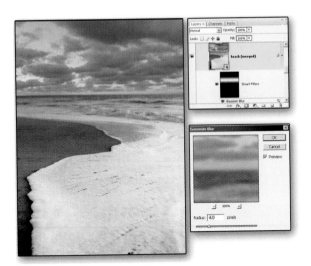

FIGURE 6.62 Create a smart object and apply Gaussian Blur.

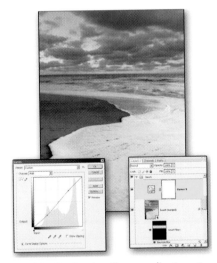

FIGURE 6.63 Apply a Curves adjustment layer two dark in the lower tonal information.

9. Use the Quick Selection tool to isolate the stone structures. This may not be perfect since much of the information is of similar color and tonality. Press Q on the keyboard to enter into Quick Mask mode. Edit the image with your paintbrush until you get something that looks like Figure 6.65.

FIGURE 6.64 Apply the bridge image.

10. To enter into Standard Selection mode, press Q once again. Next, apply a layer mask so that it will utilize the selection to isolate the stone structures (see Figure 6.67). Your layer mask will reflect this.
11. Another way to modify your selections is to isolate your local information on a transparent layer and use the Refine Edge command, which is new in Photoshop CS3. After you have a selection, activate Refine Edge (Edit > Refine Edge). A dialog box comes up that gives you several options for refining the selection's

FIGURE 6.65 Apply the bridge image.

FIGURE 6.66 Apply the Quick Mask to help isolate the bridge image.

FIGURE 6.67 Apply a mask to the bridge image.

edge by use of feathering, expanding, or contracting until your object is outlined as accurately as you need. You can preview the results in several ways as shown in Figure 6.68. You can view them as a selection (see Figure 6.68A), as a red mask (B), as a black mask (C), as the isolated image (D), or as a layer mask (E).

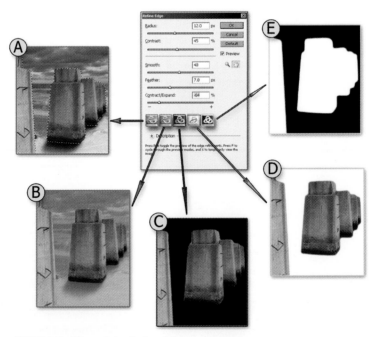

FIGURE 6.68 View of the Refine Edge command.

12. The radius adjusts the edge intensity in a pixel radius from the original se-lected shape as shown in Figure 6.69 and Figure 6.70.

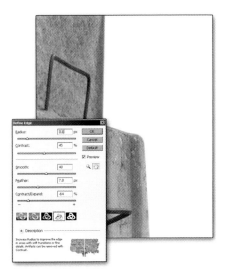

FIGURE 6.69 Expanding the Refine Edge radius.

FIGURE 6.70 Contracting the Refine Edge radius.

13. The Contract/Expand sliders adjust the distance of the selection from the cho-sen shape as shown in Figure 6.71 and Figure 6.72.

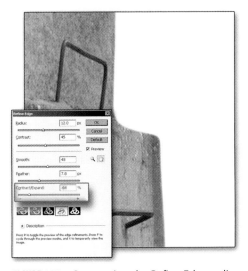

FIGURE 6.71 Contracting the Refine Edge radius with the slider.

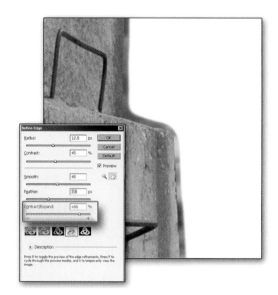

FIGURE 6.72 Expanding the Refine Edge radius with the slider.

14. Go back to the stone structure with its layer mask, and increase the highlight information on the structures. Use the Levels layer mask to do this (see Figure 6.73).

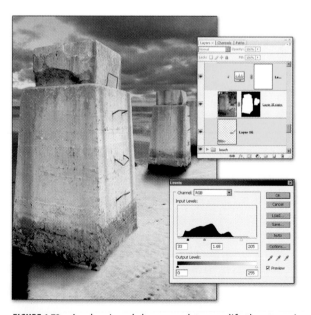

FIGURE 6.73 Apply a Levels layer mask to modify the stone image.

15. The color balance of the overall area is shifted toward a bluish cast, so modify the stone structures to reflect the ambient light in the surrounding area. Apply a Curves adjustment layer, and in the Channel drop-down list, select Red, Blue, and Modified Curve as shown in Figure 6.74. By removing red, you have added cyan. Also, blue has been added by shifting the curve slightly upwards. The ambient light is actually closer to being a combination of blue and cyan. Since it appears that the midrange areas are most affected, this is where you will place the point on the curve. Experiment with other options as well.

ON THE CD

16. Now let's add another dimension inside of the stone structures. On the CD-ROM, open `stairs 002.jpg` and position it as you see in Figure 6.75.

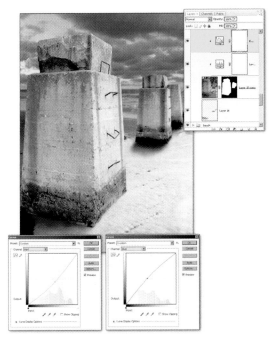

FIGURE 6.74 Apply a Curves adjustment layer to modify the color of the image.

FIGURE 6.75 Position the stairs image.

17. Apply a layer mask to the stairs to give the appearance that the viewer can walk into the opening and into another dimension (see Figure 6.76).

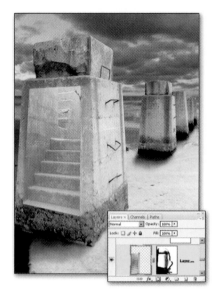

FIGURE 6.76 NEED CAPTION

FIGURE 6.77 Add a layer mask to the stairs image.

18. Apply a Curves adjustment layer so that you can bring down the density of the stairs only (see Figure 6.78). To do this, hold down the Alt/Option key, place your mouse inbetween the two layers, and click to isolate the adjustment to the stairs only.

FIGURE 6.78 Add a Curves adjustment layer to the stairs image.

19. Create a rectangular marquee on top of other locations on the stone structure. Copy and paste this information to outline the entrance of the object. Give it an Overlay layer blend mode to accentuate texture detail (see Figure 6.79).
20. Apply this technique multiple times to enhance the detail on the monolith (see Figure 6.79). Continue to add extra texture to the entry area of the stone monolith.

FIGURE 6.79 Add extra texture to the entry area of the stone monolith.

21. To help bring the viewer's eye toward the main subject matter in the foreground desaturate the structures to the rear. You could apply an adjustment layer of Hue and Saturation and desaturate a portion of the image, but there's another new command in CS3 called Black & White that you can try. Black & White (Cmd+T) is also an adjustment layer, so you can apply that. Figure 6.80 shows the adjustments of both the red and the blue information.
22. The way that this new tool works is that every color has a grayscale equivalent from 0 (black) to 255 (white). This is also how our channels are displayed as a system of grayscales. By selecting the color, you can use the slider to alter its grays toward something that is visually appealing to you. It is also important to notice what colors are dominating in your particular image. If there are no greens in your image, then the Green slider will have no affect. In this example, we have mostly red and blue. Figures 6.80A and B show the results of the red color being altered. In addition, Figures 6.80C and D show the results of the blue color being altered. Also, play around with the yellow slider because there is some slight hint of that in the image as well. Figure 6.80 shows the final setting that has been chosen for this particular image.

FIGURE 6.80 Adjust the red and blue color in the new Black & White command.

Fill the Black & White adjustment layer with black to block out its effects (see Figure 6.74). Ctrl+click/Cmd+click on the layer masks that you created in step 10 to pull a selection from it. You will utilize a selection tool to isolate the effects of the Black & White command. Activate the Gradient tool (G), and apply a gradient with white and the background and foreground in black. This would desaturate the stone of Jake's to the rear but allow the color to remain in the foreground, thus keeping the viewer's eyes more focused in that area.

FIGURE 6.81 Final results of the new Black & White command.

FIGURE 6.82 Apply the gradient with the new Black & White command.

Using the Vanishing Point

Photoshop has greatly improved the new Vanishing Point feature in CS3. Let's explore some of those features and apply them to the concrete structures.

1. Select the "bridge" layer group, hold down the Alt/Option key, and select Merge Group from the Layers drop-down menu. This will merge all of the layers in a layer group into their own layer without affecting the others. You will use the layer to work with the new Vanishing Point. On the CD-ROM, access an image called `texture.jpg`. Place it on its own layer on top of other structures, and Ctrl+click on it to create a selection. Copy the contents of the selection (Ctrl+C/Cmd+C) and access the Vanishing Point feature (Filter > Vanishing Point).

FIGURE 6.83 Copy the texture.

FIGURE 6.84 View of the merged concrete objects on their own layer.

2. On first inspection, there's not much change visually. The changes are in how it functions. Establish a perspective grid as shown in Figure 6.85A. On the top-left corner of the interface, you can adjust the sizing of the grid (see Figure 6.85B).

3. After you establish the first grid, you can tear off another in a different direction by holding down the Ctrl/Cmd key and clicking and dragging on the center point of the grid's edge. As you can see in this example, you want the grid to be heading in a different direction leading to the rear of the monolith. This is easy in the new Vanishing Point. Just hold down the Alt key, place your mouse outside the right edge of the new grid, and click and hold to watch the grid rotate in either direction. You can also just click and drag on each point, making sure that the grid stays a blue color, which indicates that the perspective is correct

(see Figure 6.85D). If the color turns red, your perspective is incorrect, and the corners will need to be adjusted until it takes on the blue hue. The improvement over the previous version of Vanishing Point is that your perspective grid is not restricted to only 90-degree angles. Now you can alter the angle of the new grid manually.

4. In addition, if you are doing any architectural layout, you will find the inclusion of the Measurement tool to be quite helpful as shown in Figure 6.85C. This tool helps determine the distance from one point two another even though you're working at different angles in the Vanishing Point. The Measurement tool also gives you the ability to determine the angle of corners as if you were using a protractor.

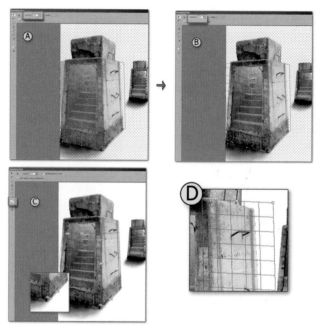

FIGURE 6.85 View of the grid adjustment and Measurement tool addition to the Vanishing Point feature.

5. Before entering Vanishing Point, you copied the graphite texture. Now, you're going to paste it into the perspective grid. Press Ctrl+V/Cmd+ V to apply the texture (see Figure 6.86). At first, the texture shows up on a flat plain, but you can slowly move it down toward your perspective grid and watch how it wraps around the shape of the grid (see Figure 6.87).

6. Vanishing Point also has a command to resize your texture (see Figure 6.88). Select the Transform button and alter the size and rotation as you would if using the Free Transform command. Make sure that you cover the entire concrete object that is closer to the foreground. Commit the changes, and notice that the results have been committed to the layer that you had selected.

FIGURE 6.88　Resize the texture on the grid.

FIGURE 6.86　Paste the texture onto Vanishing Point.

FIGURE 6.87　Place the texture onto the grid.

7. The purpose of using Vanishing Point in this tutorial was to wrap the texture around the object, which is exactly what you have just done. Now, let's the blend the texture onto the object by altering the blend mode to Darker Color as shown in Figure 6.89.

8. For the final step, apply a layer mask to isolate the textures to the monolith. Figure 6.90 shows the final results of this tutorial.

FIGURE 6.89　Change the blend mode of the final results to Darker Color.

FIGURE 6.90　Final results of the tutorial.

FIGURE 6.91 Stone texture is applied to the grid.

FIGURE 6.92 Hold down the Alt key to duplicate an image across the grid.

ON THE CD

Vanishing Point can export the grid information onto a 3D layer or as three objects in the supported formats. Figure 6.91 is an example of a wall created with a stone texture that has been copied and pasted onto the perspective grid. Multiple copies can be applied to a grid. Instead of pressing Ctrl+V repeatedly, just hold down the Alt/Option key and drag the texture to its new location (see Figure 6.92).

9. As mentioned before, Vanishing Point also can export 3D objects or 3D Layers in Photoshop as shown in Figure 6.93.

FIGURE 6.93 View of the 3D capabilities in Vanishing Point.

10. Figure 6.94A shows an example of the wall committed as a 3D layer in Photoshop. However, if you chose to export it as a DXF 3D format, Figure 6.94B shows the result in Newtek's LightWave. Be aware that the Vanishing Point capability for working with 3D at this point is limited, but it has great potential. Experiment with these features and derive your own unique way of creating.

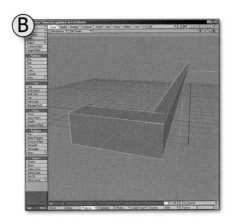

FIGURE 6.94 Vanishing Points 3D and 3D layers.

What You Have Learned

In this chapter, you have learned

- That the establishing depth can be a combination of shallow depth of field, tonal control, and atmospheric haze
- That although 3D layers are limited in its capabilities to adjust lighting, you can use adjustment layers to apply the effects directly to the model
- How to edit the texture on 3D layers
- How to use creative approaches for reflections
- How to use simplicity to create compelling imagery

7 WORKING WITH PEOPLE AND BACKGROUNDS

IN THIS CHAPTER You will Learn:
- Turning portraits into ceramic objects
- Custom-creating clouds
- Using textures to blend with human skin
- Using masks to isolate a person
- Adding animal attributes to a human

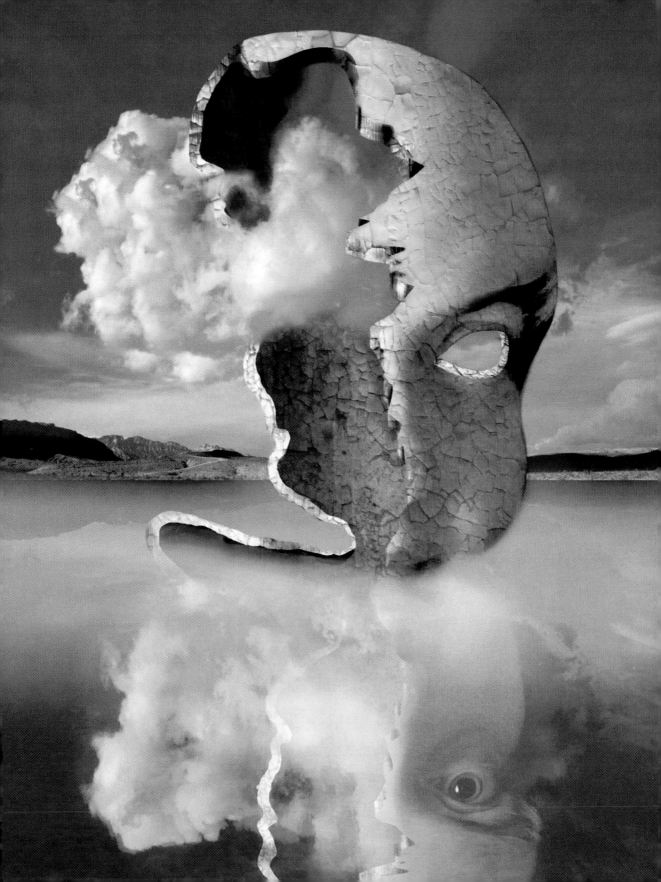

CREATING THE BACKGROUND AND MASK

In this exercise, you will transform a simple head shot into a ceramic mask floating over a watery landscape. You will start by creating the background, and then you will edit the headshot.

1. Create a file that is 10 × 12 inches with a resolution of 300 ppi. Access the `Tutorial/ch 7 cracked head` folder on the CD-ROM, drag in `cloud.tif`, and place it in the upper half of the composition, as shown in Figure 7.1. Use Free Transform if you need to.
2. Underneath this layer, create a new layer and fill it with black.
3. Next, add a little contrast to the mountain range by applying a Curves adjustment layer, and edit out the background by filling the mask with black and painting the mountain area with white to restrict the effect of the Curves adjustment to the mountain range.

FIGURE 7.1 Place the cloudscape.

4. Place these layers into a layer set titled "background." Turn off the clouds for now, but allow the black background to stay visible.

5. Access the `Tutorial/ch 7 cracked head` folder on the CD-ROM, and drag in `portrait.tif`. Place it in a layer set above the background titled "portrait" (see Figure 7.2).
6. Remove the hair by using the Clone Stamp tool. Use the skin as the source and slowly shape the head. Make sure that you use a soft-edge brush. In addition, you are going to cut out and retexture most of the head, so do not spend a lot of time trying to get it perfect, however, this is a good opportunity

to use the Clone Source feature. This will allow you to store several clone sources in memory from which you access them to paint with anywhere on your image. You have the ability to set up to five clone sources and each one is represented by a rubber stamp button. This feature is available to both the Clone Stamp as well as the Healing brush tool. Let's play with it.

7. Create a new layer above the portrait so that you can experiment. Activate the first button on the left then use Alt+click/Option+click on the left eye of the portrait. Proceed to paint on the skin portions of the portrait and clone it over the hair. The goal is to get a fleshy overlay for most of the head. This is the beginning of the mask (see Figure 7.3).

FIGURE 7.2 Portrait.

FIGURE 7.3 Remove the hair.

You could do this by painting with the color of the skin tone, however, you may lose the original texture that was captured by the camera.

8. Use the Pencil tool to plan out how the face will be cracked. Draw on a separate layer above the head. This approach allows you to outline more freely. Use Figure 7.4 as a guide, but feel free to make your own designs.

You may end up creating several versions, but be patient. Also, consider using broken glass or eggshells for inspiration.

9. Use your Pen tool to follow the outlines that you drew (see Figure 7.5). This will give you more control of the outlines in the end.
10. Apply a Layer mask to the portrait.

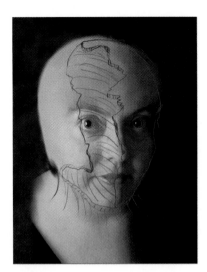

FIGURE 7.4 Draw outlines.

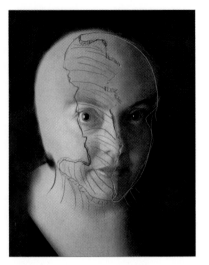

FIGURE 7.5 Apply the Pen tool to outlines.

11. In your Path Palette (Windows > Path), find a thumbnail of the outline that you just created. Ctrl+click on the thumbnail to create a selection.
12. Edit the mask so that the left side of the face disappears. Edit the mask to remove the socket (see Figure 7.6).

FIGURE 7.6 Apply a Layer mask.

ON THE CD

13. Access the Tutorial/ch 7 cracked head folder on the CD-ROM, and drag in texture 1.tif underneath the portrait. Use the Layer effect to create a Gradient Overlay. Follow the parameters in Figure 7.7. Give the texture a Layer mask to isolate it to the left side of the face.

FIGURE 7.7 Apply a Layer mask.

14. Duplicate the portrait layer, and place it underneath the texture. Add noise (Filter > Noise > Add Noise), and give it some Motion Blur (Filter > Blur > Motion Blur), as shown in Figure 7.8.

FIGURE 7.8 Noise and Motion Blur.

15. Apply a mask, and fill it with black to block out the image. Edit the mask with white paint in the eye socket to simulate thickness for the walls of the mask (see Figure 7.9).
16. Duplicate this layer again, but this time, add the rear frame to the mask, as shown in Figure 7.10.

FIGURE 7.9 Creating the eye socket.

FIGURE 7.10 Add the rear frame.

17. Duplicate this layer one last time, and add the thickness to the side of the face, as shown in Figure 7.11.

ON THE CD

18. Access the `Tutorial/ch 7 cracked head` folder on the CD-ROM, and drag in `texture 2.tif`. Add the crackling paint texture to the edge borders. Use layer masking as you did in step 13 to achieve this (see Figure 7.12).

FIGURE 7.11 Add thickness to the side of the face.

FIGURE 7.12 Add texture to the edges.

19. Duplicate the head shot layer, and edit the mask so that the eye is visible. Hold the Alt key and select Merge Visible in the Layers submenu. Now this image is in one layer.
20. Turn off the visible properties for now; you will use this for the reflection later (see Figure 7.13).
21. Duplicate the texture layer you used in step 14, and edit the mask to overlay it over the entire head (see Figure 7.14).

FIGURE 7.13 Make the eye visible.

FIGURE 7.14 Add texture to the mask.

22. Make the edges more distinct by giving them a less saturated look. Apply a Hue/Saturation adjustment layer. Reduce the saturation as shown in Figure 7.15, and edit the mask to restrict the effect to the cracked edges.

FIGURE 7.15 Reduce the saturation.

23. Now you need to make the water that the mask will sit in. Make sure that your foreground and background colors consist of a light blue and a dark blue hue. Create a new layer, and fill it with the light and dark blue clouds (Filter > Render > Clouds).

24. Use Free Transform (Ctrl+T) to restrict it to the lower half of the layers. Use a Layer mask to soften the rear edge of the water. Also use Perspective (Edit > Transform > Perspective) to make the foreground look as if it's closer.

25. When you are finished, access the layer effects, and add a Gradient Overlay to allow the rear portion to become more luminous than the foreground (see Figure 7.16).

26. Turn on the background clouds that you turned off in step 1 (see Figure 7.17).

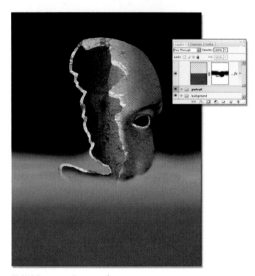

FIGURE 7.16 Create the water.

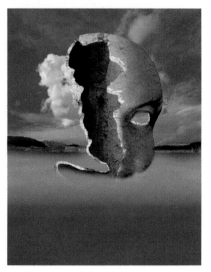

FIGURE 7.17 Turn on the background.

27. Duplicate the cloud layer and place it in a layer set titled "levitating clouds." Edit the mask to allow the clouds to appear as if they are extending from the inside of the mask. Use several duplicates if you like for more expressive clouds, and just edit their masks to integrate them (see Figure 7.18).

28. It's time to turn on the reflection that was created in step 20. Inverse it vertically (Edit > Transform > Inverse Flip), and place its base at the base of the mask, as shown in Figure 7.19.

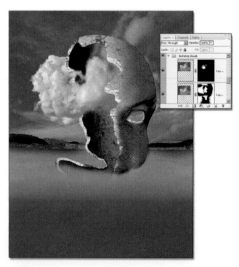

FIGURE 7.18 Create levitating clouds.

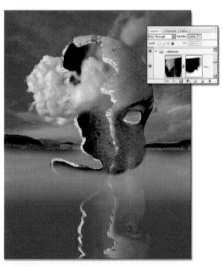

FIGURE 7.19 Create reflections for the mask.

29. The mask has a reflection, so the clouds should too. Duplicate the clouds, and inverse them vertically (Edit > Transform > Flip Vertical) to create their reflections. Change their opacity to around 46% (see Figure 7.20).

30. Duplicate the clouds again to add the reflection for the entire sky. This will add a more saturated blue to the water (see Figure 7.21).

FIGURE 7.20 Create reflections for the clouds.

FIGURE 7.21 Create reflections for the sky.

31. Add two Nik Color Efex Pro 2.0 filters. Start with the Sunshine filter and follow the settings in Figure 7.22. The result is shown in Figure 7.23.

FIGURE 7.22 Add the Sunshine filter.

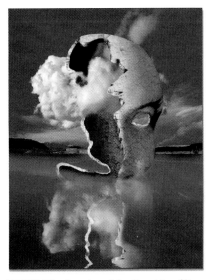

FIGURE 7.23 Results of the Sunshine filter.

32. Apply the Bicolor Cool/Warm filter, and edit its mask so that the results of the Sunshine filter remain on the face (see Figures 7.24 and 7.25).

FIGURE 7.24 Add the Bicolor Cool/Warm filter.

FIGURE 7.25 Results of the Bicolor Cool/Warm filter.

The final results, as shown in Figure 7.26, are very interesting.

FIGURE 7.26 Final results.

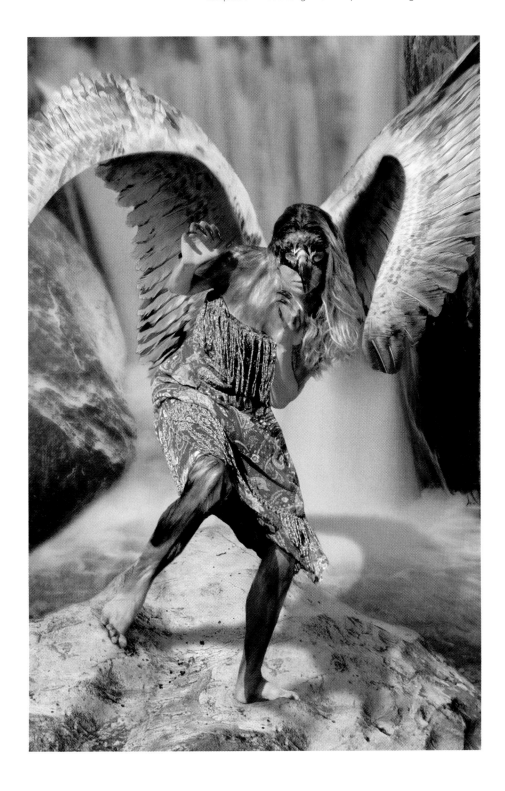

CREATING THE WINGED WOMAN

In this exercise, you will transform a woman into a human/hawk hybrid. She will be poised in front of a waterfall cavern that you will create by using two different photographs. This tutorial uses Free Transform, Warp, and masking.

ON THE CD

1. Create a new file that is 10 × 12 inches with a resolution of 300 ppi. Access `Tutorial/ch 7 morph` on the CD-ROM, and open `sand and boulder.tif`. Drag this image into the new file, and resize it to fit the frame (see Figure 7.27).

FIGURE 7.27 Sand and boulders.

2. Giving an image depth from the beginning is always a helpful strategy. So give the foreground boulder and the one to the left more contrast and saturation by duplicating the original layer and changing the blend mode to Hard Light. This will increase the contrast and saturation of the image. Apply a black mask to this layer, and apply the effect to the two stones by painting. Experiment with duplicating the layer again to apply a different blend mode to make the background even more dynamic (see Figure 7.28).

ON THE CD

3. Access the `Tutorials/ch 7 morph` folder on the CD-ROM, and drag in the `water fall.tif` and the `water fall 2.tif` files. Drag in both images with water fall 2 on top. Give both layers a mask to isolate the water behind the three foreground boulders. Use water fall to fill the ground (see Figure 7.29).

4. Apply a little contrast change with a Curves adjustment layer to increase the overall contrast. This gives some detail to the textures. Lock the adjustment to the image by holding the Alt key while placing your mouse in between the two layers and clicking. Now the adjustment effects are isolated to the layer below it (see Figure 7.30).

FIGURE 7.28 Sand and boulders composite.

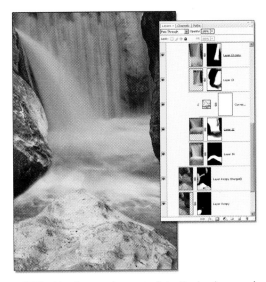

FIGURE 7.29 Composite water into the background.

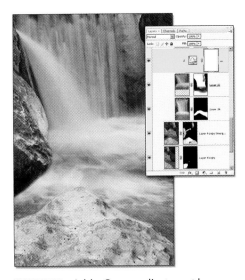

FIGURE 7.30 Add a Curves adjustment layer.

5. Give a little more interest to the foreground by duplicating one of the water-falls and transforming (Ctrl+T/Cmd+T) to give a slightly different shape (see Figure 7.31).
6. Give this new waterfall a little more brightness by applying a Curves adjust-ment layer. Apply the settings as shown in Figure 7.32. Fill the mask with black, and paint with white in the waterfall location (see Figure 7.32).

FIGURE 7.31 Add another waterfall.

FIGURE 7.32 Add Curves to the waterfall.

7. Create some shallow depth of field by merging all visible layers into one independent layer (Ctrl+Alt+Shift+N+E/Cmd+Option+Shift+N+E).
8. When you are done, give this layer a Gaussian Blur (Filter > Blur > Gaussian Blur). Then apply a mask to the blurred layer, and give it a gradient of white at the top and black at the bottom so that the effect is less prominent in the foreground. Use Figure 7.33 as a guide.

FIGURE 7.33 Apply a depth of field.

9. Access the `Tutorials/ch 7 morph` folder on the CD-ROM, and drag in the `crouch pose.tif`. Use layer masking to isolate the model. Place the woman image in a layer set titled "winged woman" (see Figure 7.34).

10. To assist your masking efforts, press the \ key when the mask is selected and the black portions of the mask appear in red. This gives you the advantage of seeing the mask and the image simultaneously as you edit with the Brush tool (see Figure 7.35).

FIGURE 7.34 Apply the model.

FIGURE 7.35 Apply the mask.

11. Access the `Tutorials/ch 7 morph` folder on the CD-ROM, and drag in the `feather detail.tif`. Change its blend mode to Hard Light, apply a black mask, and edit the mask to reveal the feather detail on the model's skin. You will need to duplicate these layers several times to achieve this over the entire body (see Figure 7.36).

12. Now it's time to add the wings. Bring in the `wing.tif` from the `Tutorial/ch 7 morph` folder on the CD-ROM, and position and transform it so that it extends past the model's head toward the upper-right corner (see Figure 7.37).

13. Apply a mask to isolate it from its background. Use a soft-edge brush, and zoom in to obtain the best results. You will create more wing details, so make a layer set for them and call it "right wing" (see Figure 7.38).

14. Duplicate the wing, and apply the Free Transform (Ctrl+T) and the Warp command (Edit > Transform > Warp) to curve and twist the wing toward the foreground (see Figure 7.39).

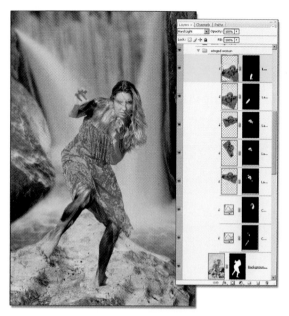

FIGURE 7.36 Add the feather detail.

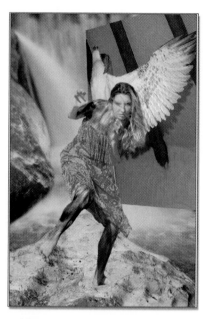

FIGURE 7.37 Add the wing detail.

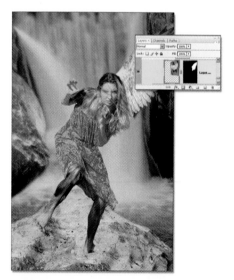

FIGURE 7.38 Add a mask to the wing.

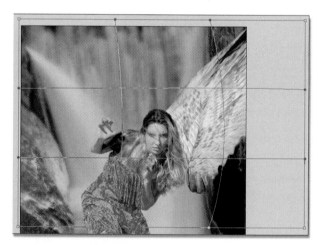

FIGURE 7.39 Apply Warp.

15. Duplicate the wing, and apply the Hard Light blend mode. Add contrast and richness to varying areas to enhance its texture. Next, add shading underneath the wing, as shown in Figure 7.40.

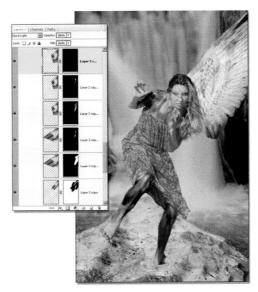

FIGURE 7.40 Add shading underneath the wing.

16. Create a new layer below the series of duplicated wings that make up the one curving to the front. Fill the layer with black, and give it a black-filled mask. Edit the mask with white to create the illusion of curvature to the underside of the wing. Use Figure 7.41 as a guide.

FIGURE 7.41 Create the illusion of curvature to the underside of the wing.

17. Now create a wing for the left side of the model using the same procedures from steps 12 through 16. Note that you do not want the same shape of the other wing, so when you apply Warp to shape it, give the shape some variance. Place them into a layer set titled "left wing" (see Figure 7.42).

FIGURE 7.42 Add left wing.

You could just merge your original wings into a new layer and apply the Warp tool, but this may not give it the spontaneity that you need. Going through each of the steps but giving them variances is a good way to protect against redundant forms.

18. Create the shadow for the figure. Merge the wings and the model into a layer, and fill the pixels with black (Edit > Fill > Fill with Black). Make sure that the Preserve Transparency box is checked so that the entire layer isn't filled with black (see Figure 7.43).
19. Place the shadow layer beneath the "winged woman." The sunlight is coming from the left, so use Free Transform to position the shadow on the ground to the right-hand side. Allow the shadow to flow with the contour of the stone. Use Liquefy (Filter > Liquefy), press W for the Forward Warp tool, and push the edges of the shadow to conform to the contour of the rock. When you are done, click OK.
20. Apply the Warp command (Edit > Transform > Warp) to make some global adjustments to fine-tune the flow of the shadow (see Figure 7.44).

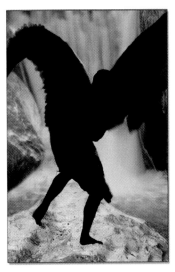

FIGURE 7.43 Create the shadow.

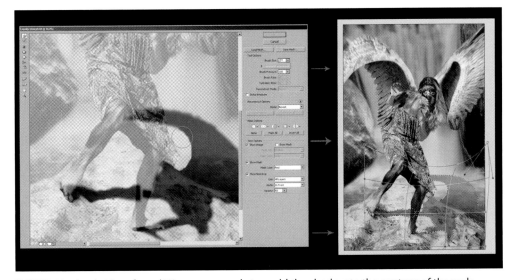

FIGURE 7.44 Apply Liquefy and Warp commands to mold the shadow to the contour of the rock.

21. Use the beak from the hawk, and apply it as claws for the bird woman. Select it and place it on its own layer (see Figure 7.45).

22. Duplicate the beak, and use Free Transform to alter the size. Additionally, use the Warp tool to alter the shape of each claw. Use layer masking to blend each claw with its designated finger. Remember to zoom in and fill the screen with the subject so that editing the mask is not a chore. Place the claws in a layer set called "claws right hand" (see Figure 7.46).

FIGURE 7.45 Place the beak on its own layer.

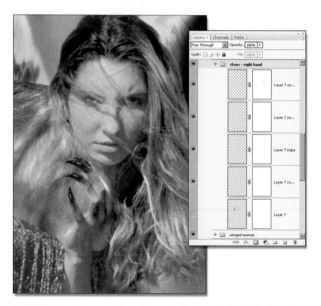

FIGURE 7.46 Create a claw for each finger of the right hand.

23. Do the same for the other hand, as shown in Figure 7.47. Place the claws in a layer set titled "claws left hand."
24. To give the woman a bird-like face, bring in the hawk image, as shown in Figure 7.48.

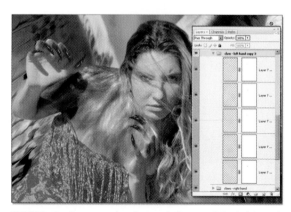

FIGURE 7.47 Create a claw for each finger of the left hand.

FIGURE 7.48 Place the hawk image.

25. Apply a mask, and edit to shape it. Duplicate the layer and change the blend modes as a means to alter the contrast and saturation of the overall look and feel (see Figure 7.49).

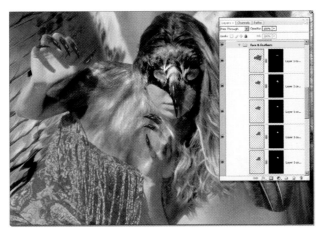

FIGURE 7.49 Edit the face mask.

26. To allow the winged woman to stand out in the foreground, apply a Curves adjustment layer, and edit the hawk woman mask so that its effects are isolated to the winged woman (see Figure 7.50).

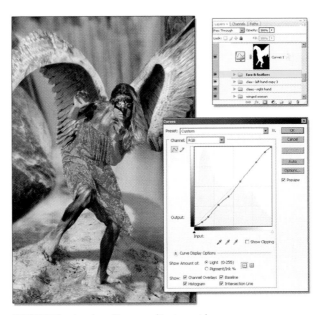

FIGURE 7.50 Apply a Curves adjustment layer.

27. The woman's red dress is visually distracting and draws too much attention, so use the settings shown in Figures 7.51 through 7.53 to make color and tonal changes to the dress. Edit one mask, and then hold the Alt key and drag the mask to the other adjustment layers.

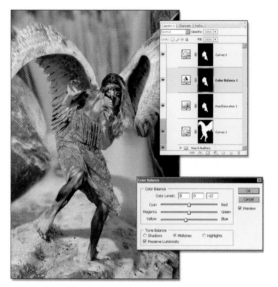

FIGURE 7.51 Apply the Hue/Saturation adjustment layer.

FIGURE 7.52 Apply the Color Balance adjustment layer.

FIGURE 7.53 Apply the Curves adjustment layer.

28. To complete the piece, add two Nik Color Efex Pro 2.0 Filters: Sunshine and Classic Soft Focus (see Figures 7.54 and 7.55).

FIGURE 7.54 Apply the Sunshine filter.

FIGURE 7.55 Apply the Classic Soft Focus filter.

Let's view the final piece, as shown in Figure 7.56.

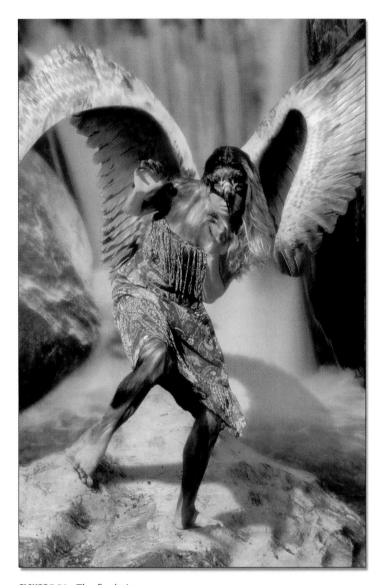

FIGURE 7.56 The final piece.

WHAT YOU HAVE LEARNED

In this chapter, you have learned

- How to create depth by altering color and saturation
- How to use creative applications of Nik Color Efex Pro 2.0
- How to use creative approaches for reflections
- How to use simplicity to create compelling imagery
- How to use masking for human subjects
- How to turn portraits into ceramic objects
- How to use textures to blend with human skin
- How to use masks to isolate a person
- How to add animal attributes to a human

8 FINE ART

IN THIS CHAPTER You will Learn:
- How to create a custom interior from simple textures
- How to open a door in Photoshop
- How to recreate cloud formation from photographic images
- Creative use of Liquefy
- FX tricks to create motion
- How to custom create light rays

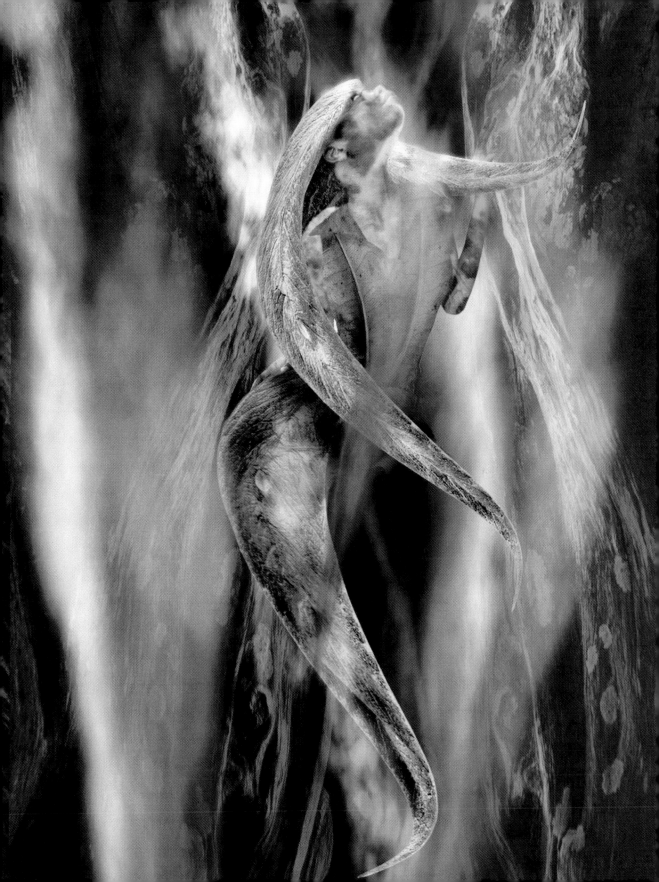

USING PEOPLE TO INTEGRATE INTO YOUR ART

There is a new movement using new tools in art today and this movement is directly the result of the computer technology and software used to make digital expressions. The *digital* medium has allowed artists, and the public in general, to have the freedom to create a unique vision to reflect the traditonal art form via a computer. This freedom is unique to the digital medium. Today's interest in digital technology is breeding a new interest and vision in art, and as the computer becomes more sophisticated, artists are given the tools to become more prolific and daring in what they create. A combination of photography, 3D sculpturing, painting, and scanning of 3D objects can be used in ways not seen before.

ON THE CD

In Tutorials/ch 8 sipapu on the CD-ROM, you will find the source photographs of the model and the tree bark, captured with a Canon D60 digital camera, which produced a 6.1-megapixel image. All of the leaves were scanned at a resolution of 1200 ppi with an HP Scanjet 6300 C, which produced file sizes of 30 MB and up. The smoke streams are 3D-rendered HyperVoxel objects created in LightWave 8.

The objects were chosen primarily for their textures; each one is unique, therefore it is challenging to decide how to utilize them to complete the final result. Let's walk through the process of creating the image that is called Sipapuwhich. Sipapu relates to the American Indian folklore that when one died the spirit enters into a world beneath the land. The concept is interpreted a little differently in this case where the spirit emerges from beneath the land as a new creation. Let's have some fun.

1. Continue to keep everything organized in layer groups. Each one will be introduced along the way, but begin by creating several layer groups titled: "light streak," "steam," "girl 1," "steam 2," and "background" (see Figure 8.1).

FIGURE 8.1 Create layer sets.

ON THE CD

2. From the CD-ROM, open tree bark.tif in the Tutorial/ch 8 sipapu folder. The tree bark has an interesting biomorphic feel, which is ideal to serve as a background for the human model. After duplicating the layer (Ctrl+J) and inverting it horizontally (Edit > Transform > Flip Horizontal), use a mask to hide the seams where the two images come together. Use your Paintbrush and paint with black on the mask to make the bark go away (see Figure 8.2).

3. Create a sense of depth by allowing the viewer to focus more on the foreground areas. You can use two techniques to achieve this. First, merge everything into a new layer (Alt+Ctrl+Shift+N+E). All layers are merged into the new one without merging the original ones. Next, apply the Gaussian Blur to the new layer because this will provide the shallow depth of field (see Figure 8.3).

FIGURE 8.2 Background created.

FIGURE 8.3 Gaussian Blur added to background.

4. Associate a mask and edit it so that the blur effect is restricted mostly to the center portion of the background, as shown in Figure 8.4.
5. The background has a reddish color cast, so using a Hue/Saturation adjustment layer, pull the Saturation slider all the way to the left leaving the image black and white. Because we do not want the color to be completely taken away, edit the mask to isolate the reddish hue to the foreground areas (see Figure 8.5).
6. The background still has quite of bit of tonal information that could compete with the main subject matter, so apply a Curves adjustment layer to restrict the tonal range to deeper shades of gray. Drag the white points on the Curve down to lower the highlights to a richer tone, as shown in Figure 8.6. Edit the mask to apply its effect in the center region of the background.
7. Duplicate the Curves layer to ensure that the tones are very rich, and once again edit the mask to restrict the tones to the center of the image (see Figure 8.7).

FIGURE 8.4 Mask added to the background.

FIGURE 8.5 Hue/Saturation Mask edited.

FIGURE 8.6 Curves adjustment layer applied.

FIGURE 8.7 Curves adjustment layer duplicated.

8. To bring the model in, access `Tutorial/ch 8 sipapu` on the CD-ROM, and open `figure.01.tif`. Place her into the girl 1 layer set organized on top of the background, and apply the Distort tool (Edit > Transform > Distort) to stretch her body up toward the upper right (see Figure 8.8).

9. Open the `figure.03.tif` file in the `Tutorial/ch 8 sipapu` folder. Change the lower part of her body into a leaf-like figure using the Shear tool (Filters > Distort > Shear) on the red leaf. Use Figure 8.9 as a guide.

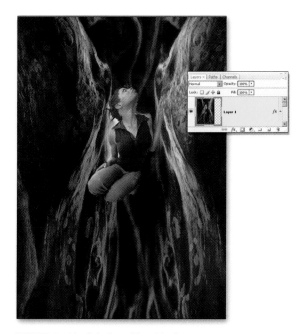

FIGURE 8.8 Model placed in girl 1 layer set.

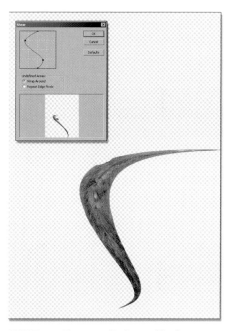

FIGURE 8.9 Shear applied to red leaf.

10. Position the leaf to resemble a tail, and add a mask. Edit the mask to mold the leaf to the model's lower body. Duplicate the leaf layer as many times as you see fit, and use each one to assist you in sculpting the tail to your liking. There are no right or wrong ways to do this. Try to get as close as possible to what is shown in Figure 8.10.

11. Open the `figure.02.tif` and `figure.04.tif` files in the `Tutorial/ch 8 sipapu` folder. Next, apply these leaves to the body. Figure 8.11 shows how the green and yellow leaf's blend mode is set to Linear Light in one layer example. The green leaf's blend mode is set to Hue in the lower layer example. Both examples blend well with the skin and maintain the model's contour. (In the next step, you will discover some details about how this is initially applied.)

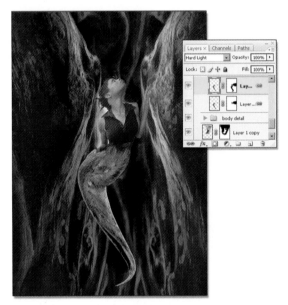

FIGURE 8.10 Sculpted red leaf.

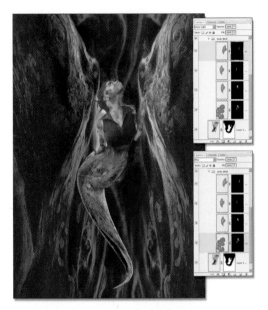

FIGURE 8.11 Texturing of the body.

12. Figure 8.12 shows the leaf before a mask is applied in the lower window as well as the results after the mask is edited in the main image. Use the WACOM tablet for editing the mask.

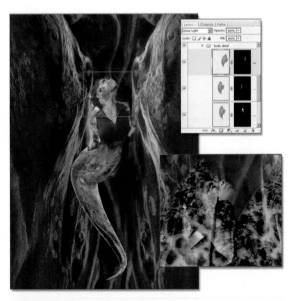

FIGURE 8.12 Texturing detail of the green and yellow leaf.

13. Here are the results of the green leaf when applied. Notice how the mask is edited to allow the green hue to dominate only in selected regions. Try to do the same, and be patient. Start with lower opacity settings when you start editing the mask, and build the effect slowly (see Figure 8.13).

14. In the same way that you created the tail in step 10, add the red leaf to the head of the model to represent her hair. Place these layers into the Head Set folder (see Figure 8.14).

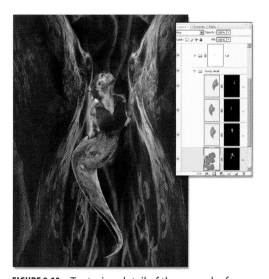

FIGURE 8.13 Texturing detail of the green leaf.

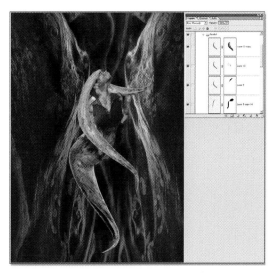

FIGURE 8.14 Head detail with the red leaf.

ON THE CD

15. Access the `Tutorials/ch 8 sipapu` folder on the CD-ROM, and place `brown leaf.tif` into the file. Restrict its textures to the model's upper body to form a type of clothing unique from the original. Finally, use the kelp to form the collar (see Figure 8.15).

16. The brown leaf was successful for the upper body, so use it as an additional composite for her face and neck region, but this time, change the blend mode to Overlay. Figure 8.16 is an example without the mask applied.

17. Figure 8.17 is an example of the brown leaf with the mask edited to restrict its detail to the face and neck region.

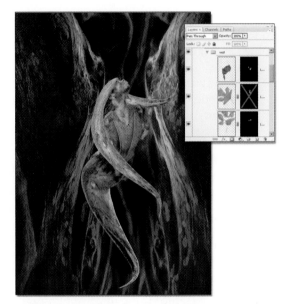

FIGURE 8.15 Brown leaf and dried kelp detail in the upper body.

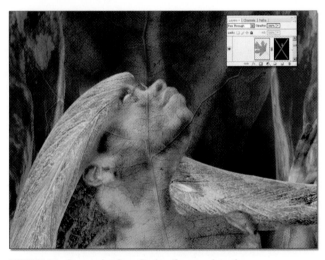

FIGURE 8.16 Brown leaf applied to face and neck.

ON THE CD

18. From the CD-ROM, open smoke 6.tif and smoke 7.tif in the Tutorials/ch 8 sipapu folder. Now it's time to bring in the smoke streams that you rendered in LightWave 8. The two images were rendered and saved as TIFFS so that the smoke would be rendered onto a transparent background. After the layer is placed, resize and duplicate it to compose the steamy smoke streams

FIGURE 8.17 Brown leaf applied to face and neck with the mask applied.

around the model. Place these images into the steam 2 layer set that is positioned just above the background layer set but below the girl 1 folder. Later you will see the details for creating the smoke streams with HyperVoxels in LightWave 8 (see Figure 8.18).

FIGURE 8.18 Smoke streams with the mask applied.

19. Add more of the smoke streams, but this time place them into the steam layer set, which is positioned above the girl 1 folder. Change the blend mode to Screen to enhance the whites. Now the effect is more steam than smoke (see Figure 8.19).

20. Place the light streak layer set on top of all the other layers. Within it, place a layer with a small swatch of white paint applied using the Paintbrush, and position it over the model's face (see Figure 8.20).

FIGURE 8.19 Smoke streams with mask applied in steam layer set.

FIGURE 8.20 White paint applied over the model's face.

21. Change the blend mode to Overlay, and apply a mask to restrict its effects to the edge of the model's face and leaf hair. This will represent the highlights reflected from above the model (see Figure 8.21).

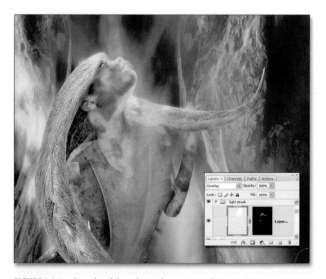

FIGURE 8.21 Overlay blend mode set to white paint.

22. Give the image a little more contrast using the Curve adjustment layer (see Figure 8.22).

Figure 8.23 shows the completed version

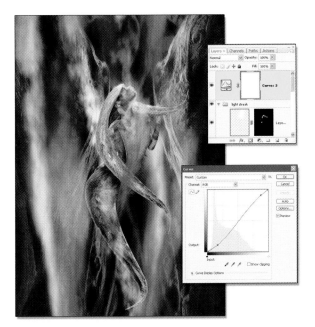

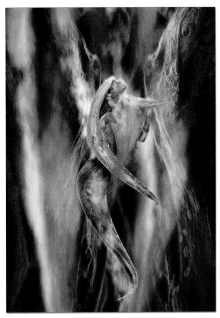

FIGURE 8.22 Curve applied to complete the image.

FIGURE 8.23 Final results of the completed image.

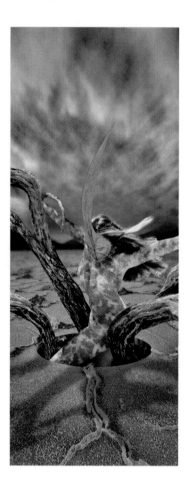

In this exercise we will combine three different landscape-type images to serve as a backdrop for the emerging figure coming forth from beneath the depths. We will start by combining the landscape image. Then we will add custom-created clouds to enhance the scene. Next we will add the human figure, which we will later clothe in a series of textures. This will be fun, but be patient and take your time.

ON THE CD

1. Create a 2 × 5-inch file with a resolution of 300 ppi. Access the `Tutorials/ ch 8` folder on the CD-ROM, and open `devils-golf-course.tif`, `death- valley-race-track.tif`, and `sunset.tif`. Since you are already familiar with layer masking, Figure 8.24 shows the completed results. However, we'll quickly review the procedure.

2. Blend the three images by placing devils-golf-course as the top layer, death-valley-race-track below it, and sunset on the bottom. Now use your layer masking to produce something that resembles Figure 8.24.

3. When it's complete, merge the layers so that you can continue to work on a single layer (see Figure 8.24).

4. Now it's time to create the opening in the ground. Associate a layer mask to the newly merged background layer. Outline a small area that is one-third of the way up from the bottom with the Elliptical Marquee tool, and fill the mask with black (see Figure 8.25).

FIGURE 8.24 Portrait of the completed landscape.

FIGURE 8.25 Hole made in the ground.

5. Add some depth to the sides of the hole. Duplicate the background layer. Select the layer below and with your Move tool activated, nudge the lower layer down by pressing the Down Arrow key a few strokes to offset the two. Ctrl+click on the mask of the layer above to get a selection. Now press Ctrl+Shift+I to invert the selection. Press Delete to give this image a hole. Access your Move tool, and nudge the lower layer down by 10 pixels by pressing the Down Arrow key to offset the two layers. Give this a little Motion Blur, and change the contrast so that the two layers are distinctly different. This now gives the illusion that there is depth along the edge (see Figure 8.26).

6. Create a new layer below the background, and fill it with black to give the hole a sense of depth. Now place some of the ground texture from the death-valley-race-track image above the black-filled layer to be seen through the hole. Reduce its opacity so that you maintain depth but also see a hint of texture (see Figure 8.27).

FIGURE 8.26 Hole edge created.

FIGURE 8.27 Add texture inside the hole.

7. Give the entire scene a little more richness through the use of Curves and Levels adjustment layers (see Figures 8.28 and 8.29).

FIGURE 8.28 Curves adjustment layer.

FIGURE 8.29 Levels adjustment layer.

8. This is a good time to place everything into a layer set. In this example, it's called "landscape" (see Figure 8.30).
9. Fill a new layer with 50% gray and white clouds (Filter > Render > Clouds). Change blend mode to Overlay so that you will see only the white. Use Perspective (Edit > Transform > Perspective) to allow the clouds to appear forward to the viewer (see Figure 8.31).

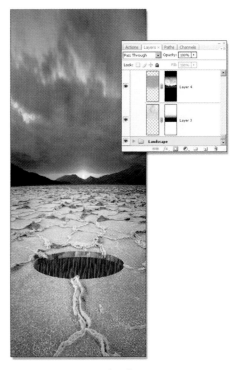

FIGURE 8.30 Place layers in the "landscape" layer set.

FIGURE 8.31 Create clouds.

10. Your goal is to create a sunset reflecting on the clouds. To do this, you will need to add more clouds to represent the color scheme of the sunset in the background. Recreate step 9 in four more layers, but instead of using white, use your Eyedropper tool to select a shade of red, and use this color for one of the cloud layers. Red has a tendency to dominate, so create a cloud layer using black to add some depth to the scene. Use the top two layers to add different variations on the clouds by using different cloud patterns using white. Their brightness will assist in creating the illusion that the clouds are coming forward. This works in tandem with the black clouds to create the depth. Transform each layer differently to achieve a more spontaneous look. Reduce the opacities of all the layers to get what you like best. Experiment! (See Figures 8.32 through 8.35.)

FIGURE 8.32 Create clouds using more colors.

FIGURE 8.33 Transform each color to get a natural look.

FIGURE 8.34 Reduce the opacities of the layers.

FIGURE 8.35 Experiment to create clouds as shown in step 10.

11. Give the upper one-third section of the image a little more density by using a Levels adjustment layer. In addition, apply a Gradient Mask to isolate its effects to the top one-third of the image, as shown in Figure 8.36.

12. Place the `portrait.tif` from the `Tutorial/ch 8 emergence` folder into the scene, and position the figure above the opening you created (see Figure 8.37).

ON THE CD

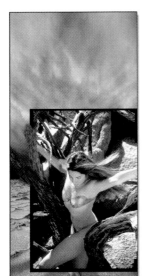

FIGURE 8.36 Apply a Levels adjustment layer and a Gradient Mask.

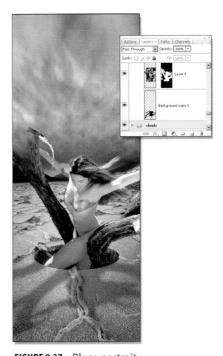

FIGURE 8.37 Place portrait.

13. Edit the figure's layer mask to isolate the body and the main tree trunks from the background, as shown in Figure 8.38.

14. Extend the tree to the edge of the frame on the left, and add an additional tree stump coming out of the hole. Start by selecting a portion of the existing limb from the lower-right corner and pasting it into place as shown in Figure 8.39. Use Free Transform (Ctrl+T) and Distort (Edit > Transform > Distort) to line them up as close as you can with the initial tree branch. Use layer masking to assist you in shaping the limbs. Use your Clone tool with a soft-edge brush to cover up the edges that resulted from the cut-and-paste technique in order to integrate them as one solid piece. With the Clone tool activated, Alt+click on a portion of the tree trunk and clone over the torn edges. Adjust the brush edge by using Shift+[for a soft-edge brush or Shift+] for a hard-edge brush.

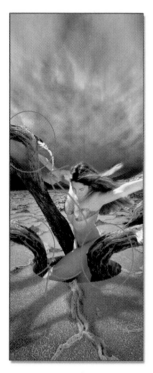

FIGURE 8.38 Edit the mask.

FIGURE 6.39 Clone the tree trunk extensions.

ON THE CD

15. Access the `Tutorial/ Ch 6 Emergence` folder on the CD-ROM, and open `leaf-1.tif` and `leaf-2.tif`. Place them over the portrait layer. Change their blend mode to Hard Light, and position each one over different areas of the model. Duplicate the leaf layers to give yourself greater control over placement, and use Layer masks to isolate the texture to the body of the model. Use the leaf-1 with a mask to restrict its detail to the face and neck region (see Figure 8.40). Use a soft-edge Paintbrush to add the texture to the body.

You can also use the mask you created in step 11 to isolate the model's body by Alt+dragging the mask on top of the leaves to get things started.

16. Merge the texture into its own layer (Ctrl+Alt+Shift+ N+ E). Apply a Hue/ Saturation and Selective color adjustment layer. Use Figures 8.41 and 8.42 as starting examples, and then experiment on your own.
17. Bring in the `leaf-1.tif` again, and use the Warp command to transform it into the headdress, as shown in Figure 8.43. Figure 8.44 shows the completed headdress.

FIGURE 8.40 Body detail with leaves.

FIGURE 8.41 Hue/Saturation adjustment layer.

FIGURE 8.42 Selective color adjustment layer.

FIGURE 8.43 Headdress detail with red leaf.

18. The overall image appears to be a little flat tonally, so let's use Curves to increase Contrast and Hue/Saturation to punch up the color a bit. In addition, add some steam coming from underneath with the use of one of the smoke brushes that you used in Chapters 3 and 4. Make sure that you add a little Motion Blur to the smoke to give it a sense of movement. See the final results in Figure 8.45.

FIGURE 8.44 Headdress completed.

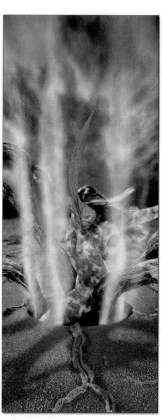

FIGURE 8.45 Final image.

THE NEW PRINTING DIALOGUE

Adobe has made some great improvements to the printing dialog. Instead of having a "Print With Preview" option you now have one single printer dialog box that combines "Print With Preview" with the standard printing interface. In this example the printer of choice is the Photosmart Pro B9180 (*www.HP.com*) which is a pigmented based printer that is getting great reviews for its ability to rival the current printers in quality and speed. This medium format printer produces photo quality images up to 13 × 19 inch borderless or with borders with a maximum print resolution of 4800 × 1200 DPI. It weighs 37.7 pounds with physical dimensions of 26.5 × 16.9 × 9.5 inches.

FIGURE 8.46 Front view of the HP Photosmart Pro B9180 with cartridges and

The printer has the ability to allow you to manually feed in thicker stock papers from the rear manual loading slot or from a holding tray that will support up to 200 sheets of paper. This printer uses 8 inks that include: 2 shades of magenta, 2 shades of cyan, 1 yellow, and 3 shades of black.

When you access the print dialog (File > Print) you will see the standard print interface combined with the preview of how the image would be placed on the size of paper that you specified. To choose the paper size as well as other options just click the "Page Setup" button and let's take a look at the other variables you have at your disposal.

Your options are divided among four separate tabs. The first of these is the "Advanced" options. Here you can customize your margins, the inks spray and a volume, mirror the image or set the poster printing settings.

FIGURE 8.47 View of the "Advanced" tab.

Next we have the "Printing" options tab where you have a series of presets listed in a scroll box to the left. To the right of the scroll box you're able to set your print quality, the paper type that you're using, paper size, the printing method, the source of your printing, and your color management options, which is in this case Adobe RGB (1998).

The third tab is the "Features" options. This will allow you to set the print quality as well as the paper type that you're using.

FIGURE 8.48 View of the "Printing" tab options.

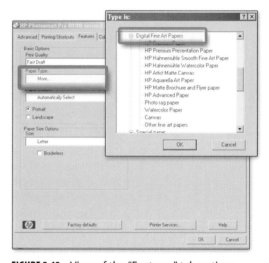

FIGURE 8.49 View of the "Features" tab options.

Digital Art Supplies (*http://www.digitalartsupplies.com*) specialize in papers for the international market. Some of the finest quality acid free papers used for digital fine art are carried by this company. Some of them are:

Crane: Museo Silver Rag, Museo Max, Crane Museo, and Museo II

Hahnemuhle: German Etching Board 310, William Turner 190, Albrecht Durer 210, and Photo Rag Satin 310

Arches: Arches Infinity Smooth 230, Arches Infinity Smooth 355, Arches Infinity Rough 230, and Arches Infinity Rough 355

Schoellershammer: Linen 225, Linen 300, Velvet 225, and Velvet 300

Somerset: Somerset Velvet, Somerset Photo Enhanced Velvet, and Somerset Photo Enhanced Textured

HP themselves have produced a line of papers that has a 11.5 mil thickness and a 75lbs weight that has been engineered with a surface coating that is optimized for the Hp inkets in producing an incredible dynamic arrange. The three most widely used surfaces are the High Gloss, Soft Gloss, and Satin.

High Gloss

Soft Gloss

Satin

FIGURE 8.50 View of HP papers.

The final tab has the "Color" options. Here you can select a profile to print with and in this case the Adobe RGB(1998) is chosen. This is where you can also manually adjust your inks to compensate for any color cast or make corrections to contrast. To get access to your color adjustments simply click on the "more color options" button and this will bring up the sliders for your colors, brightness, saturation, and color tone.

Once you have made your corrections simply commit your changes and you are ready to output photorealistic imagery.

In the same dialog box you can also select the color management options that allow you to choose a profile so that profile will manage the color on your final print. In addition, you can select "Color Handling," which allows you to choose whether or not you want the output to be managed with the profile or whether you would like to have manual control by altering the color ink settings to balance the color.

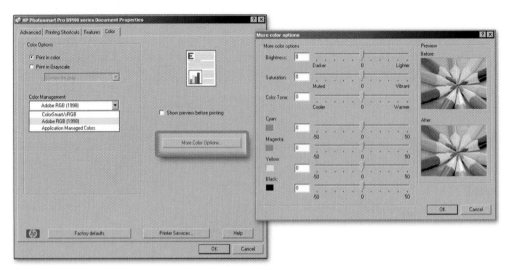

FIGURE 8.51 View of ink settings display.

WHAT YOU HAVE LEARNED

In this chapter, you have learned

- How to make seamless textures
- How to apply Vanishing Point
- How to create paths from selections
- How to custom create fog light rays
- Creative applications of Color Efex Pro 2.0
- The improvements to the Printing Dialog

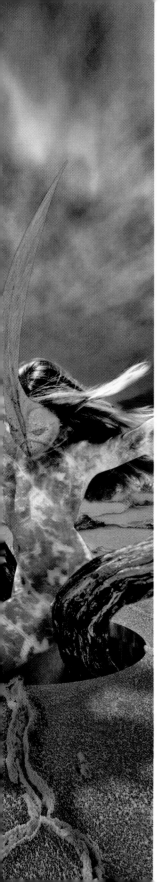

ABOUT THE CD-ROM

The CD-ROM included with *Advanced Photoshop CS2 Trickery & FX* includes all files necessary to complete the tutorials in the book. It also includes the images from the book in full color, and demos for you to use while working through the tutorials and exercises.

CD FOLDERS

Images: All of the images from within the book are in full color in Jpeg format. These files are set up by chapter.

Tutorials: All of the files necessary to complete the tutorials in the book including backgrounds, textures, and images. These files are all in TIF formats, which can be read by most graphic applications. They are set up in folders designated by chapter and tutorial heading under the Tutorial folder.

Demos: We have included a demo of Photoshop CS3 (PC only), Nik multimedia's Nik Color Efex Pro 2.0 and Nik Sharpener Pro 2.0.

The first is a demo version of Photoshop CS3 for Windows. This is a 30-day time-limited fully working demo. Contact *www.adobe.com* to get student or full prices if you are interested in downloading the Macintosh version, or in purchasing this powerful package.

The second application is a demo version of Nik multimedia's Color Efex Pro 2.0 (Windows). This is a fully functioning package with no time limitations however a Nik watermark stamp will appear on rendered images. A PDF user's manual is included in the Nik Color Efex Pro folder. See *www.nikmultimedia.com* for more information.

The third application is a demo version of Nik multimedia's Nik Sharpener Pro 2.0 (Windows). This is a fully functioning package with no time limitations, however a watermark stamp will appear on rendered images. A PDF user's manual is included in the Nik Sharpener Pro folder. See *www.nikmultimedia.com* for more information.

NIK COLOR EFEX PRO 2.0 AND NIK SHARPENER PRO 2.0 (WINDOWS) SYSTEM REDQUIREMENTS

For both systems you will need Nik Color Efex Pro 2.0. The trial versions for the PC are included on this CD-ROM and will let you work through the projects, with no limitations except that a watermark will be placed on the final results.

For Macintosh versions of the demos, please visit *www.nikmultimedia. com.*

Windows

- Windows 98 Second Edition (SE) through Windows XP, or later
- 300 MHz Pentium or better (800 MHz or faster recommended)
- 128 MB RAM (256 MB recommended)
- 800 × 600 screen resolution at 16-bit color depth (1024 × 768 at 24-bit depth recommended)
- 300 MB of hard-disk space for the Complete Edition, 190 MB of hard disk space for the Select Edition, and 90 MB of hard-disk space for the Standard Edition required
- Image-editing application that accepts Photoshop plug-in

Macintosh

- Mac OS 9.2.x and OS 10.1.5 or later
- G3 processor or better (G4 or better recommended)
- 128 MB RAM (256 MB recommended)
- 800 × 600 screen resolution at 16-bit color depth (1024 × 768 at 24-bit depth recommended)
- 480 MB of hard disk space for the Complete Edition, 290 MB of hard disk space for the Select Edition, and 130 MB of hard disk space for the Standard Edition required
- Image-editing application that accepts Photoshop plug-ins

Nik Color Efex Pro 2.0 Selective Tool

Windows:

Windows 98 through XP

Adobe Photoshop 5.5 through CS or Adobe Photoshop Elements 1 & 2.0

Macintosh:
- Mac OS 10.1.5 or later
- Adobe Photoshop 7 through CS & Adobe Photoshop Elements 2.0

Note for Nik Sharpener:
Nik Sharpener filters are Adobe Photoshop compatible plug-ins that are compatible with the following operating systems:

- Windows 98SE/ME/NT/2000/XP
- Macintosh OS 10.2.4 through 10.4.x

Nik Sharpener is compatible with the following image editing applications:

- Adobe Photoshop 5.5 through CS2
- Adobe Photoshop Elements 1 through 3.0
- Adobe PhotoDeluxe
- Adobe Photoshop LE
- Corel Paint Shop Pro
- Corel PHOTOPAINT
- Microsoft Digital Image Pro
- Ulead PhotoImpact

INSTALLATION

To use this CD-ROM, you just need to make sure that your system matches at least the minimum system requirements. Each demo has its own installation instructions and you should contact the developer directly if you have any problems installing the demo. The images and tutorial files are in the Tif file format and should be usable with any graphics application.

INDEX